THE
MOUNTAINS
of IRELAND

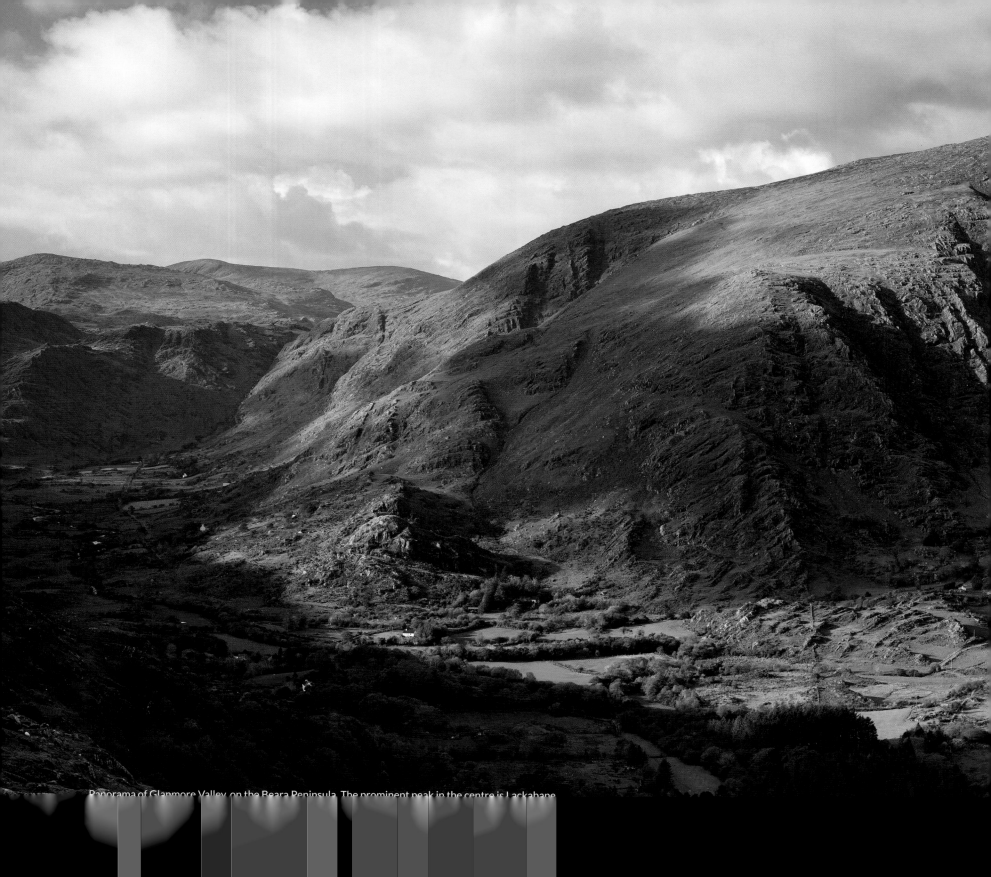

Panorama of Glanmore Valley on the Beara Peninsula. The prominent peak in the centre is Lackabane.

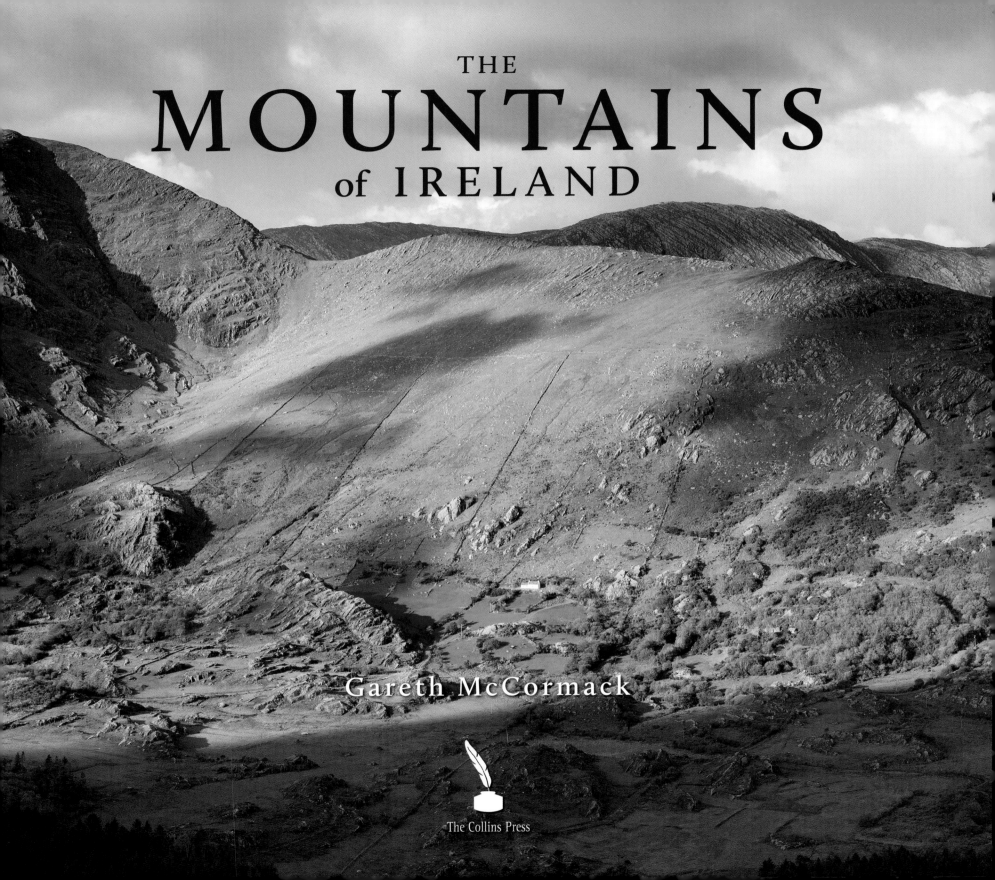

THE
MOUNTAINS
of IRELAND

Gareth McCormack

The Collins Press

Errigal

Derryveagh
Mountains

Antrim
Plateau

DONEGAL
HIGHLANDS

Sperrin
Mountains

Bluestack
Mountains

Slieve
League

Dartry Mountains

Benbulbin

Slieve
Donard

Cuilcagh
Mountain

MOURNE
MOUNTAINS

Ox
Mountains

Cooley
Mountains

Croaghaun

NEPHIN BEG
RANGE

Croagh Patrick

Sheeffry Hills

Mweelrea

Partry Mountains

Maumturk Mountains

The Twelve Bens

Slieve Bloom
Mountains

WICKLOW
MOUNTAINS

Lugnaquilla

Silvermines

Mount Leinster

GALTEE
MOUNTAINS

Blackstairs

COMERAGH
MOUNTAINS

Mount Brandon

Sliabh Mish
Mountains

Knockmealdowns

Carrauntoohil
MacGILLYCUDDY'S
REEKS

BEARA

CONTENTS

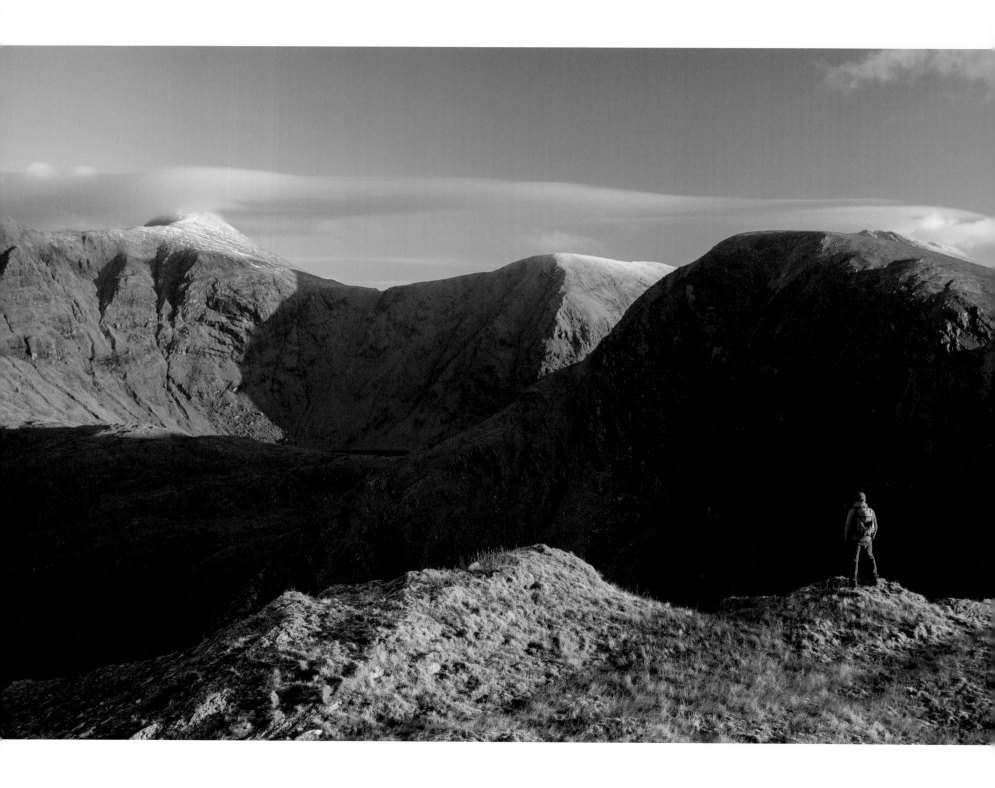

Preface

In all my years of photographing the mountains of Ireland, I have gone wherever the good light may be, pursuing ephemeral opportunities, drawn by topographical charisma and the most dynamic landforms. This book is not – and was never meant to be – an encyclopaedic reference to the mountains of Ireland. Over the years I've found that good photography is rarely made as part of a cataloguing endeavour. If I have omitted your favourite mountain, it was not through lack of time – some twenty years span the oldest and newest images in this book. Neither was it through lack of effort – I've worn and torn plenty of cartilage hauling camera gear up and down mountains over that period.

I also resisted the temptation to make the book a comprehensive reference to geology, history or wildlife. Each of these subjects could take up an entire book on its own, a task best left to experts in those fields. My passion has always been to capture the landscapes of our mountains and hills in the best images my skills, experience and equipment can muster.

There were a great many things I did not know about Ireland's mountains before working in earnest on this book. Some were prosaic, like the name of the obscure range of hills on the Kerry/Limerick border through which I have passed countless times on the way to Kerry (the Mullaghareirk Mountains, if you're interested). Some were important, like the geological processes underlying the formation of our mountain ranges. Some were titillating, verging on absurd, like the mention of the MacGillycuddy of the Reeks in the 1949 BBC Green Book (its policy guide for writers and producers of variety programming).

The naming of mountains in Ireland is sometimes not a straightforward task. Inconsistencies abound, and it is not uncommon for Irish mountains to have four names: the original Irish, an anglicised version used on official mapping, a name used by locals and a familiar name. Some mountains are not even labelled on official mapping, or are given erroneous and mistranslated names. Anyone interested in the naming of Irish mountains should consult the compendium of Irish hill and mountain names on the Mountain Views website (www.mountainviews.ie). In this book I have largely applied the most commonly used name for each mountain, except where I have felt there is something interesting to say about other names or the translation of the original Irish.

There is a tendency today for the viewer to look at any impressive landscape photograph with scepticism and to make the assumption that what they are looking at is the product of Photoshop rather than a creative capture of a beautifully lit landscape. Modern digital photography is not possible without some post-processing of the image files, and the sometimes overenthusiastic use of saturation sliders and other enhancement techniques means that photographers have only themselves to blame. Yet nature itself can produce light shows of great power and beauty; the colours and contrasts sometimes do seem unbelievable, even as you watch them unfold with your own eyes. It is a fine line to tread between producing an image that is faithful to the power of the original scene and an image so denuded of contrast and colour that it should not warrant suspicion.

It is an unending challenge for any landscape photographer to render the sensory and emotional stimulus we experience through three dimensions and five senses into a digital file. No matter how many megapixels technology provides, there is often no way of recording the other stimuli that made a scene or moment memorable, such as sounds, smells and emotions. But with creativity, good judgment and no small amount of luck, sometimes it is possible to transport the viewer to that time, that place, even for just a few moments. If, through the images in this book, I can inspire the same sense of awe in the viewer as I experienced when pressing the shutter, then I will have succeeded in some small way.

A walker looking towards Broaghnabinnia and the MacGillycuddy's Reeks from Stumpa Duloigh, County Kerry.

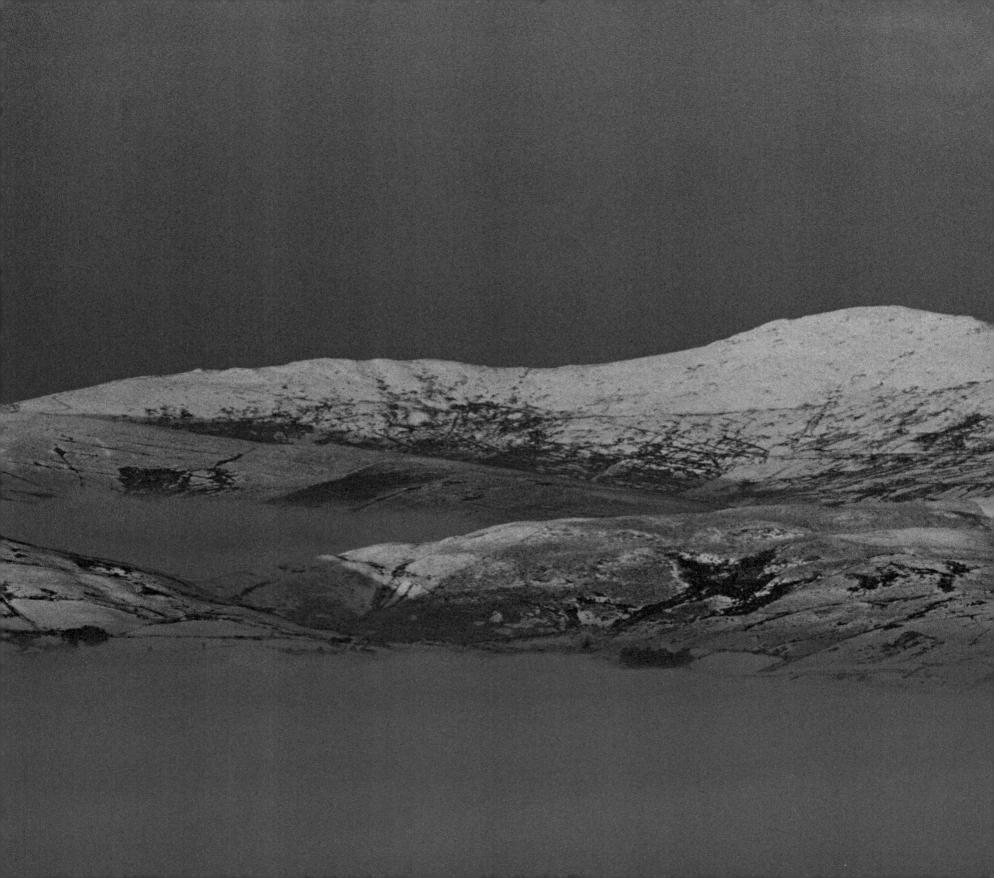

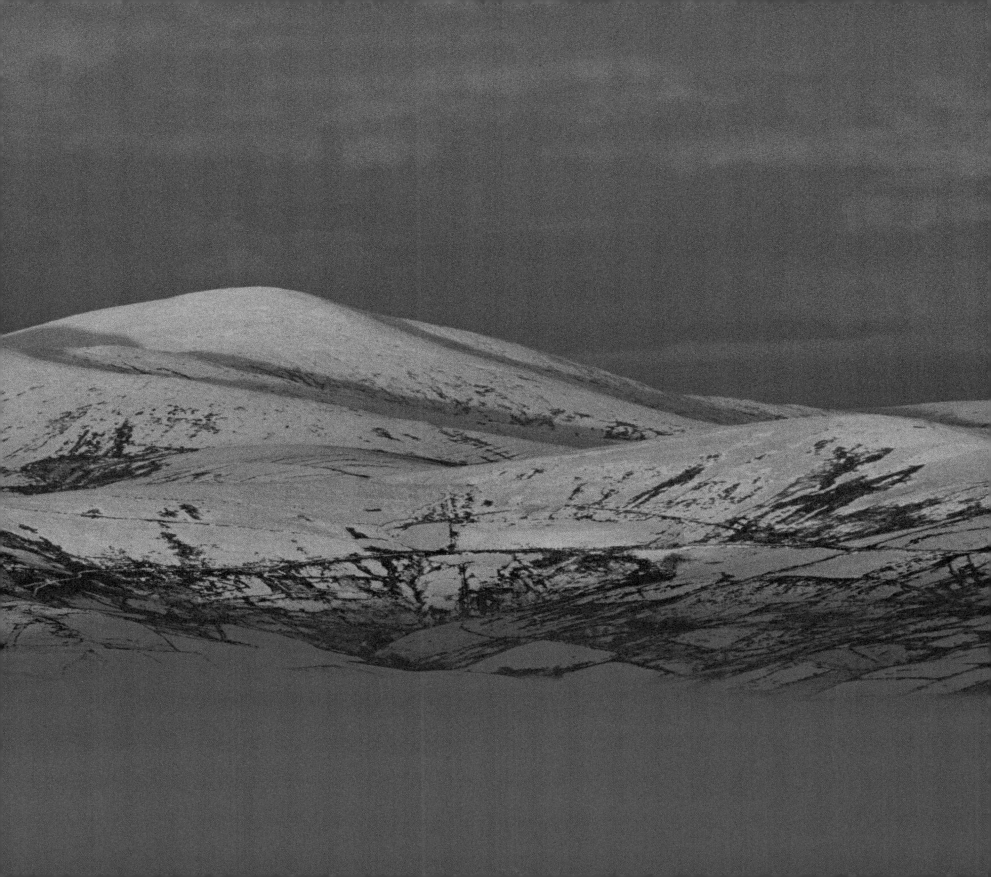

Photographer's Notes

This project spanned the end of the film era and the beginning of digital. Approximately 35 per cent of the images in the book were shot on film (primarily Fuji Velvia but also some Kodak E100VS), including almost all of the images of the Donegal Highlands. The rest of the images were shot on Canon digital SLR cameras – the 5D, 5D MkII and 5Ds. I generally use two lenses on the hill: a 16–35mm for wide-angle scenes, and a 24–105mm for general work. My large and heavy 100–400mm telephoto is rarely carried up mountains, but is a fantastic lens for picking out detail and compressing topography.

There are many images in this book that were only made possible by advances in imaging technology, including the panoramic images that were created by shooting several overlapping frames that are later stitched together using Adobe Photoshop's alignment and blending algorithms. For all of the advances in technology, however, the weight of equipment I need to carry into the hills has not diminished. If anything, the equipment I use today is heavier than in the days of film. Where possible I have reduced weight by carrying a limited selection of lenses and using a small, lightweight tripod. Even so, the total weight of equipment is rarely much less than 3kg – not a big weight when carried for a short distance over flat ground, but a considerable millstone when carried for an entire day up and down a mountain.

For the film-based images, almost all the work towards creating the final image is complete once the shutter is pressed. The processed film is scanned, and only small adjustments are needed to correct colour casts. Digital images, however, require substantial post-production because the unprocessed RAW files tend to look a little bit like an old print that's been sitting in a window for a couple of decades. Contrast

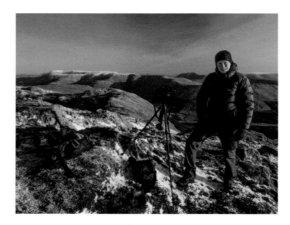

needs to be returned to the final image along with some colour saturation and tonal adjustments. In general, I have sought to remain faithful to my memory of how the original scene looked and felt, but this will always be a subjective process. Balancing foreground and sky exposures is a key skill for any landscape photographer, and in the days of film I used 2- and 3-stop graduated neutral density filters to 'hold back' the sky in many of my images. Although I continued using graduated filters in the early days of digital, I now choose almost

exclusively to shoot lighter and darker exposures of the same scene and blend them later on the computer. Digital has also allowed more latitude for error. Although many shoots afforded the luxury of carefully checking settings and reviewing images, at other times the light was so fleeting that the photographic process became frantic and panicked rather than patient and meditative. While overexposure cannot be corrected, Digital RAW files allow for substantial underexposure at the expense of some added noise in the final image.

Planning resources are a key element of my work, especially weather forecasting. In the early days my forecasts were general TV bulletins with no allowance for mountain conditions. Today it is possible to predict with frightening accuracy cloud cover, rainfall and wind speeds every three hours, and receive detailed satellite imagery every fifteen minutes. With a reasonable 3G mobile connection I can even access this information on the hill.

Mapping is also a vital planning tool for the landscape photographer, not only as a guide to finding a location, but also to work out what kind of images may be possible. Even today, many of my trips begin when I pre-visualise landscapes from mapping – turning contours and slope aspects into nascent ideas for photographs.

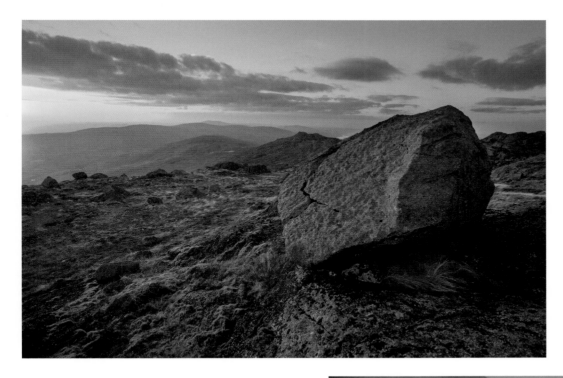

Above: An autumnal sunset illuminates a boulder at the top of Slieve Foye in the Cooley Mountains of County Louth;

Right: Storm at Doolough, County Mayo

Opposite: The author pictured during a shoot in the Maumturks.

Previous pages: Winter sunset over the Sperrin Mountains, County Tyrone.

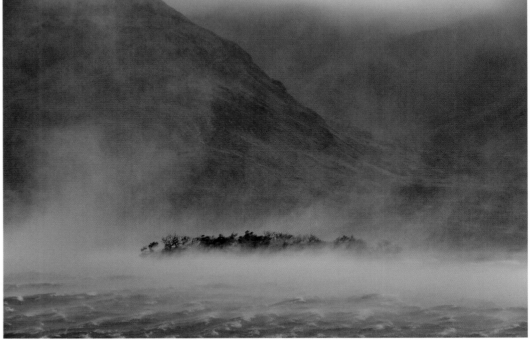

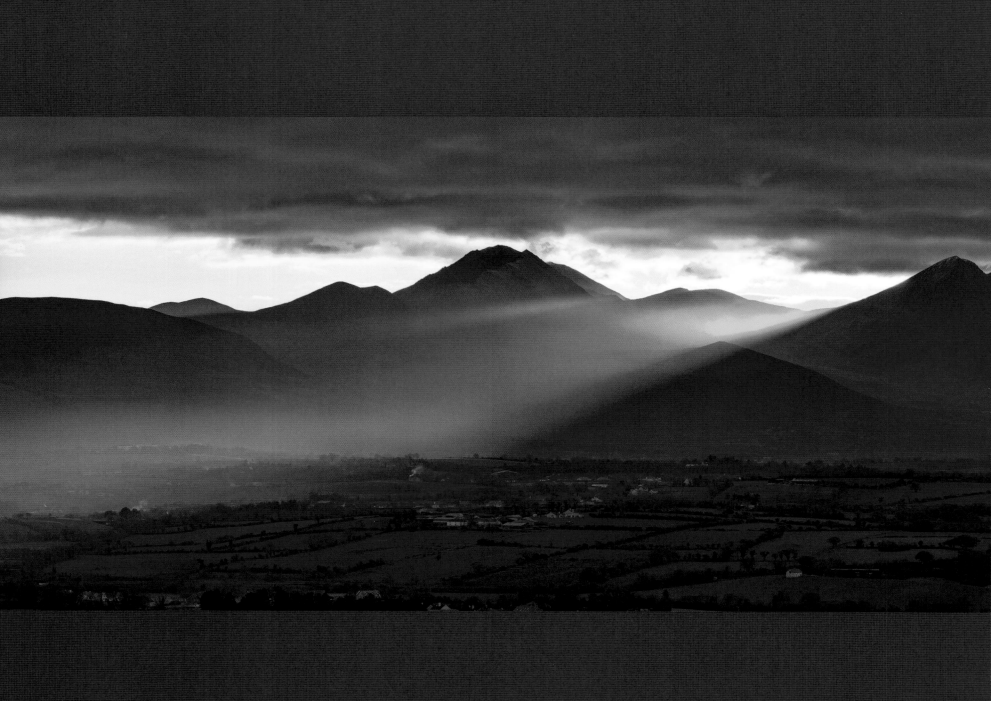

Crepuscular rays over the MacGillycuddy's Reeks, County Kerry.

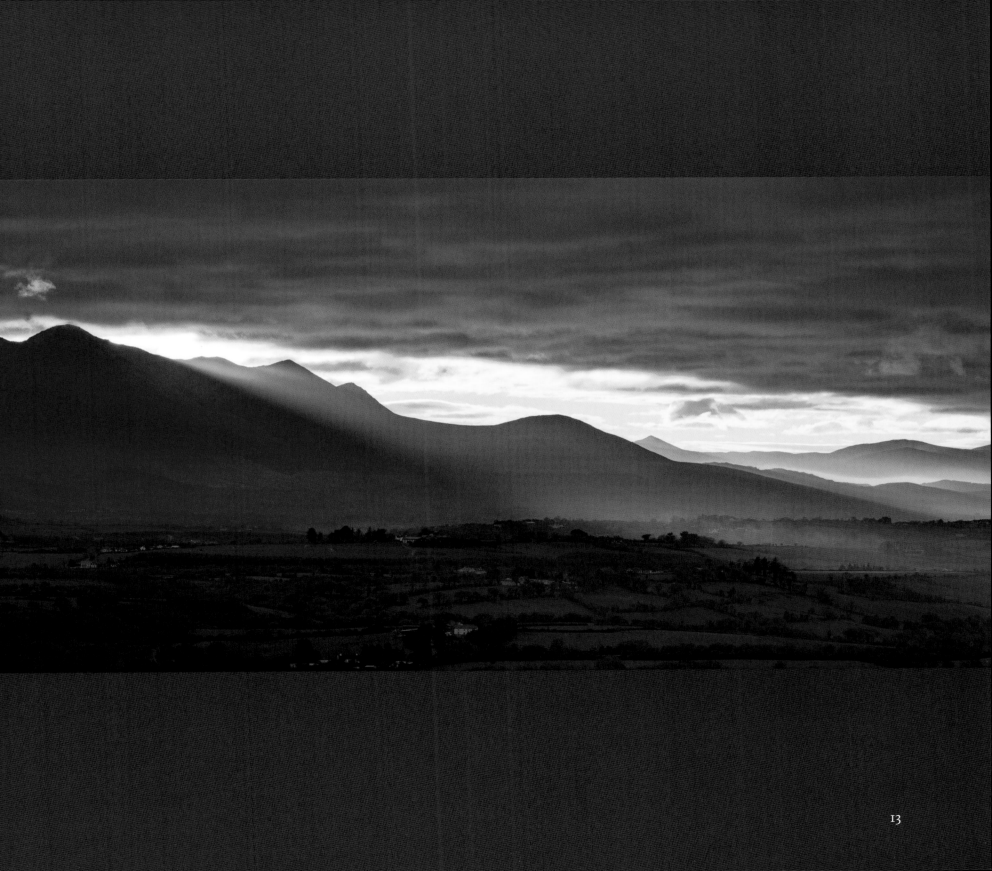

Introduction

My fingers move sporadically across the laptop keyboard – tapping out ideas and memories – teasing out moments and feelings from more than thirty years of life spent exploring the Irish mountains. The wood stove roars gently, a keening north wind rattling the flue. Squalls of inspiration and recollection arrive like the January showers hammering at the window. I picture a valley: Doolough, Glenveagh, the Black Valley – it could be any one of dozens of valleys in the Irish mountains on this day, in this weather. A stand of bare birch bending before the wind, a white-capped lake, seeping black crags sweeping up into a wet snow-line and ragged clouds trailing coteries of hail and sleet. A finger of watery sunshine moves across the mountainside, blue sky opens overhead like a hope of spring, and then the incessant wind moves it along.

I remember an Easter weekend twenty years ago, ranging across the Twelve Bens with a dozen or more friends. Crystalline views beckoning us around the classic Glencoaghan horseshoe – summit after summit falling before our young legs. Inexorable and invincible, we race down off the last peak in the cobalt dusk and drink long into the night – a pint for every peak – burning up life like it is inexhaustible.

I feel fear rising. Stabs of it in my stomach as I climb through a band of loose rock stacked like a jumble of children's building blocks. A rope trails apologetically from my waist; with no running anchors it is all but useless. I push panic away with a practised focus and carefully measure each move. The world shrinks to the moss in the crack in front of my face, the crystals of rock beneath my fingertips, the rounded camber of my foothold. The hundreds of metres of space clawing at my heels are denied like an act of faith.

The Glencullin river flowing down into Doolough on a winter afternoon.

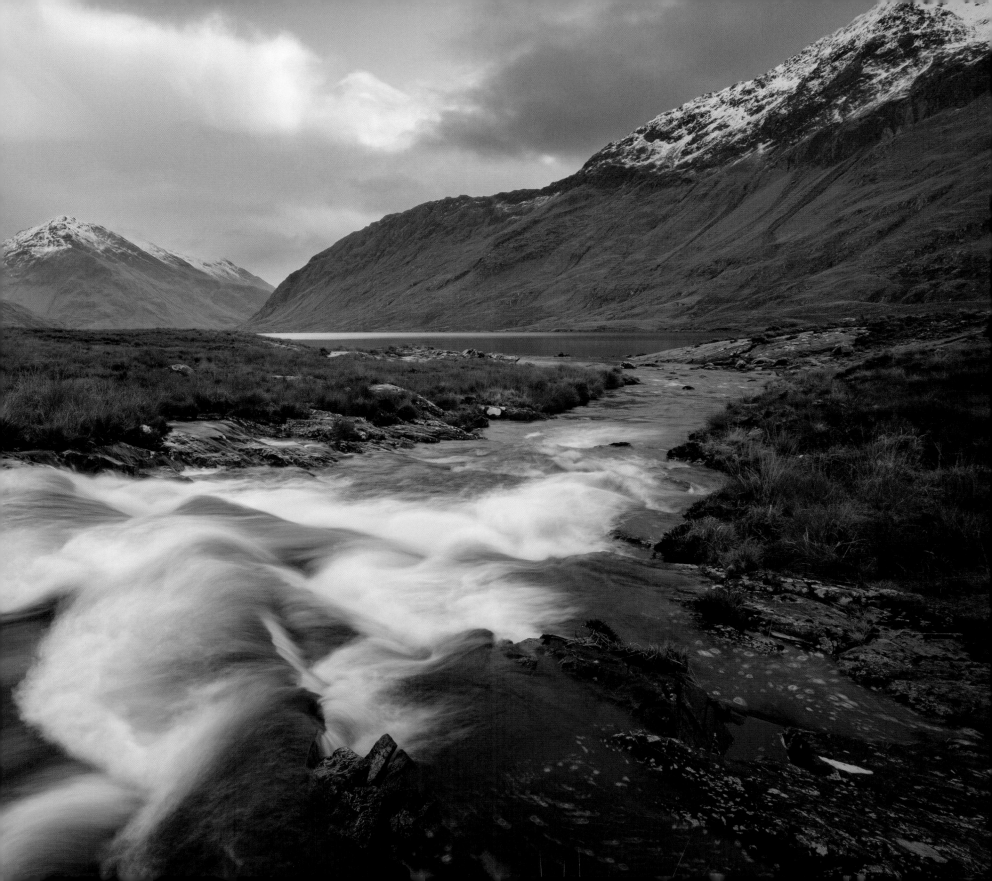

I feel warm sun on my face, sitting against a slab of rock listening to the sounds of the everyday world drift up from far below: the bark of a dog, the *putt-putt* of an old tractor. The last day trippers have already begun the long descent and for a couple of hours I am the highest person on our small island, alone amidst an immensity of space as the shadows fill in the corries below and stretch out across the distant farmlands. Hundred-mile views are at my command. The moon rises over the eastern Reeks, and to the west I watch the slow descent of the sun across a sea of lesser mountains towards the ocean beyond. A spectral mist drifts across the Beenkeragh Ridge. I move around the summit with my camera like the needle of a compass – drawn to a succession of vantage points and compositions, as the warming light brings the landscape alive.

I can reach right back into my childhood and the mountains are there. A family outing to climb Sligo's Benbulbin; scuppered far too soon by a muddy trail. The frustration and disappointment still palpable. Another family holiday to north-west Donegal, driving beneath the iconic grey screes of Mount Errigal late on a summer evening, craning my neck out of the car window, mesmerised. I'd never seen anything so high or so wild. Pouring over contours and place names on old inch-to-a-mile Ordnance Survey maps, rendering mental images of mountain landscapes that I'd yet to

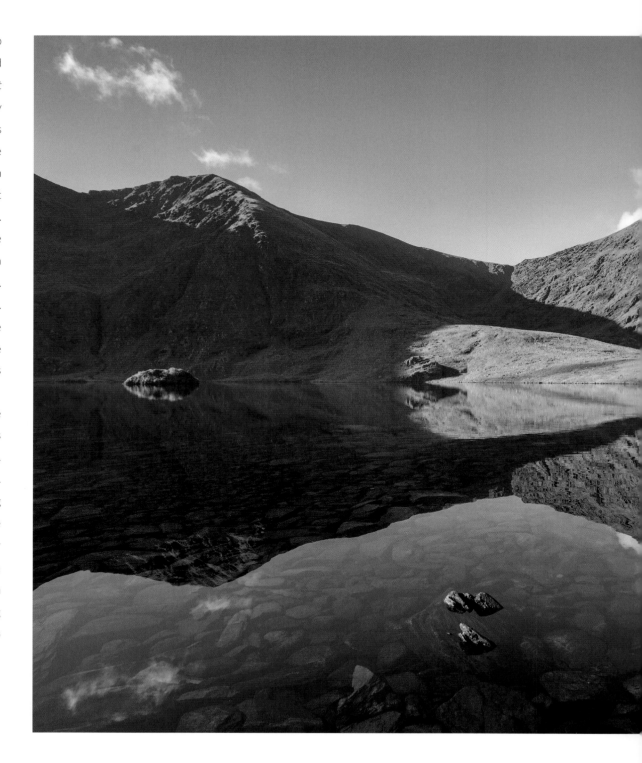

Cnoc Toinne and Carrauntoohil reflected in the waters of Lough Callee in the Hags Glen, County Kerry.

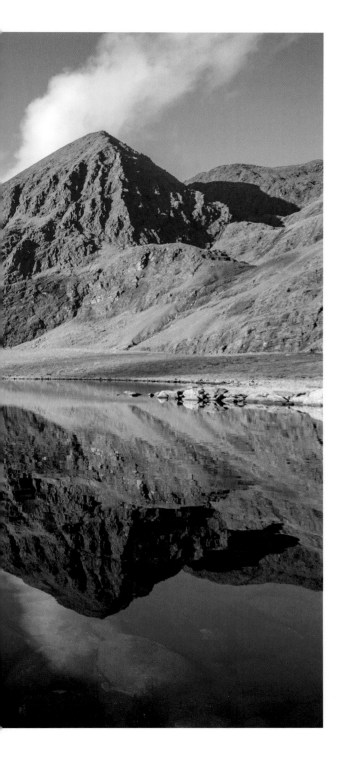

see. *Bingorms, Croaghgorm, Farscallop, the Poisoned Glen*; fine print on a sheet of paper, but in my mind, brooding cliffs and snow-capped summits. Inventing a ruse that convinced my father to drive me all the way to Donegal under the pretence of a school science project on soil moisture. The science may have been spurious but the Bingorms and the Poisoned Glen became real places for me.

To me the wild parts of Ireland are personal; I would never have embarked on a career as a photographer, would never have made the life I have, without first falling in love with the Irish mountains. This book was an ambition from the very beginning, although realising it has taken more time than I would have dreamt possible – almost twenty years. During that time I've been lucky enough to photograph many of the great ranges of the world: the Himalaya, the Alps, the Rockies, New Zealand's Southern Alps and the incredible granite spires of southern Patagonia. Yet the Irish mountains always retained a hold on my imagination.

My photographic style is bold. I've always been attracted by the singular beauty of vivid light, especially when it interacts with the landscape in dynamic synchronicity. I work often at sunset and sunrise in remote locations. I've never been interested in recording the mountains in their typical moods of grey cloud and flat light; I want to show them in their finest raiment and capture their rarest moments.

The challenge has been as much physical as artistic. Some images came like a gift – from the roadside, with a telephoto lens, without breaking a sweat. But over the years I've accumulated hundreds of thousands of metres of vertical ascent and descent – often with a heavy pack, alone and in the dark. The waiting too, when necessary, has rarely been pleasant. The cold and wind, even at the modest altitudes of our mountain summits, can be debilitating. I've never been blessed with the patience, discipline and steely resolve to wait hours for a result that might never come. I've had to fight that internal battle every time.

When the light is fleeting and magical I feel a familiar surge of adrenalin. There is a fight to control my instincts, to master the impulse to panic. Photography, in this sense, is no less intense than scrambling unroped on an airy ridge, or making a tricky move on a rock climb high above the last piece of gear. On more occasions than I can remember I've either completely missed these moments, or else failed to do them justice. But once in a while, when the planets align and I make the right decisions, the magic light plays over the mountains as if by command, and I return with images that go at least some way to conveying the power and majesty of the Irish mountains at their best.

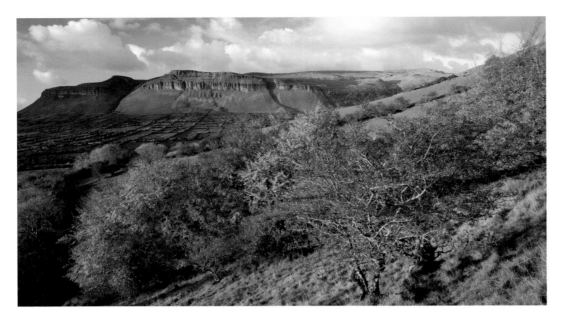

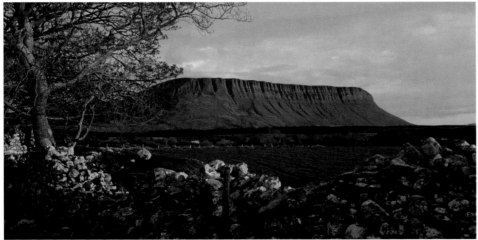

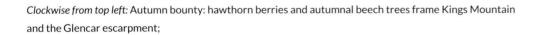

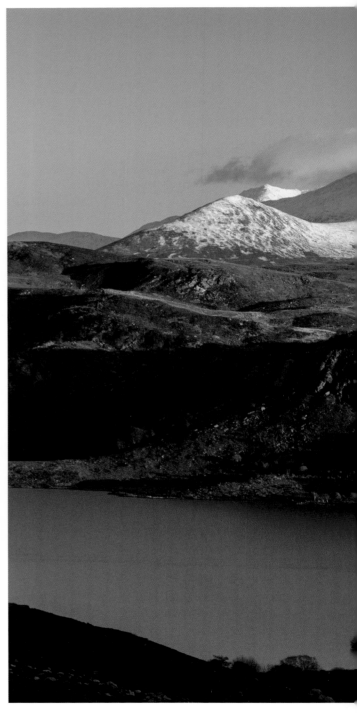

Clockwise from top left: Autumn bounty: hawthorn berries and autumnal beech trees frame Kings Mountain and the Glencar escarpment;

MacGillycuddy's Reeks in winter, rising above Lough Caragh;

Evening light on Benbulbin, Sligo's most iconic peak. The mountain was immortalised in W. B. Yeats' poem 'Under Ben Bulben'.

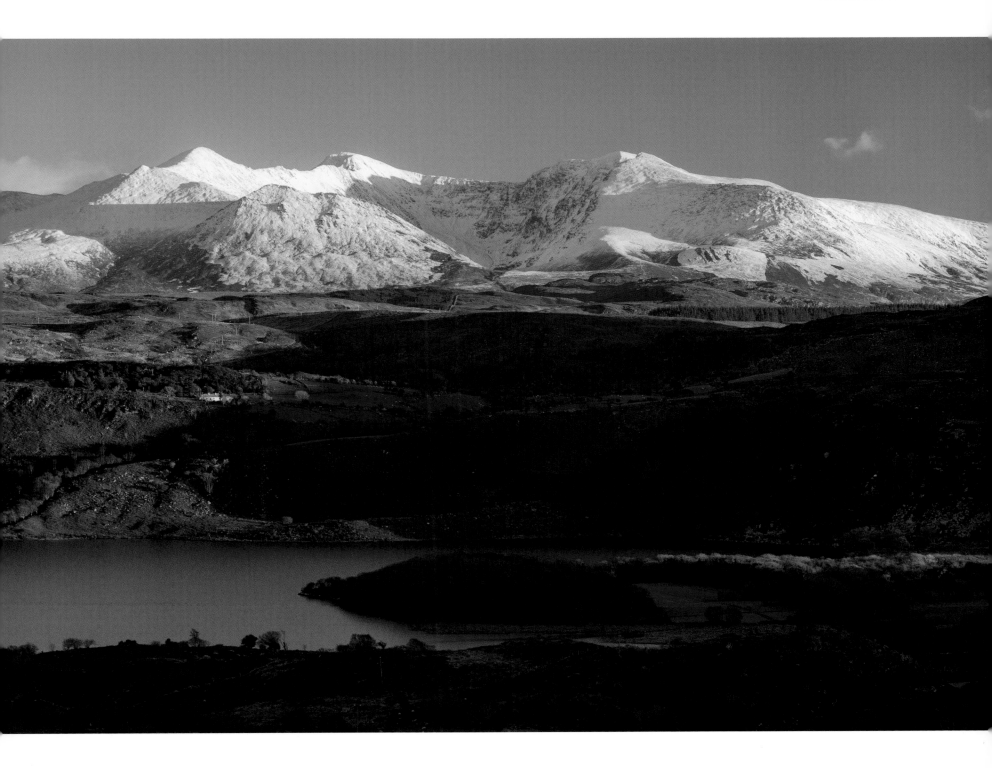

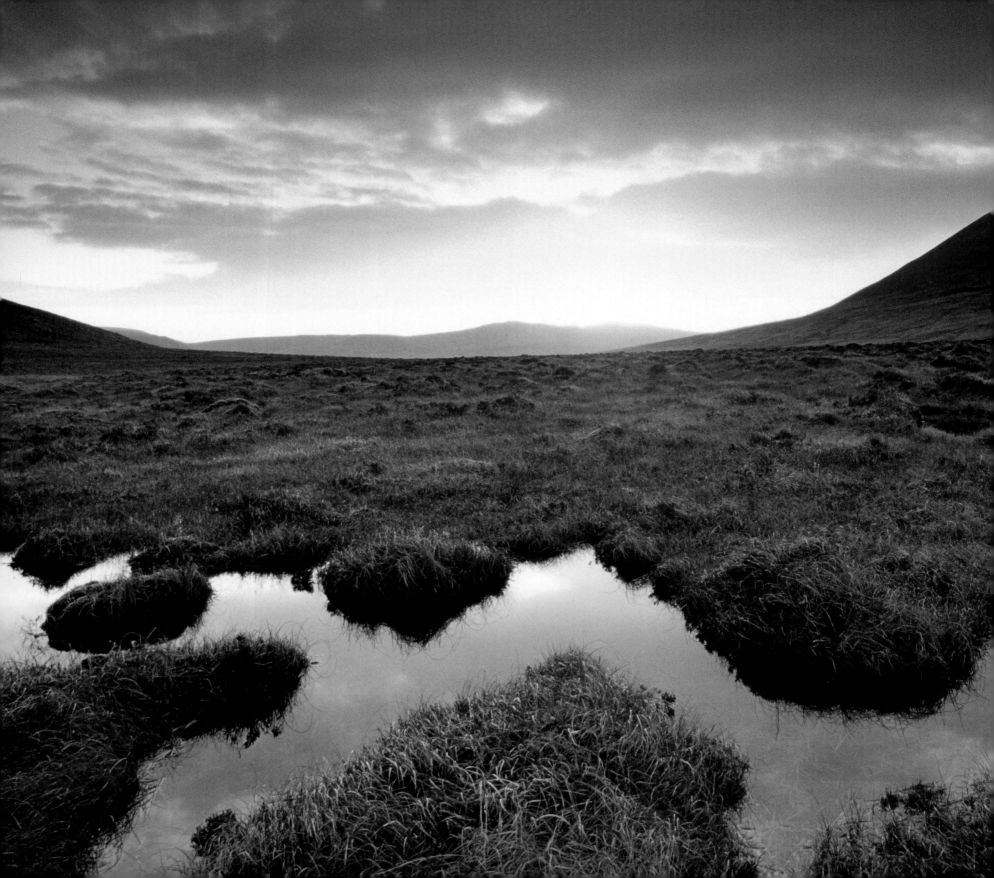

ULSTER

The Donegal Highlands

Laurentia, Avalonia, Iapetus: the shadows of lost continents, the ghosts of ancient oceans. It requires an act of mental gymnastics to think back to a time when Ireland did not exist as the island we know today, even more to go much further back, to when the mountains we climb had not yet been made: the quartzite screes of Errigal and Muckish, sliding away beneath a walker's boots; the implacable granites of the Derryveagh Mountains, the rough crystals providing friction for a climber's hands. Rocks created by unimaginable heat and pressure, melted and moulded and re-formed in the crucible of the Cambrian Orogeny, the great continental collision between Laurentia and Avalonia some 400 million years ago. Everywhere you care to look, the tectonic fingerprints of that collision are evident. On a map, the orientation of the mountain ranges, valleys and fault lines jumps out: rumples, creases and cracks in the earth's crust running along a north-east/south-west axis. Even the patterns of glaciation, the courses of streams and rivers, echo this distant epoch.

Donegal is relentlessly mountainous. Apart from the drumlins and river valleys of the far south and east, the county is almost entirely dominated by rugged and inhospitable uplands. From the Inishowen Peninsula in the north to the Bluestack Mountains in the south, the march of these ranges is broken only by the occasional tenuous strip of pastoral land, finding refuge here and there in a sheltered mountain valley or along the narrow coastal margin.

There is a mountain in Donegal with a curious name. Farscallop, on the western boundary of Glenveagh National Park, is a 420m-high, flat-topped summit that is unremarkable, uncelebrated and unfrequented. Looking south-west from here across the Glendowan Mountains is a diorama of the Donegal Highlands: sombre hills of granite, tussock grass bowing before the relentless wind, a heavy grey sky of pregnant clouds scudding across the tops.

Yet from its mundane summit, Farscallop allows us a vision beyond this depiction of topographic monotony. The brooding granite slabs and crags

Sunset colours reflected in a bog pool beneath Errigal.

of the Derryveagh Mountains lie to the north, enclosing the enormous, U-shaped glacial gouge of the Poisoned Glen and the great cliffs of the Bingorms and Glenveagh. I remember, on one particular trip, approaching the edge of Donegal's massive Poisoned Glen cliffs in heavy mist. As I crept down towards the perilous brink the cloud lifted suddenly to reveal more than 300 metres of vertiginous rock. In that moment those cliffs possessed for me all the drama and grandeur of Yosemite's famed granite walls.

Framed by a dip in the skyline, lies an arresting view of Mount Errigal, the iconic landmark of Donegal and the most photogenic of all Ireland's mountains. This nunatak once poked its beautiful quartzite pyramid above the blanket of ice and into the rock-shattering frosts of the ice age. Today Errigal presents a chameleonic array of faces and personalities, its crumbling ridges and sweeping screes gilded by evening light off the Atlantic, or reflected in the waters of Dunlewy Lough. From Farscallop its twin summits offer a passable impersonation of Machapuchare, the famed 'fishtail' peak of the Nepal Himalaya.

To the north-east of Errigal is a family line of connected mountains. Like oddball relations they share the same quartzite genetics, but the ravages of geological time have shaped individual idiosyncrasies. There is the compact trio of conical Aghlas, the mundanity of boggy, rounded Crocknalaragagh, and whale-backed Muckish with its desolate summit plateau and abandoned silica mine workings.

Immediately beneath Farscallop is the Gweebarra fault. This enormous crack in the continental plate

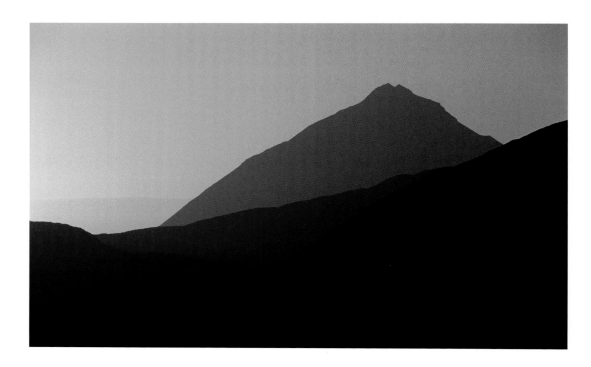

Above: The twin summits of Errigal are silhouetted at sunset. Photographed from Farscallop.

Opposite: An ancient wind-twisted holly grows on the banks of the Cronaniv Burn in the Poisoned Glen. There are competing explanations as to where the glen derives its ominous name, but it is most likely a cartographic error. The glen was originally called *An Gleann Neimhe* (The Heavenly Glen) but was wrongly translated from *An Gleann Nimhe* (The Poisoned Glen).

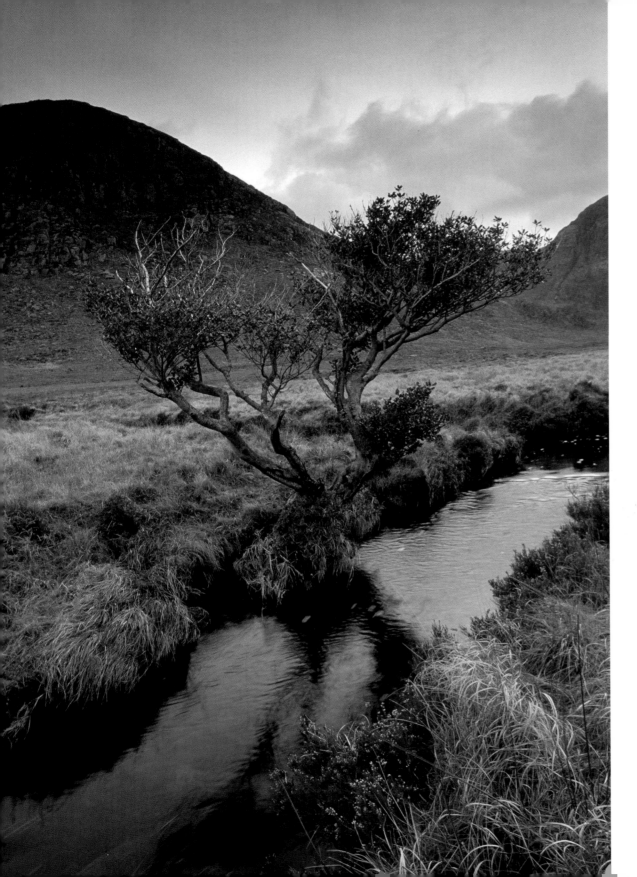

was created by the awesome shearing forces of the Cambrian Orogeny, then exploited by the glaciers of the last ice age to create Glenveagh, one of the great mountain valleys of Ireland. Today Glenveagh provides a taste of Scotland, complete with a castle built in Scottish baronial style, golden eagles, a red deer herd and a history of forced evictions and land clearance. Bequeathed to the Irish state in 1975, it is now a national park and home to rare remnants of the primeval woodlands that once covered much of Ireland. It is a wonderful place to walk in spring or autumn, the austerity of the granite crags softened by the woodland idylls of Mullangore and Glenlack.

Almost due south of Farscallop, across 25km of virtually unbroken hills and mountains, lies the granite fastness of the Bluestack Mountains. In the evocative Irish form they are *na Cruaiche Goirme*, a compact knot of summits peeping just above the 600m contour. They throw rocky arms around the dark waters of Lough Belshade, creating a natural amphitheatre at their heart. The steep, clean granite cliffs sport classic climbing lines for those willing to endure the tough walk in.

The Donegal Highlands culminate in dramatic fashion at Slieve League, where the quartzite genealogy of north Donegal finds recurring expression. Here the Atlantic has carved away the south-western flanks of the mountain, forming some of the highest sea cliffs in Europe. When Slieve League is not hooded in cloud and the air has the crystalline clarity of a polar airflow, you can gaze right across Donegal Bay to where the quartzite appears again in the mountains of Connacht. But that's a story for another chapter.

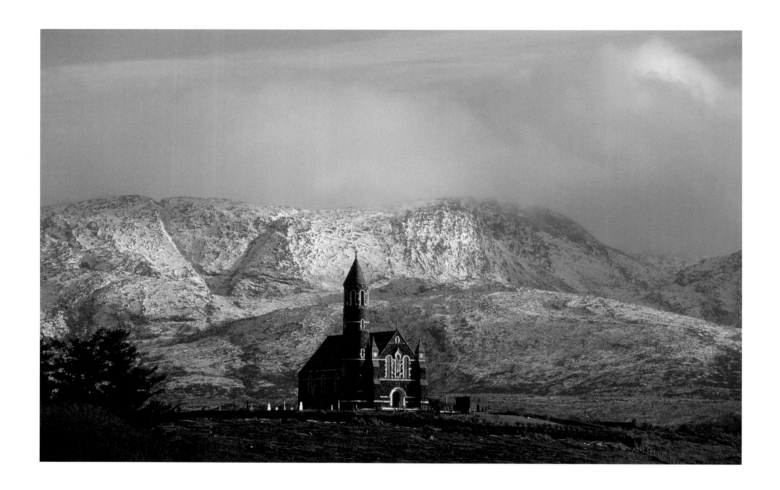

Above: Dunlewy Church framed against a backdrop of the wintry Derryveagh Mountains.

Opposite: A solitary holly tree bent against the winds that funnel along the upper reaches of Glenveagh.

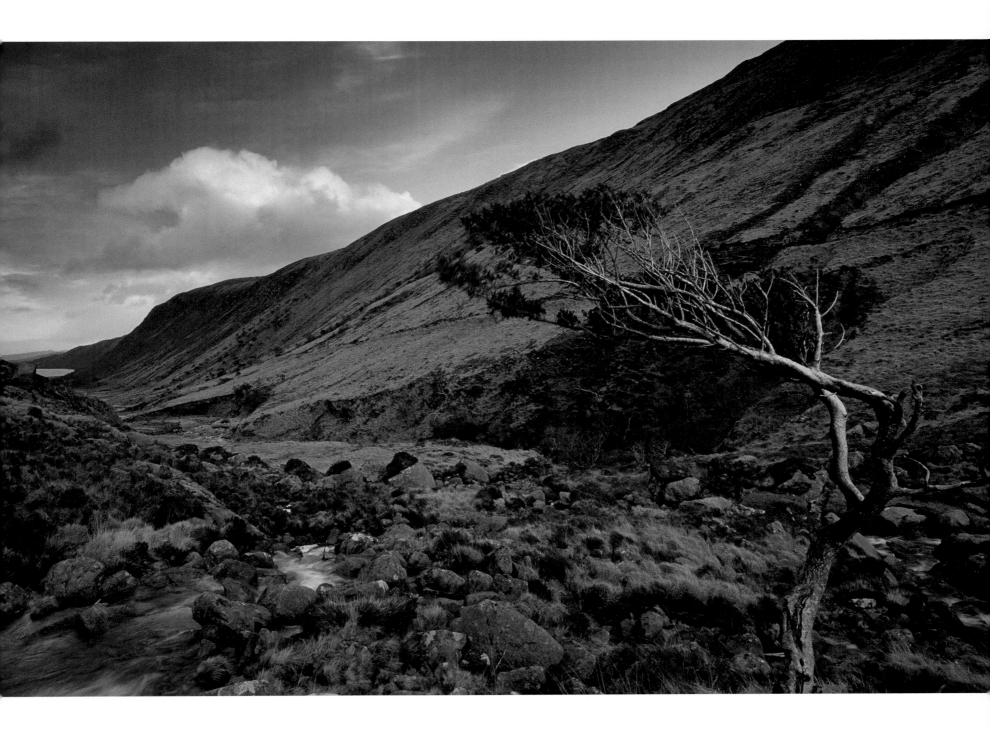

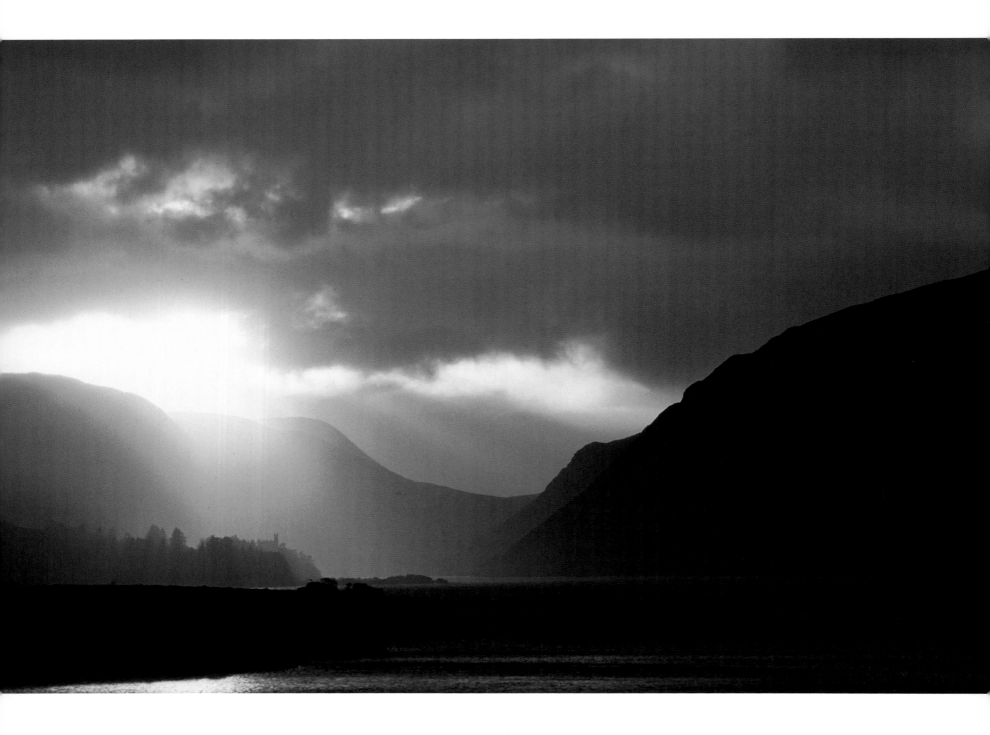

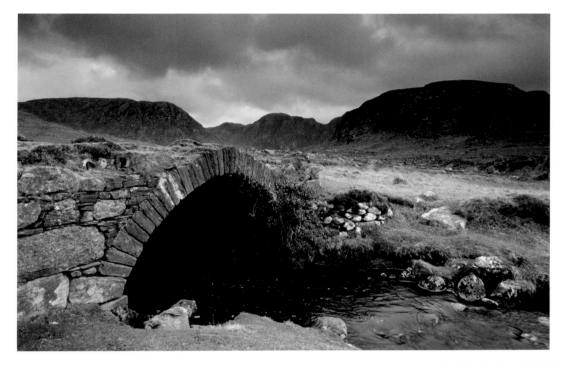

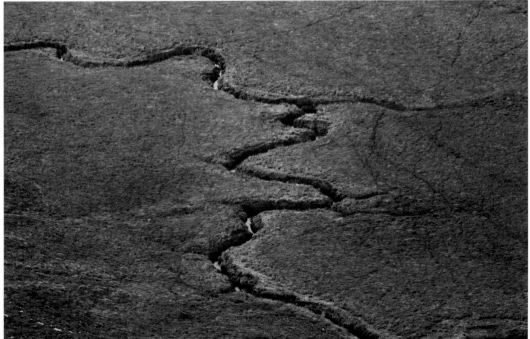

Above: Old stone bridge leading into the Poisoned Glen.

Right: Meanders of the Cronaniv Burn, which drains the Poisoned Glen.

Opposite: Sun breaking through storm clouds over Lough Veagh, Glenveagh National Park. The turrets of Glenveagh Castle are just visible.

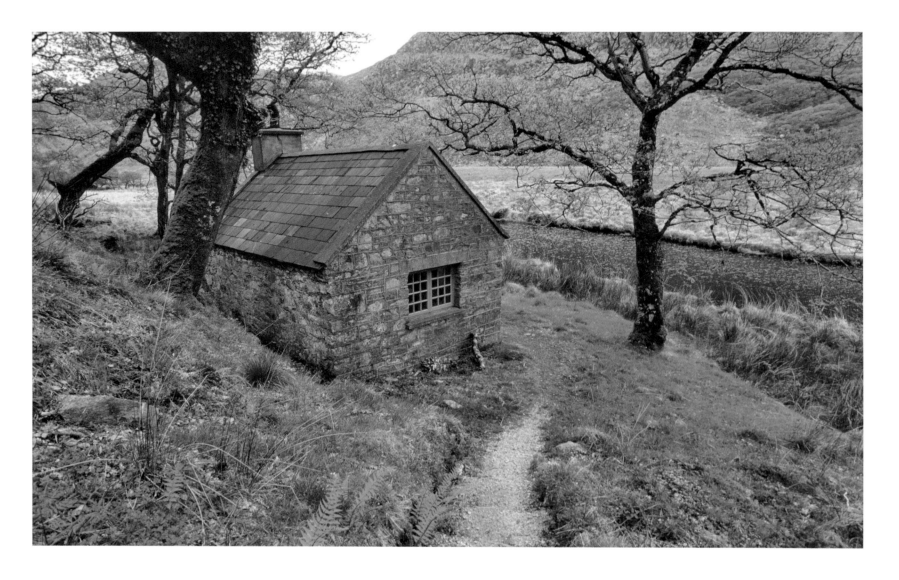

Above: The old stalker's cottage in Glenveagh National Park.

Opposite: Autumn colours in the Mullangore woodlands of Glenveagh National Park.
Mullangore is home to one of the few remnants of Ireland's ancient oak forests.

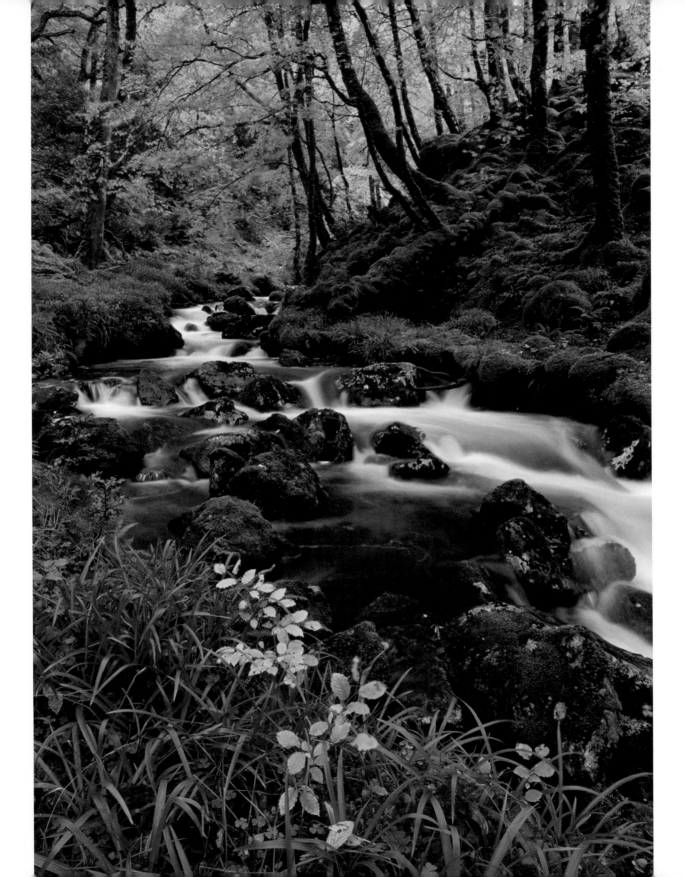

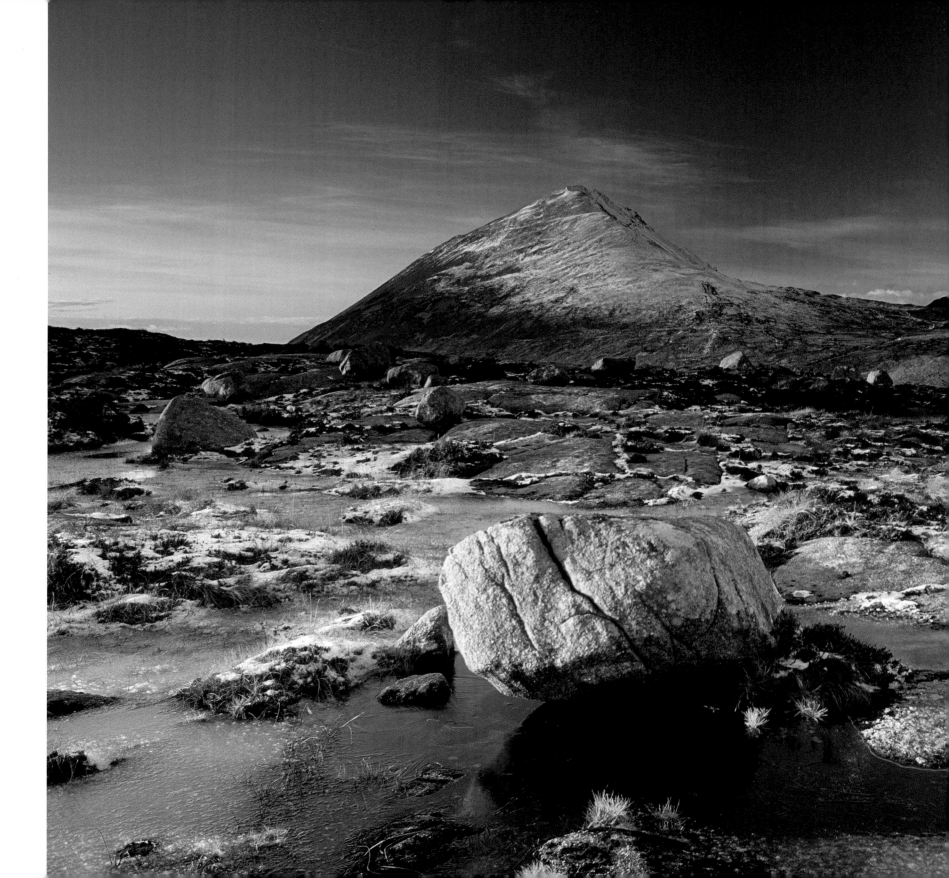

Winter view north from the granite wilderness of the Derryveagh Mountains to Errigal and its little sibling Mackoght. Like many Irish uplands, the bog pools and underlying turf freeze solid during sustained periods of sub-zero temperatures.

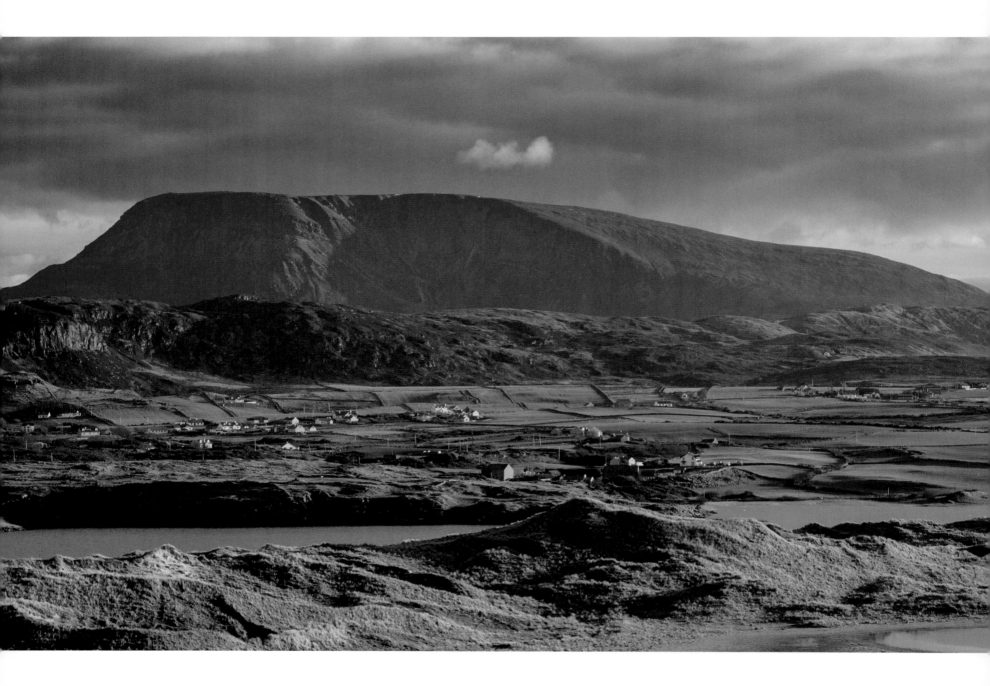

New Lake and the north Donegal mountains, County Donegal.

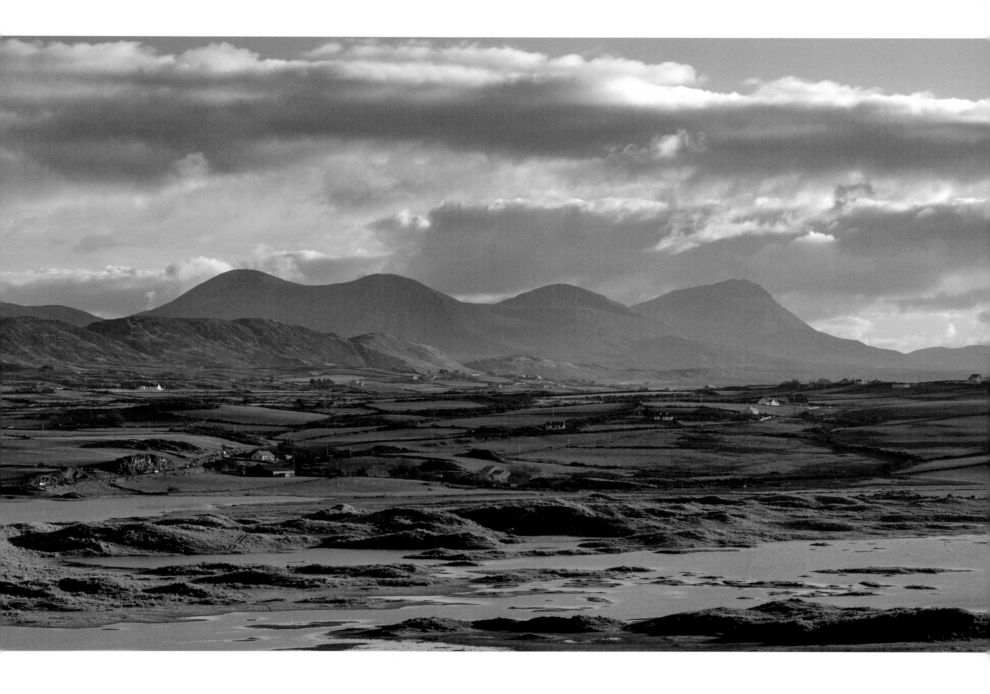

A calm winter's evening allows a perfect reflection of Errigal in Dunlewy Lough.

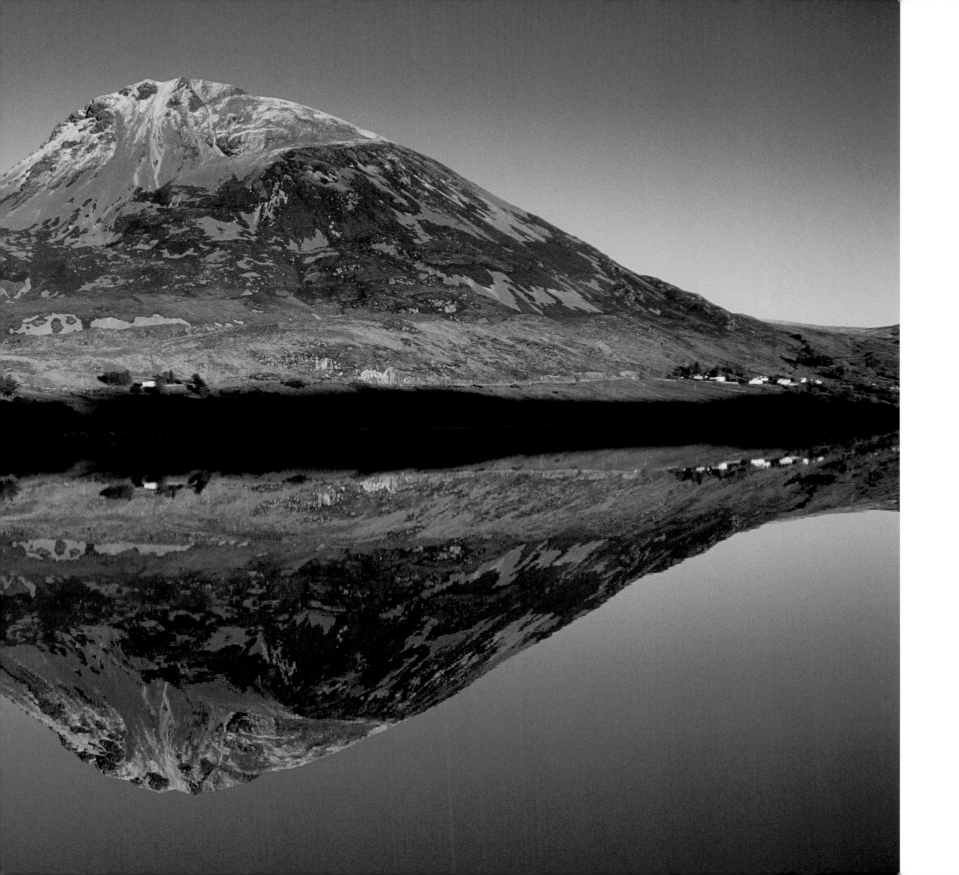

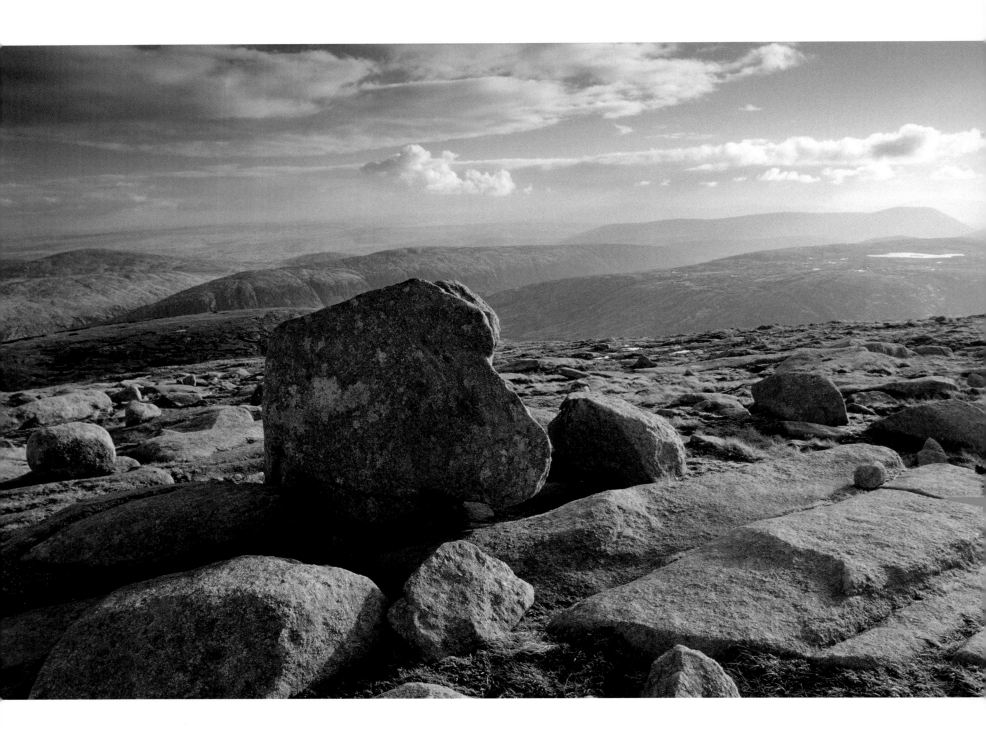

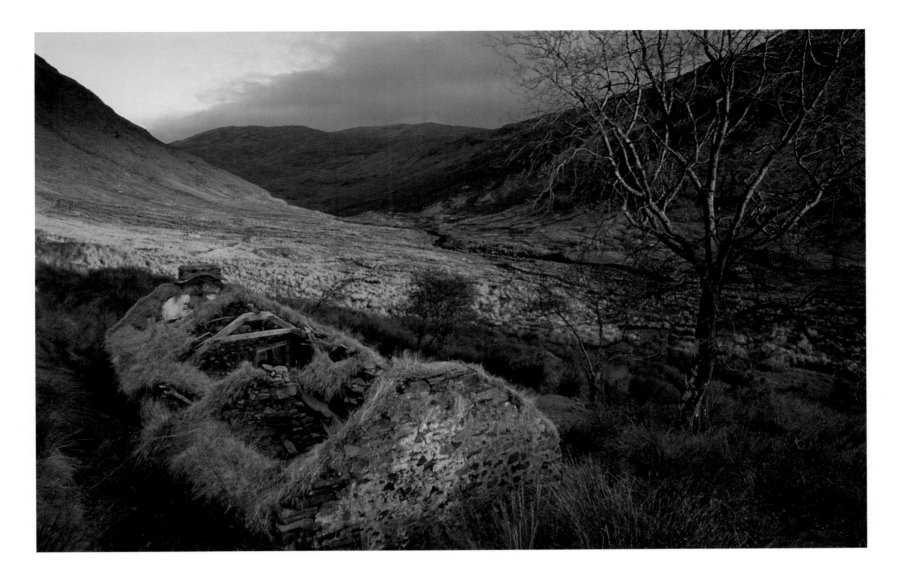

Above: Deserted cottage high in the Sruell Valley, in the heart of the Bluestack Mountains.

Opposite: A litter of granite boulders close to the summit of Dooish in the Derryveagh Mountains.

Following pages: An ever-changing display of light and shadow sweeps across Errigal.
Errigal's distinctive profile and quartzite screes make it an icon of Ireland's north-west.

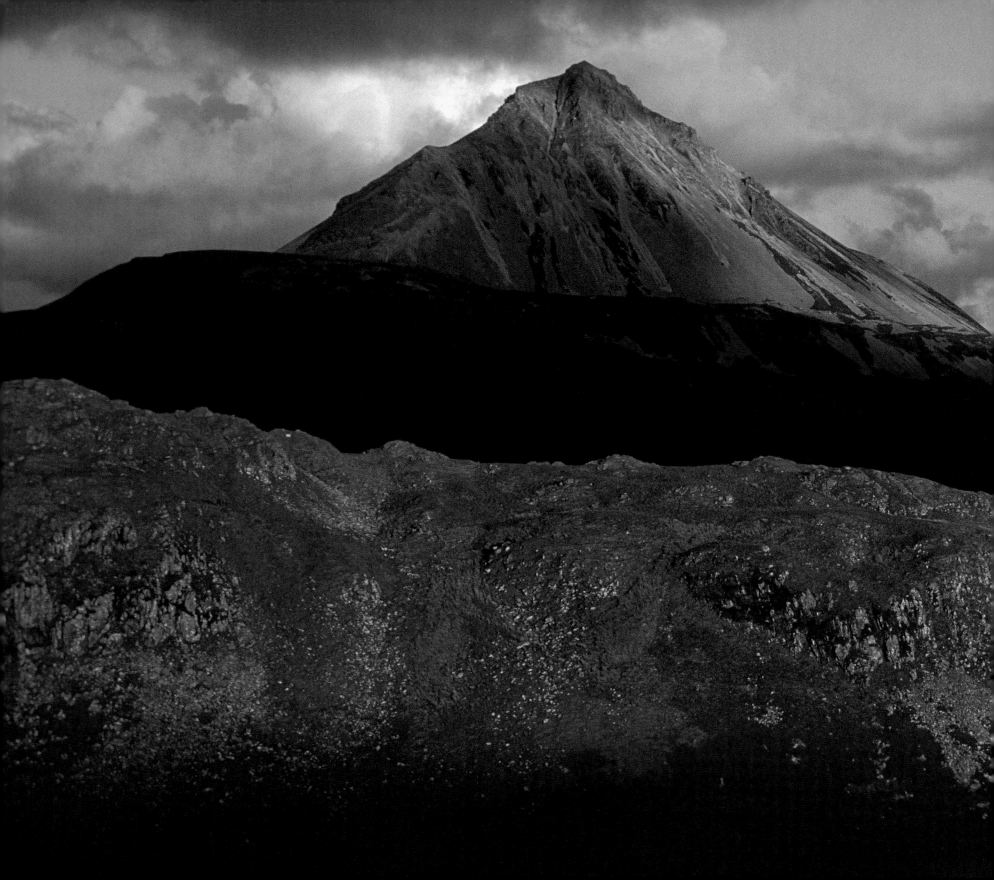

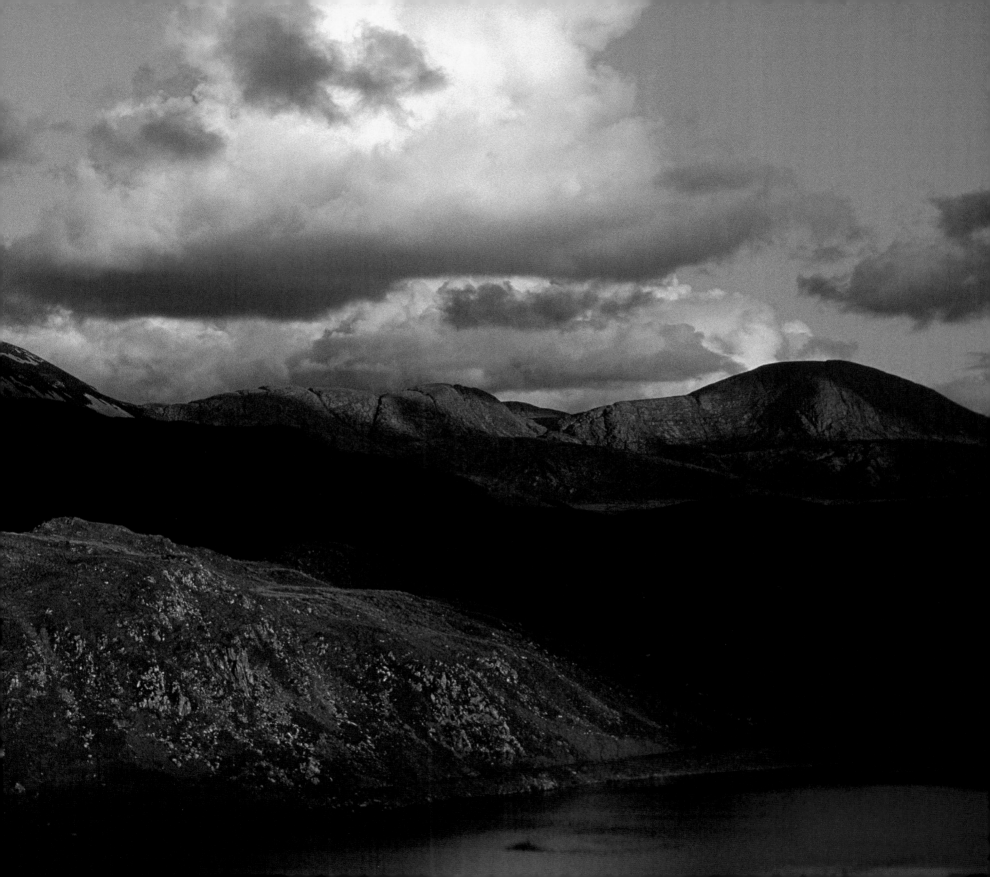

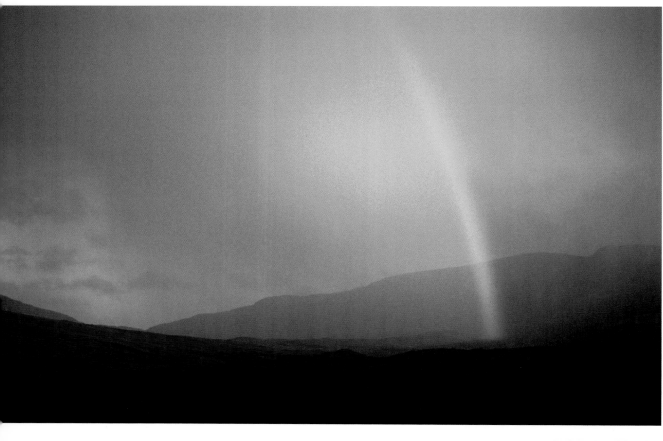

Left: A rainbow chases a sunset shower from the slopes of Muckish Gap.

Below: Miniature wonderland. The incredible diversity of moss species in upland bogs glow even in winter conditions.

Opposite: Donegal's most celebrated sea cliffs lie beneath Slieve League. Here the Atlantic has chiselled deep into the mountain's southern flank, creating a coastal precipice almost 600m high.

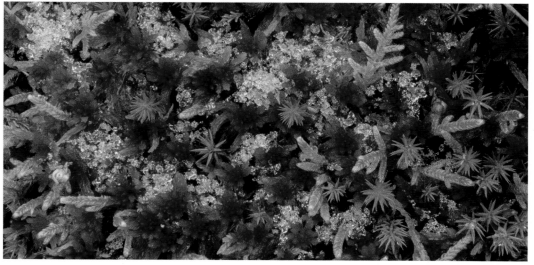

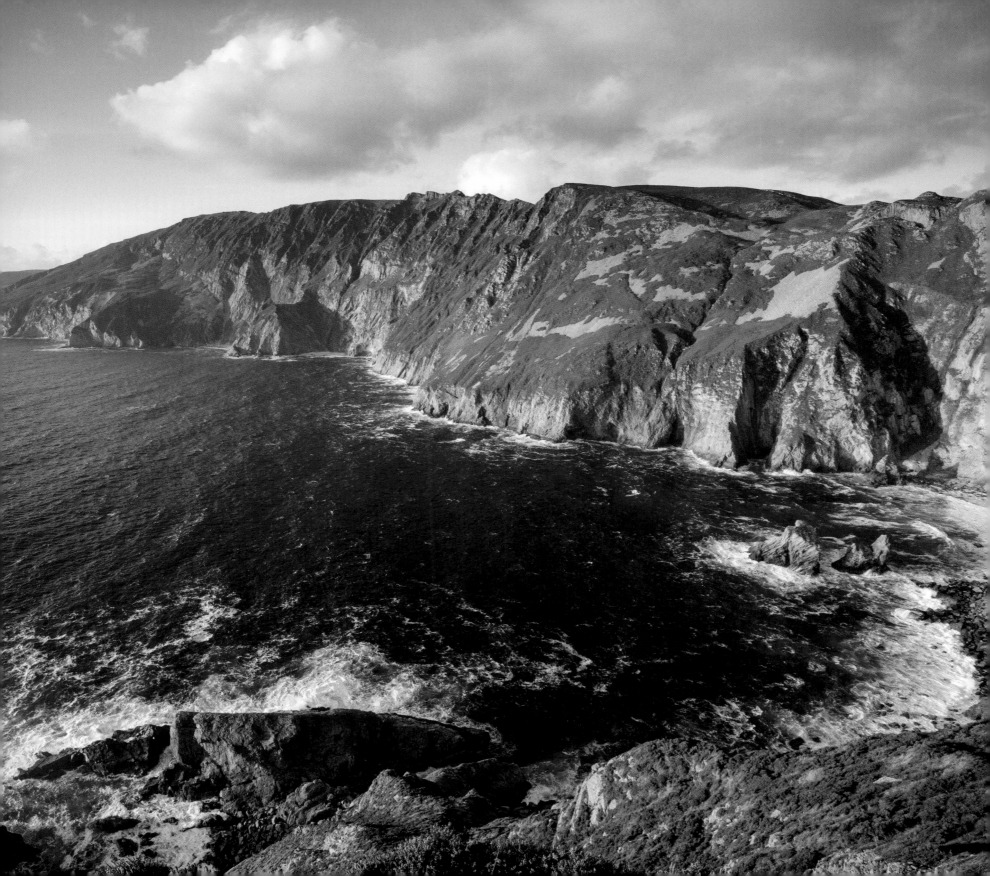

The Mournes

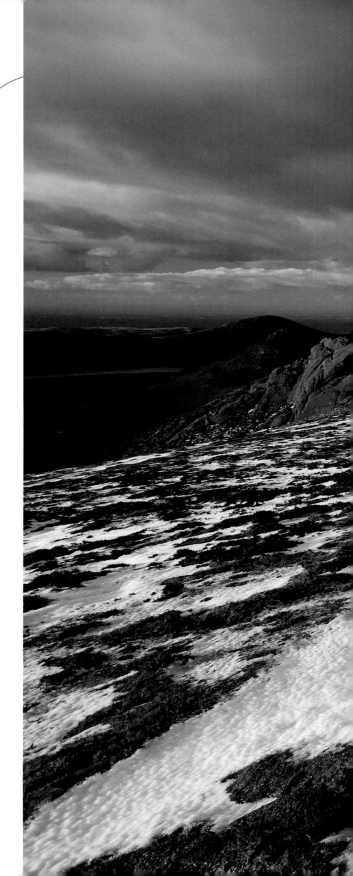

I remember like yesterday arriving at the cottage for the first time. Verging on dereliction amid a copse of wind-bent sycamore, the peeling whitewash revealing the granite stonework beneath. Under a full moon the silhouette of Slieve Binnian swept high above the surrounding stonewalled fields, its graceful outline broken only by its crown of tors. Upstairs some wooden sleeping platforms, and downstairs some mouldy armchairs and a huge open fire that was soon ablaze with turf and old pieces of wood.

There were forty of us that weekend, students from Queen's University Mountaineering Club in Belfast, brought together by a common love of walking and climbing. In the mornings we would assess the fickle weather and strike out into the hills, searching out one of the many crags, spending the day clinging to the chilled rock with numb and bloodied fingers. Only as the sun set would we leave, often reaching the car park by the light of head torches, spilling into the pub before last orders, tired and aching but thirsty for more.

Since then I have returned to the Mournes many times, to explore and photograph them. They are Northern Ireland's premier outdoor playground, the highest and most dramatic mountain range in the province, occupying a corner of County Down about an hour south of Belfast. This compact knot of inspirational summits sits amid the unspoilt scenic charm of the wider Mourne region, a landscape patchworked with woodlands and verdant farmland.

The Mournes have an evocative mystique enhanced by such foreboding place names as the Devil's Coach Road, Bloody Bridge and the Silent Valley. Most of the mountains begin with the more prosaic 'Slieve', the anglicisation of *sliabh*, the Irish word for mountain. Those that don't are often named within a curiously avian theme: Eagle Mountain, Pigeon Rock, Hen Mountain, Cock Mountain and Buzzard's Roost.

The granite of the Mournes was formed just over 50 million years ago by the volcanic upheaval associated with the separation of Europe and North

A spring snowfall melting out on the summit of Slieve Binnian in late March. The weathered granite tors are the defining feature of one of Ireland's most fascinating mountains.

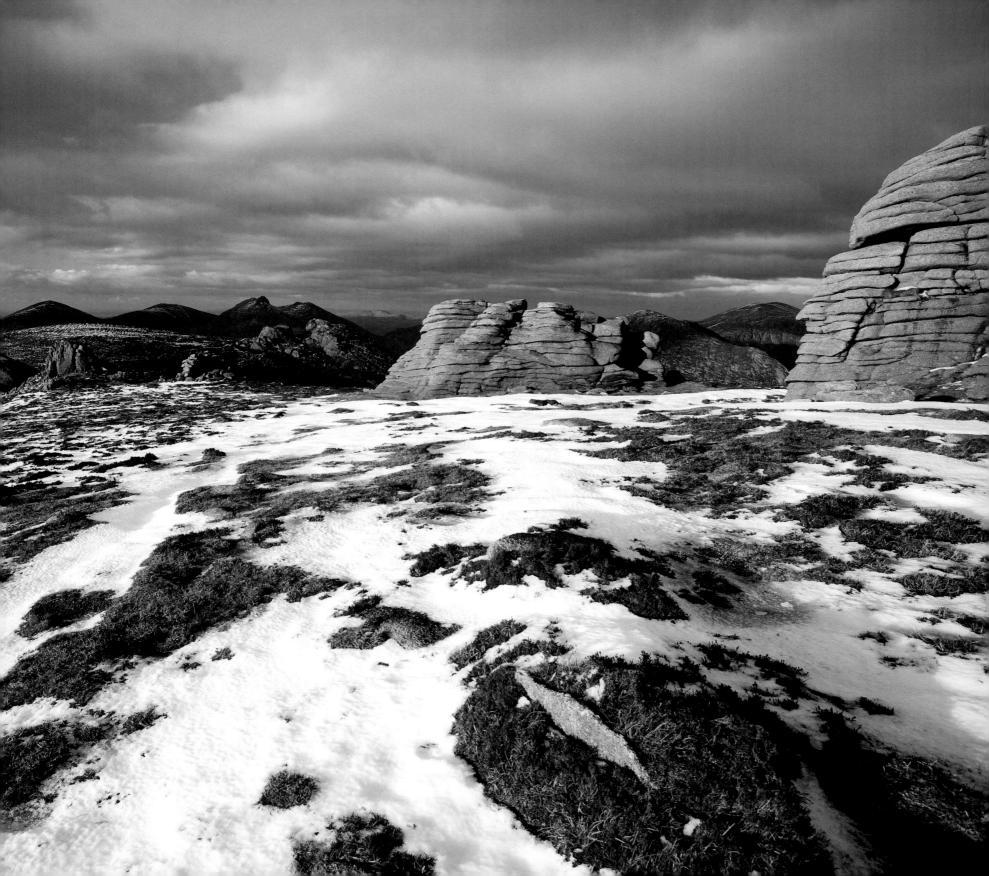

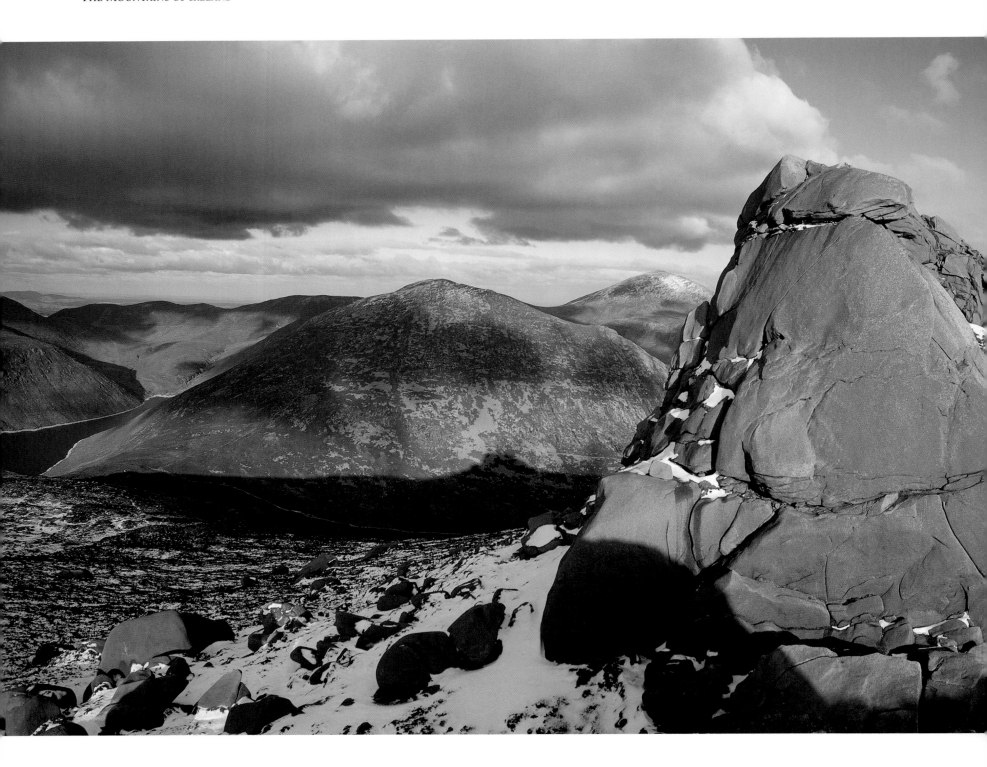

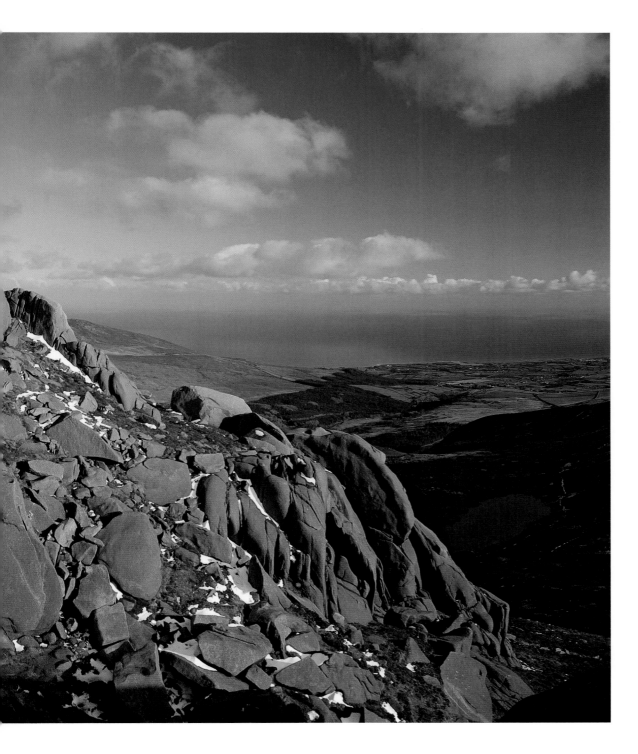

America and the creation of the Atlantic Ocean. It required many millions of years for the covering layer of shale to weather away and reveal the mountains we know today. The quality of this granite has had a great influence on the history of the mountains. Quarrying was once one of the region's major industries, with massive slabs carried down from the mountains by horse and cart to harbours at Newcastle, Annalong and Kilkeel. In time Mourne granite could be found gracing buildings and kerbstones throughout the major cities of Ireland and Britain.

Perhaps the most impressive use of Mourne granite can be found on the peaks themselves. In 1904 work began on a wall to encircle the 9,000-acre catchment area of the Kilkeel River. It took eighteen years for thousands of local men, tough and resilient as the granite itself, to build the 36km Mourne Wall. This miniature Great Wall of China traces an obstinate course right across the very highest summits. In 1923 work began on a dam to create a reservoir within this very same catchment area. The Silent Valley dam took ten years to build and employed another 2,000 men. It flooded a mountain glen that had previously been known as the Happy Valley. Today, the Mournes supply 130 million litres of water a day, much of it piped underground to Belfast.

A panorama of the Mournes from the north tor of Slieve Binnian, with the Irish Sea on the right and the Ben Crom reservoir on the left. Slieve Donard is the snow-capped peak visible just to the left of the tor.

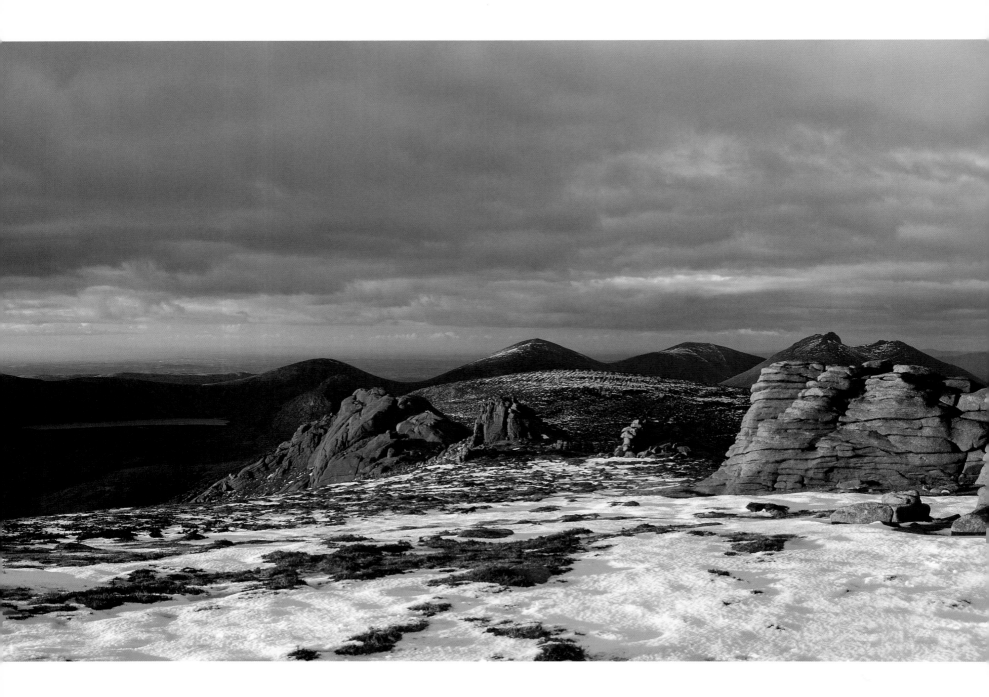

Weathered granite tors on the summit of Slieve Binnian (747m). Ulster's highest mountain, Slieve Donard, is visible on the far right.

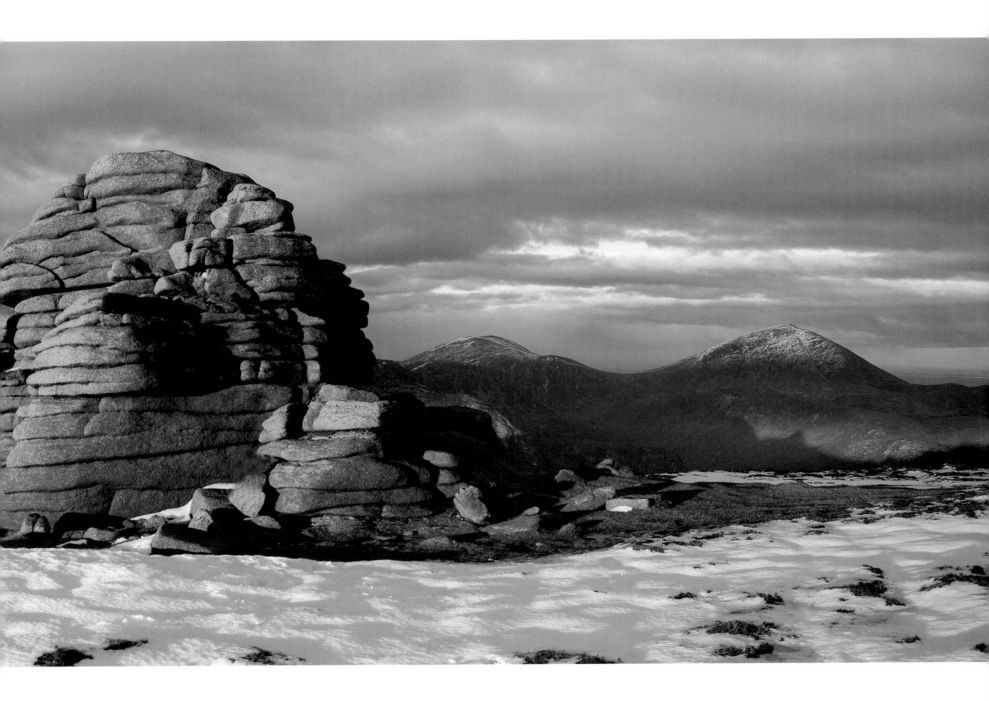

If the construction of the Mourne Wall was a feat of human will and endurance, it is in some small way still celebrated by the walkers who follow the course of the wall, crossing no fewer than thirteen summits in a single day. Indeed, the Mournes are the most popular upland walking area in Northern Ireland, and are served by the best network of paths and tracks of any mountain range in Ireland. Some of these paths have their origins in the smuggling trade that thrived here in the eighteenth and nineteenth centuries. These operations were aided and abetted by a lonely coast and a mountainous hinterland, into which illicit cargoes could rapidly disappear. Tobacco, wine, spirits, leather, silk and spices were brought in on manoeuvrable schooner-rigged craft called wherries, and landed on an isolated beach after a signal from smugglers watching from the mountain slopes. The goods would then be spirited off into the mountains and brought along tracks with names like the Brandy Pad to be distributed inland.

The biggest draw is Slieve Donard, Northern Ireland's highest mountain. On a clear day the panorama from its 850m-high summit includes a large part of Northern Ireland and also extends south beyond Dublin to the Wicklow Mountains, and east across the Irish Sea to the Isle of Man and parts of the Scottish coast. Magnificent as it may be, for many the long-distance views are surpassed by the surreal summit tors of Slieve Binnian and Slieve Bearnagh:

eroded rock formations that look as if they could have been plucked from the desert landscapes of the American south-west.

Mourne granite is also superb for rock climbing. In 1995 the Yorkshire climber John Dunne succeeded on what at the time was regarded as one of the hardest pitches of traditional climbing anywhere in the world. Dunne's route 'Divided Years' climbs an audacious line to the overhanging prow of Buzzard's Roost, a brooding crag perched high on the northern slopes of Slieve Binnian. In twenty years the route has seen only a handful of further ascents, and has cemented its reputation as one of the hardest and finest climbing routes in Ireland or Britain.

Although the Mournes are already designated as an Area of Outstanding Natural Beauty, proposals have been made to make the mountains the basis of Northern Ireland's first national park. The idea was not especially well received by local residents concerned that rules designed to promote conservation might hinder development. For although the Mournes are surely a landscape to be cherished and protected, they are not simply a wild place set apart: the mountains have been richly woven into the cultural fabric of generations of local inhabitants, a process that is still ongoing. Yet whatever the political future holds, the mountains themselves will endure, their slopes still imbued with a unique grace and character, and their summits a place of rare and other-worldly beauty.

High summer in the Mournes. Nodding heads of bog cotton high on the slopes of Slieve Meelmore in mid-July.

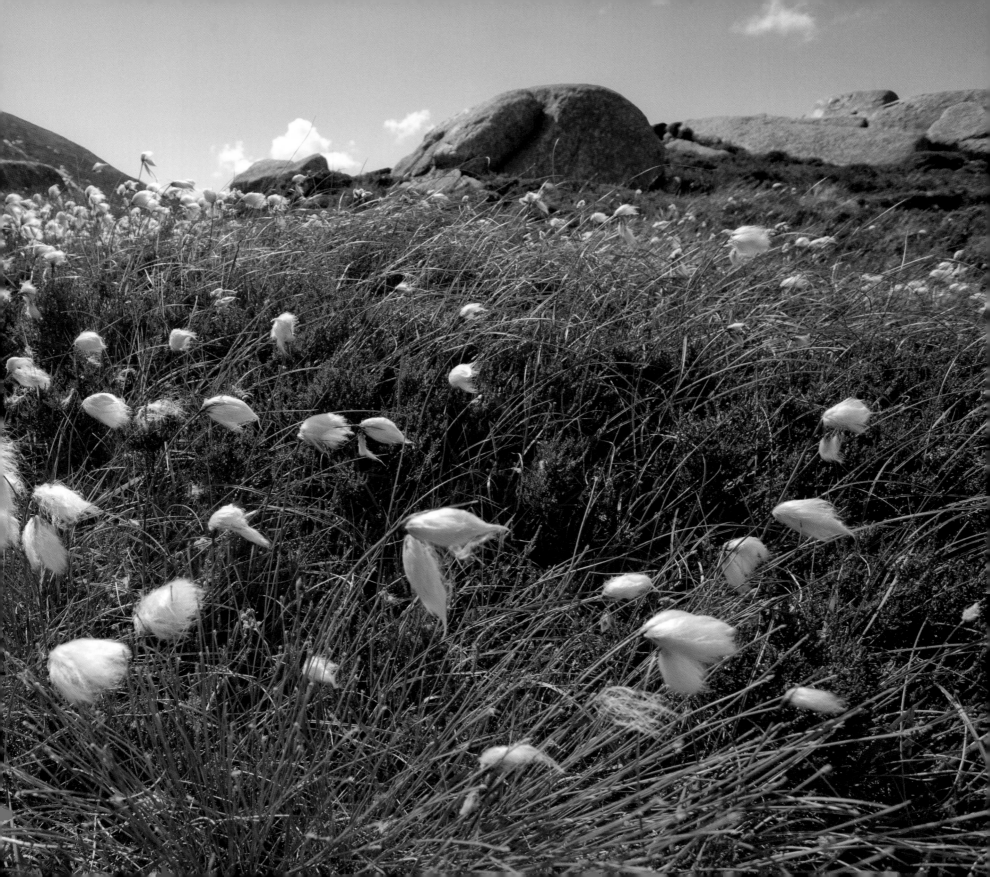

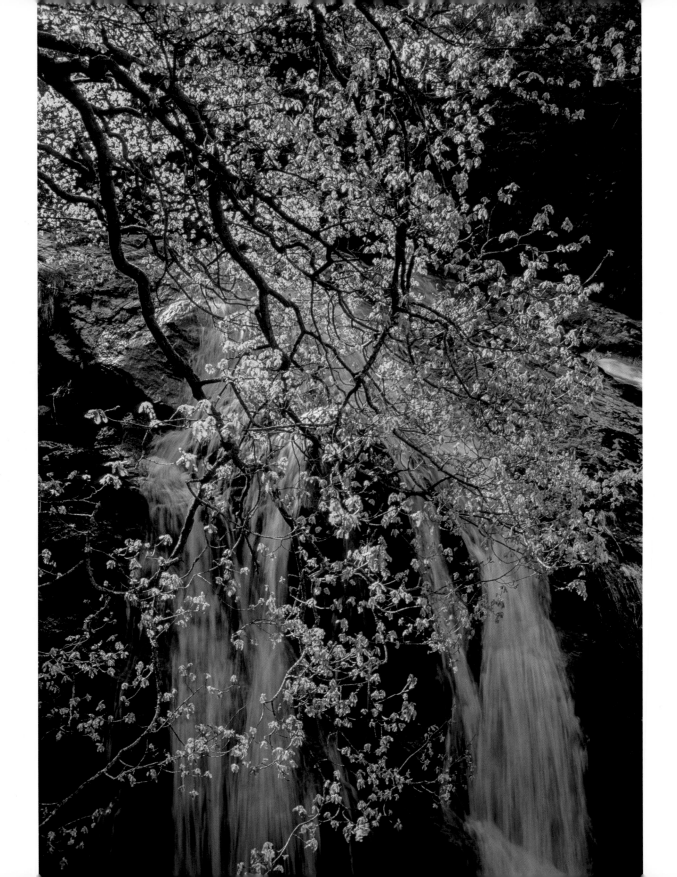

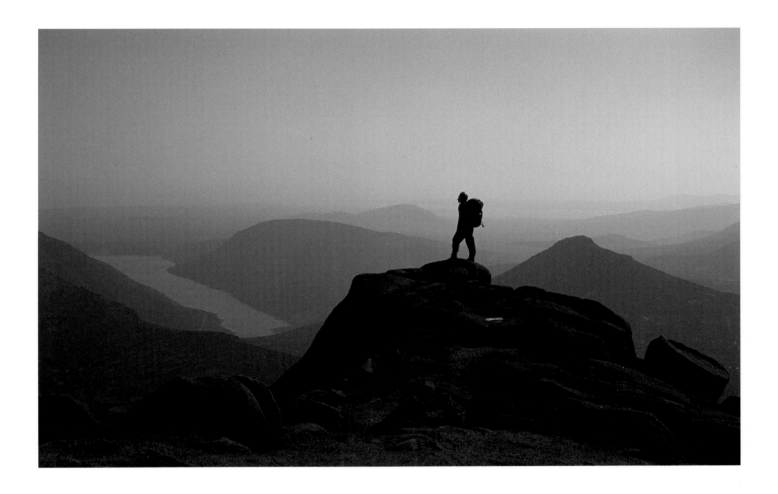

Above: A walker silhouetted on the summit of Slieve Bearnagh. The Silent Valley reservoir is on the left.

Opposite: New leaves bud on an oak tree overhanging a waterfall on the Glen River. The popular path
up Slieve Donard follows the Glen River up through Donard Wood.

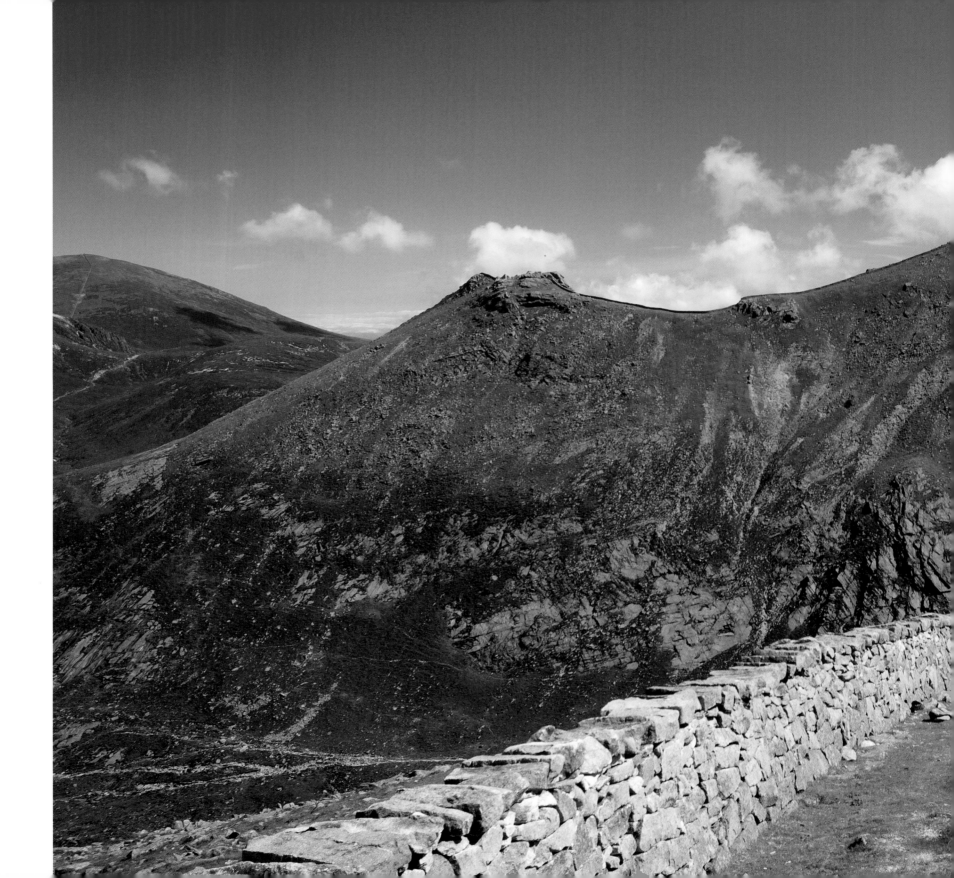

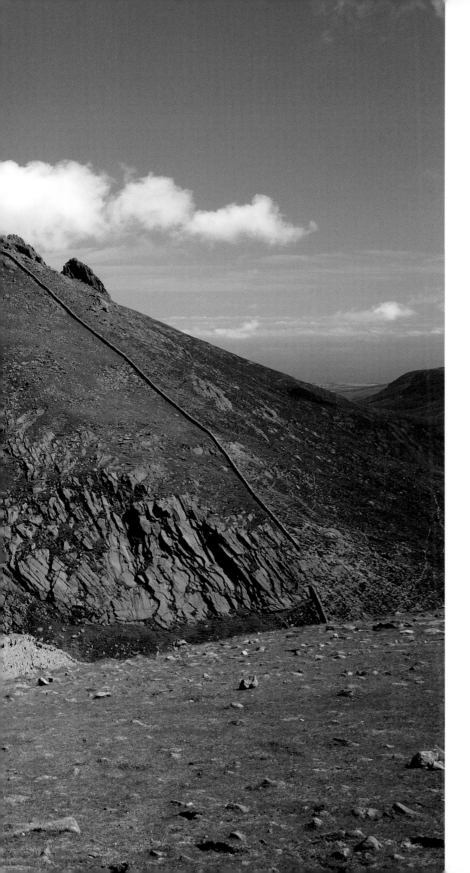

The Mourne Wall from Slieve Meelmore. It took eighteen years to build and runs for 36km across all of the highest summits in the Mournes.

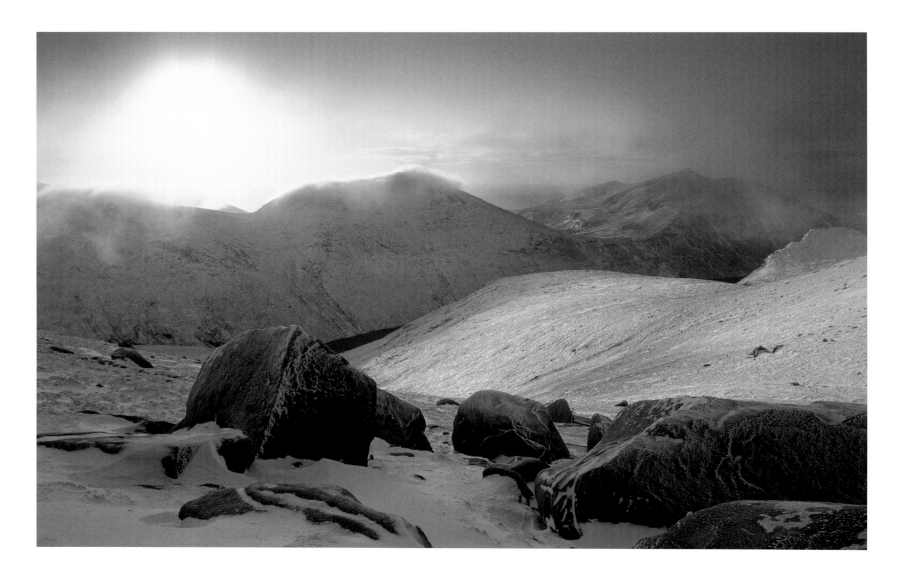

Above: Winter sunrise across the Ben Crom Valley from Slieve Bearnagh.

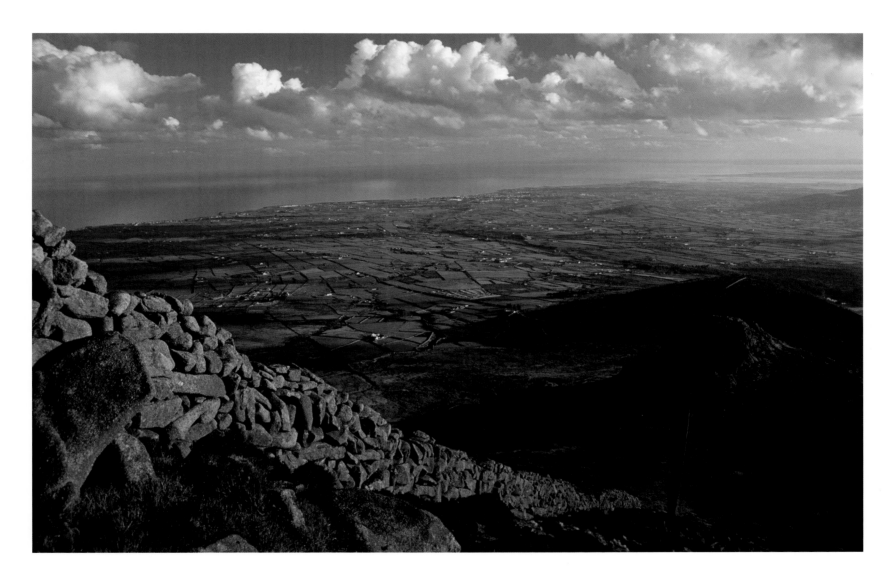

Looking south from Slieve Binnian across rich farmland towards Kilkeel as the Mourne Wall plunges straight down
the southern shoulder towards Wee Binnian.

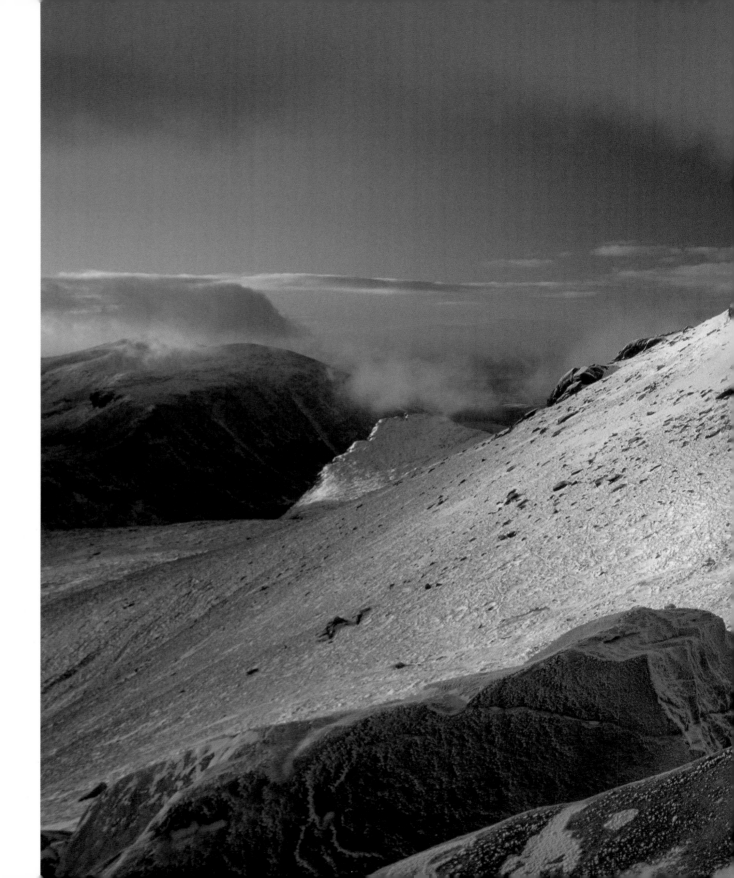

A thin winter snowfall plastered
on the rocks of Slieve Bearnagh's
summit tors.

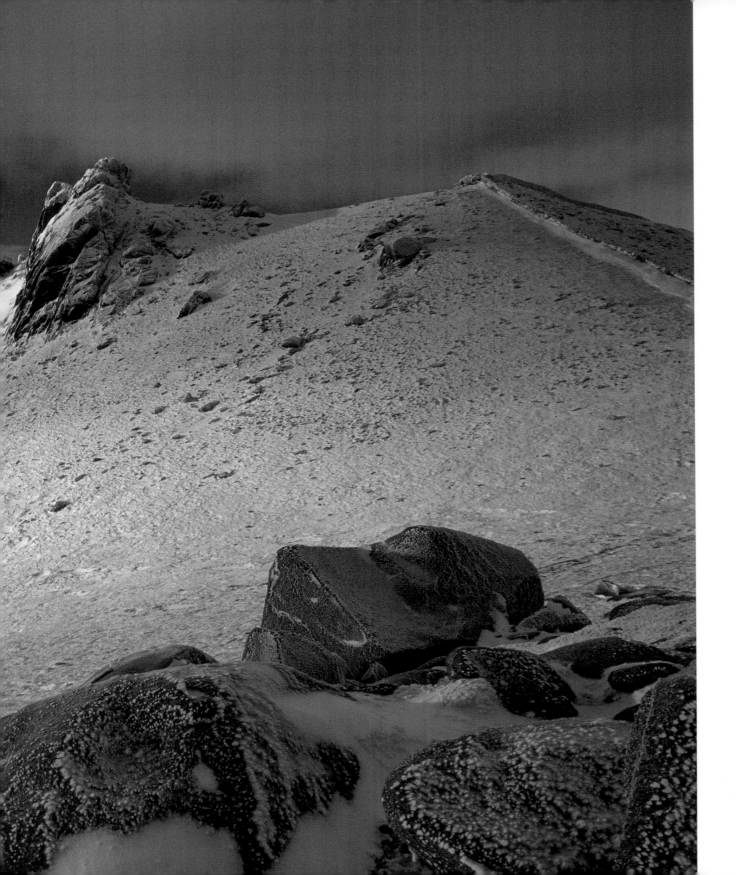

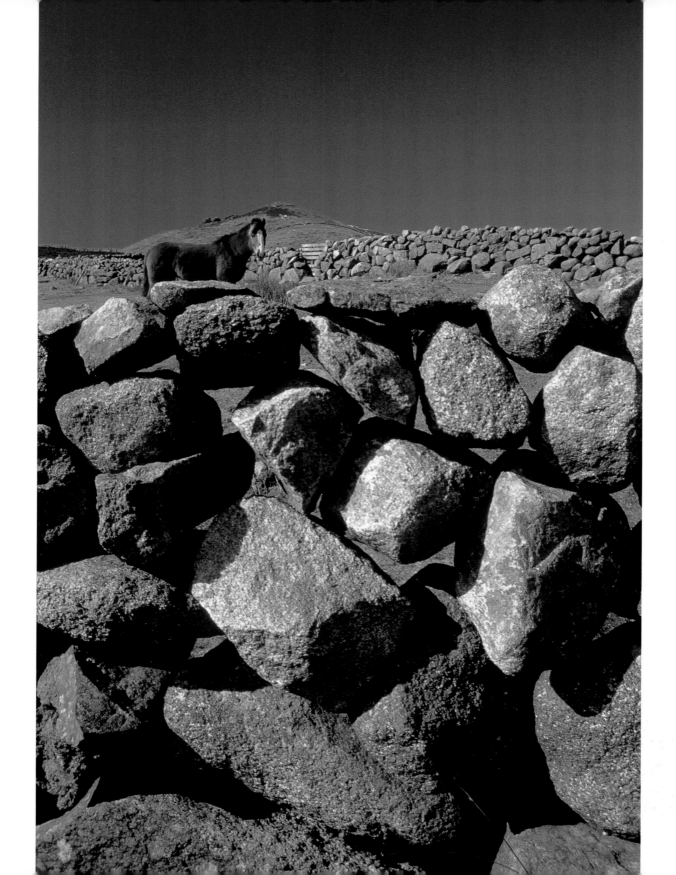

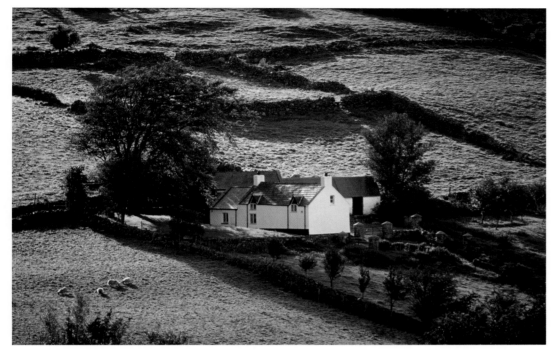

Top: Farmhouse in the Trassey Valley, Mourne Mountains.

Right: Looking west at sunset across the ridges of the Mourne foothills.

Opposite: A horse peering over a characteristic Mourne stone wall.

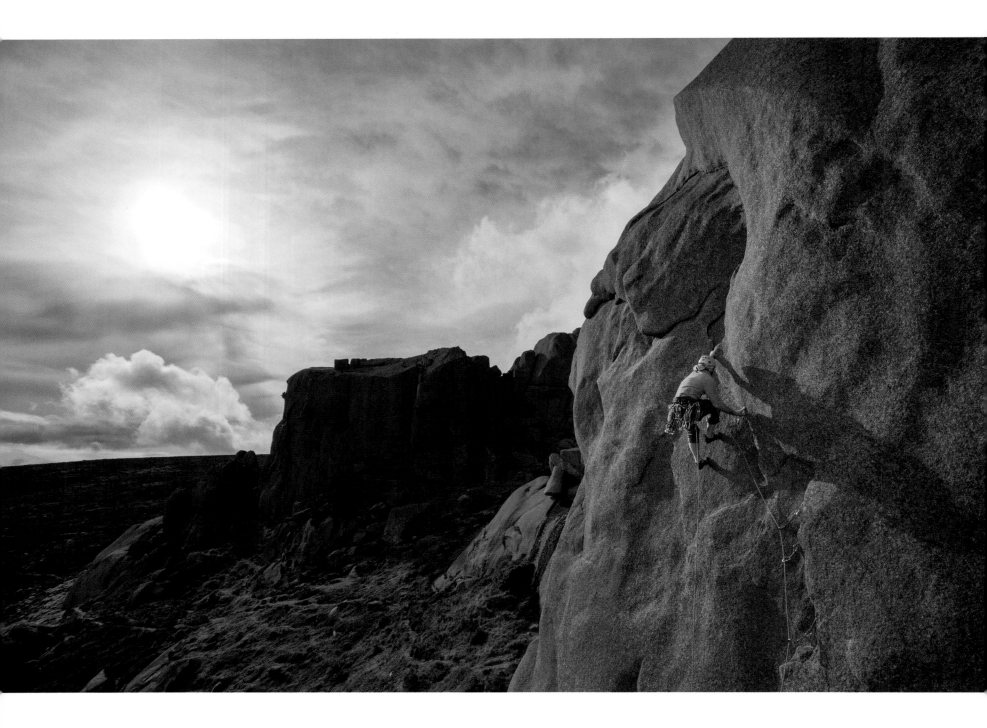

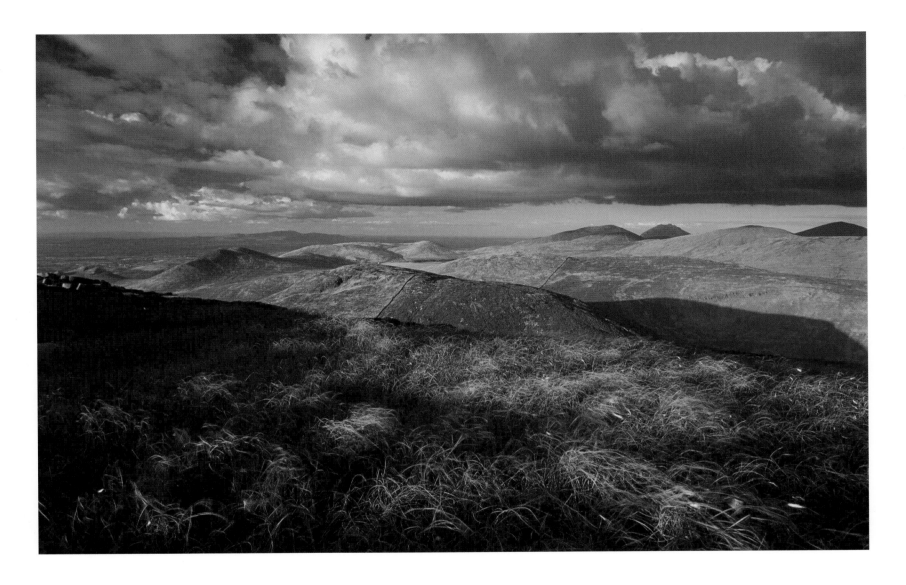

Above: Looking north-east across the Mournes from the summit of Eagle Mountain.

Opposite: Conor Gilmour climbing 'Electra' (E1 5b) high on the north tor of Slieve Binnian.

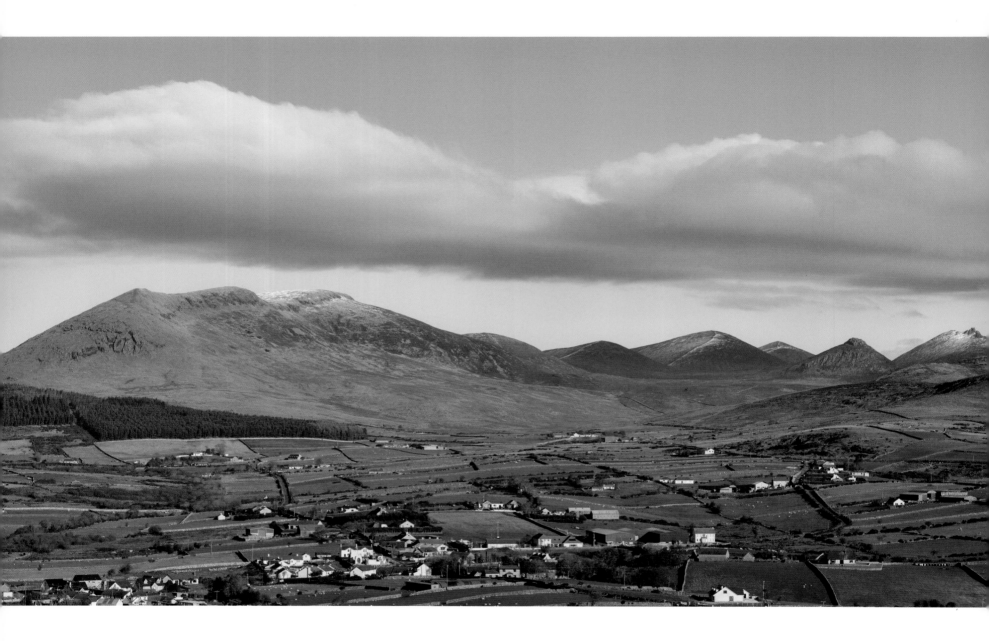

Panorama of the Mourne Mountains, from Attical. Slieve Muck is on the left followed by the Meelmores, then Doan and Slieve Bearnagh in the centre. The mountain on the right is Slieve Binnian.

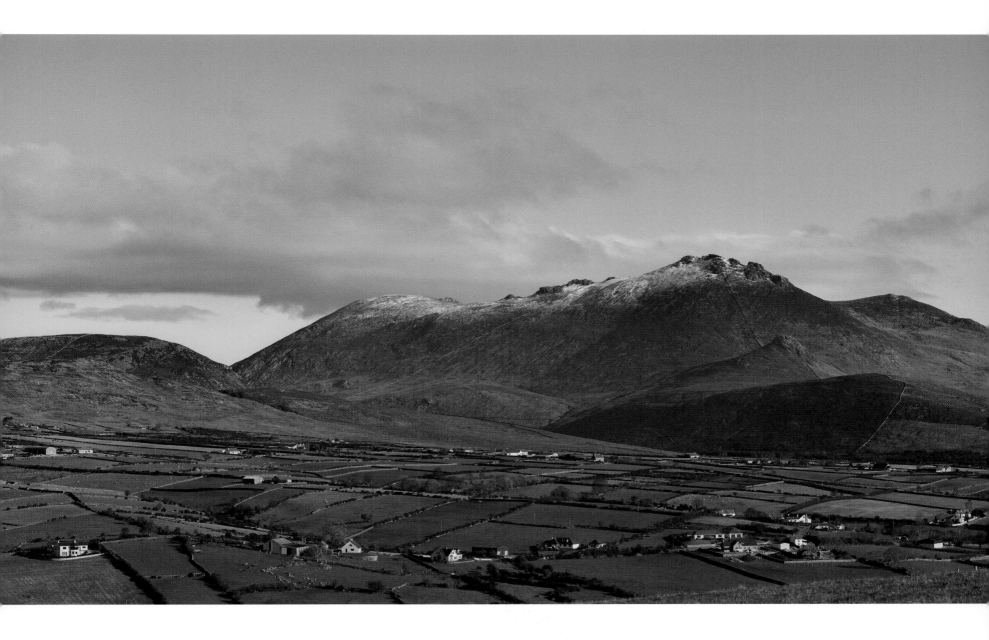

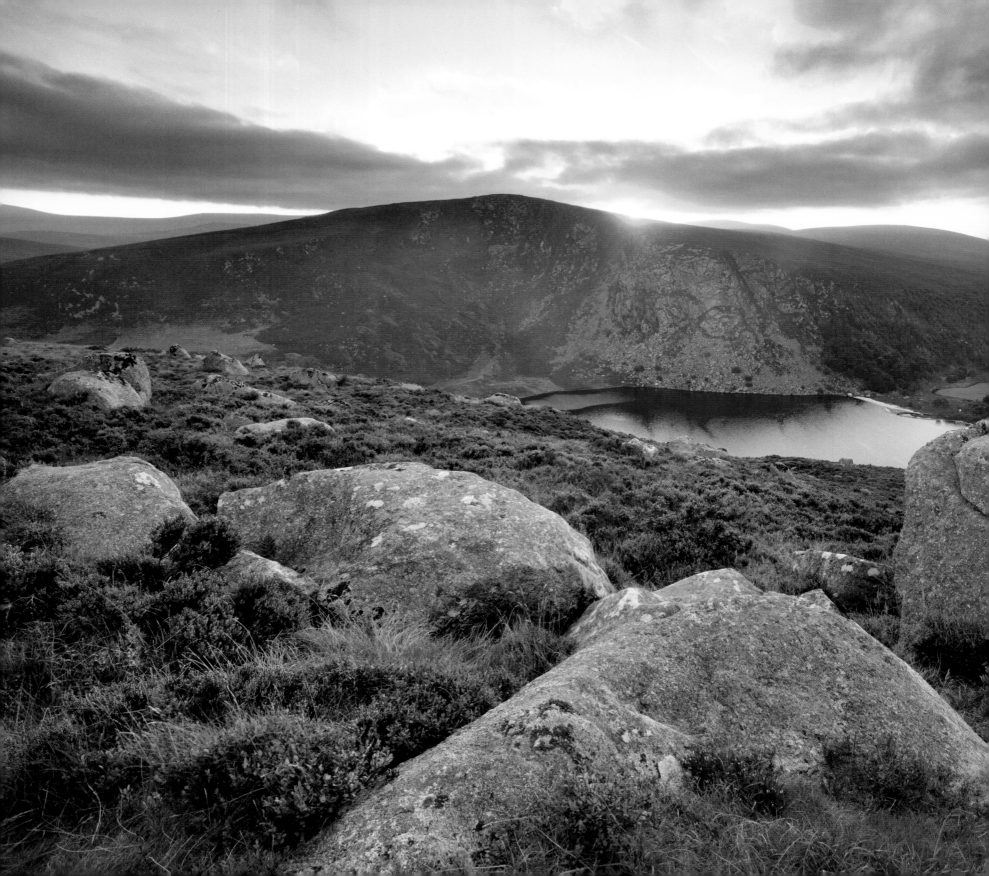

LEINSTER

The Wicklow Mountains

My options seem to narrow as I climb higher through the South Prison, an enormous pockmark gouged from the southern flanks of Lugnaquilla by the glaciers of the last ice age. Sentinels of dripping black rock erupt from the grassy slope on either side, forcing me into an ever-narrower line of least resistance. I zigzag back and forth across the steep gradient, breathing laboured, calf muscles burning. I edge my boots into the thin wet soil, my grip feeling ever more tenuous. A hand goes down here and there, looking for purchase, for security. Just another few metres, a last effort to escape the prison. Finally, I emerge over the lip of the corrie, its rim sharp as the edge of a kerbstone, and stumble onto Lug's vast rock-strewn summit plateau.

The great, angular stone cairn lies nearby – an appropriate marker for the highest mountain in Leinster. Looking east on this clear day, I can see beyond the confines of this small island to the distant, grey-blue silhouettes of Snowdonia, the mountains of another country 150km across the Irish Sea. To the north, a rising swell of summits, tawny-toned beneath their soft blanket of peat.

The Wicklow Mountains are the largest contiguous area of uplands in Ireland, a broad succession of rounded tops that rise straight out of the Dublin suburbs and march south for more than 50km to within sight of the Wexford and Carlow borders. They are also home to Ireland's oldest marked

The sun sets over Luggala Mountain, above Lough Tay.

65

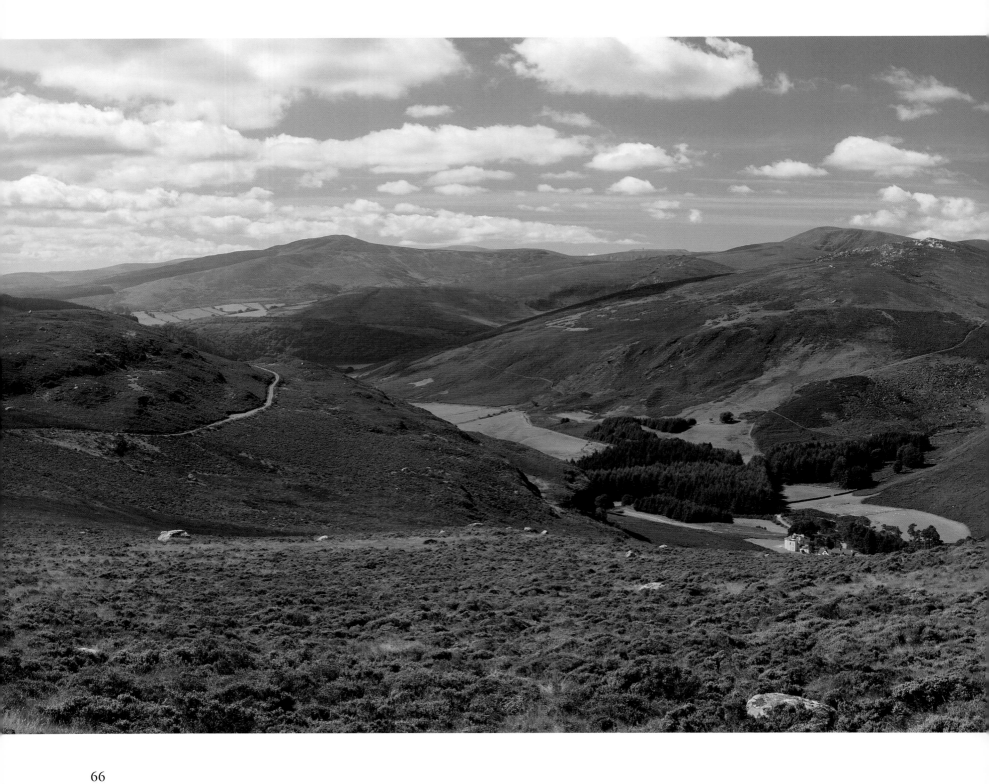

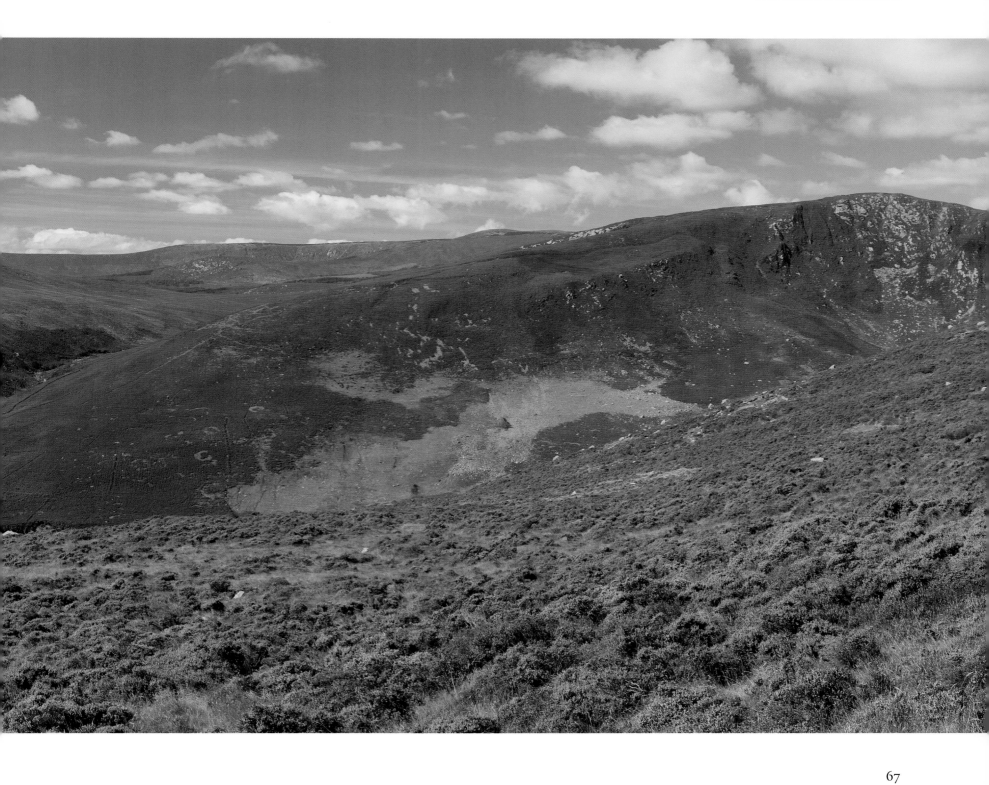

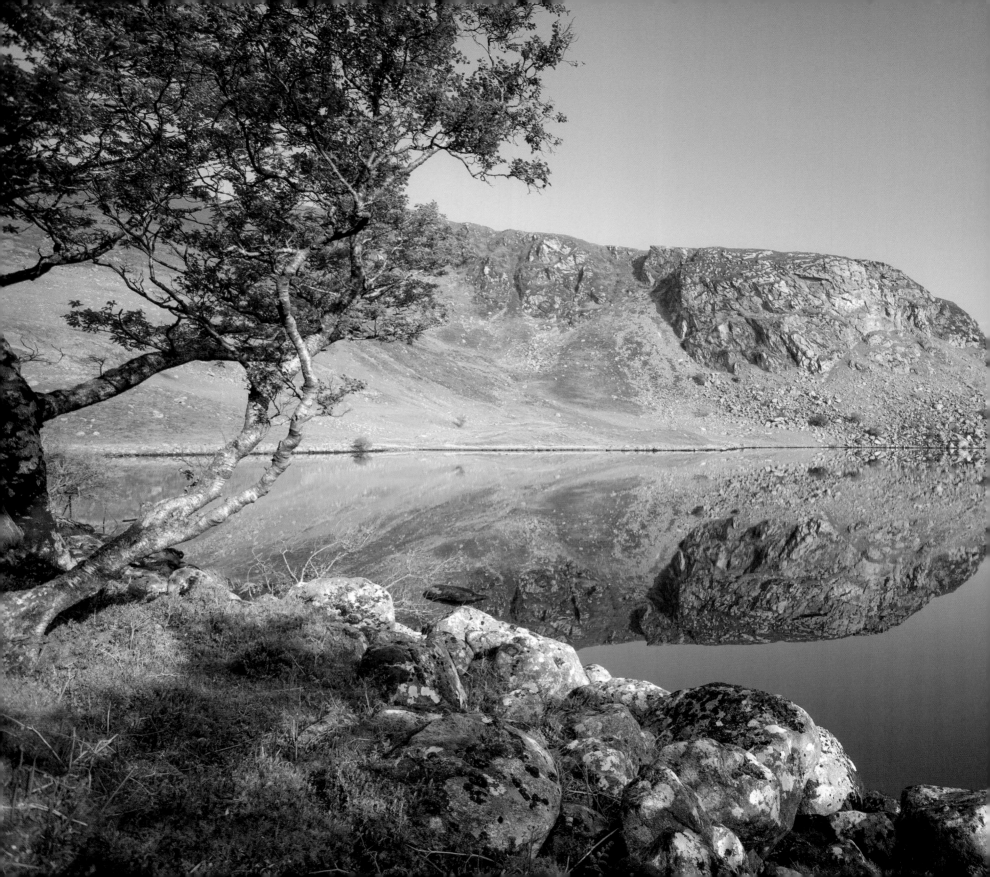

walking route, the 127km-long Wicklow Way, which crosses the mountains between Rathfarnham in south Dublin and Clonegal in County Carlow. They were created when the ancient continents of Laurentia and Avalonia collided during the Caledonian Orogeny some 400 million years ago. Despite their height and extent, the summits of Wicklow are largely gentle and undistinguished. However, they are saved from the mundane by pockets of glaciation that lend their flanks and valleys a sometimes surprising drama – the gouges of the North and South Prisons on Lug, the U-shaped valleys of Glendalough, Glenmalure and Lough Tay, the corrie beneath the summit of Kippure.

Perhaps because of their proximity to our capital city, threads of the great tapestry of Irish history are woven into the Wicklow Mountains more than any other range in the country. A high concentration of tombs and standing stones are evidence of their importance to the Neolithic people who settled the surrounding lands as early as 4000 BC. In the late sixth century, St Kevin climbed across the Wicklow Gap, and down the valley of the Glendasan River into Glendalough. The monastic site he founded there would become one of the largest and most important in Ireland, surviving countless attacks by local tribes and Viking plunderers until it was burnt by English soldiers in 1398. Today it is the beating heart of the

Wicklow Mountains National Park, which at more than 200 sq km, is Ireland's largest protected area.

From the Norman invasions of the twelfth century right through to the insurrection of 1798, the remoteness and inaccessibility of the Wicklow Mountains served to hide and protect generations of Irish rebels. Even today the violence, tragedy and tumult of that period are actively remembered. In 1592 Art O'Neill, his brother Henry and Red Hugh O'Donnell escaped from Dublin Castle in midwinter and fled across the mountains to Glenmalure. Art O'Neill died from exposure not far from safety, while Red Hugh lost several toes to frostbite. Every year hundreds of walkers and mountain runners take part in the Art O'Neill Challenge, the course closely following the original escape route. Even with modern equipment, training and preparation, it is regarded as one of the toughest ultra-marathons in Ireland. In 1798 the English Crown finally succeeded in taming Wicklow, thanks in large part to the construction of Ireland's highest public road, which allowed their forces fast and efficient access into the heart of the mountains.

The Military Road is still used today by armies of tourists and day trippers. Their proximity and ease of access to Dublin is one reason why they are the country's most heavily used hills. Just a couple

Left: The near-vertical, granite cliff face of Luggala reflected in the still waters of Lough Tay.

Previous pages: Heather frames a view along the Cloghoge Valley. Late summer and autumn are the most colourful times in the Wicklow Mountains, and across the Irish uplands generally. This is when the county's two native species of heather – Ling and Bell Heather – are in bloom, imbuing the slopes with a distinct purple hue.

of minutes' walk from the Military Road, some of the finest views in the Wicklow Mountains can be enjoyed, like the classic panorama across Lough Tay and Luggala, a scene equal parts granite wilderness and Georgian parkland.

Construction in the mountains these days is more likely to involve pathways for walkers. Often built by teams of volunteers from organisations like Mountain Meitheal, they are laboriously assembled from stone or even from old railway sleepers in the wetter areas. They serve to protect the fragile peat from the impact of increasing footfall – around a million people visit Glendalough and the easier trails of the national park each year. For generations of Irish people the Wicklow Mountains have often been their first introduction to the Irish mountain environment, an experience that inspires many to venture beyond their Dublin backyard to explore the other great ranges of Ireland.

Interlocking ridges of Knocknacloghoge and the surrounding peaks, on a summer's evening. Lugnaquilla is visible in the far distance.

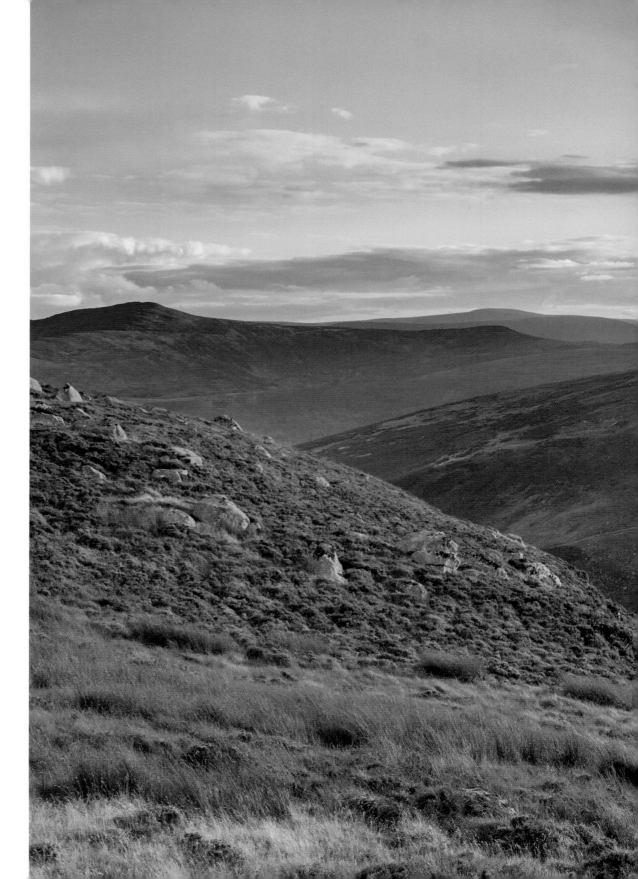

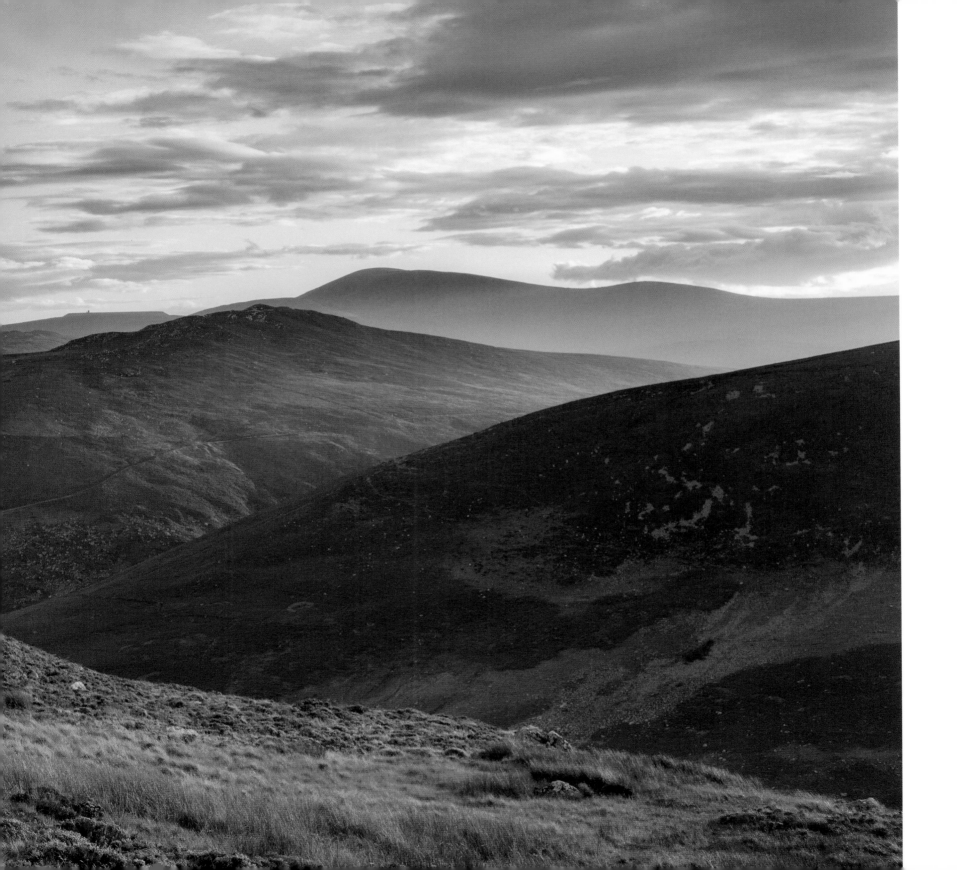

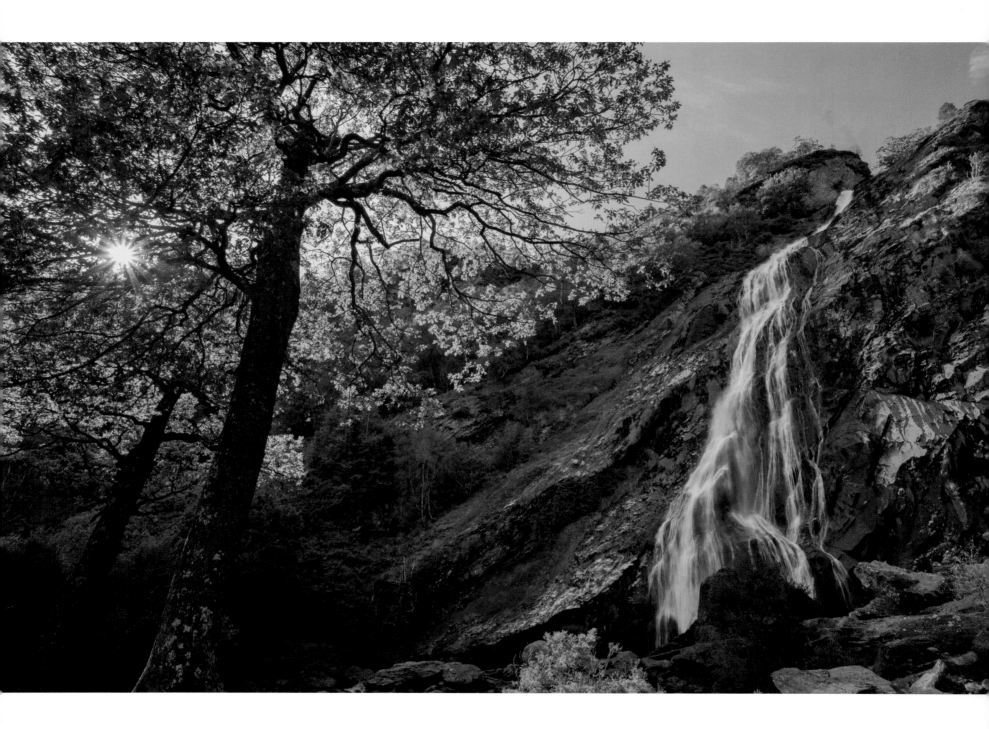

Above: The lower slopes of many of Wicklow's mountains have been planted with stands of Sitka spruce.
Autumn heather blooms beside this forest in the Glendalough valley.

Opposite: Powerscourt Waterfall is 121m high, and one of the highest waterfalls in Ireland.
It is formed by the Dargle River, as it plunges off a cliff between Maulin and Djouce Mountains.

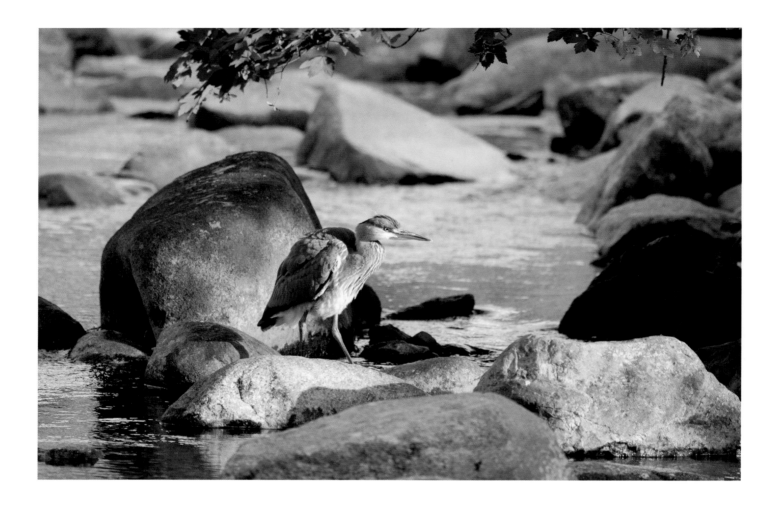

Above: The grey heron is a common sight along rivers and wetlands right across Ireland, including mountain streams in Wicklow.
Usually encountered as a solitary bird, Ireland's resident population is swelled by migratory herons arriving from Britain
and Scandinavia during the winter.

Opposite: Dawn reflection of The Spink in Glendalough's Upper Lake.

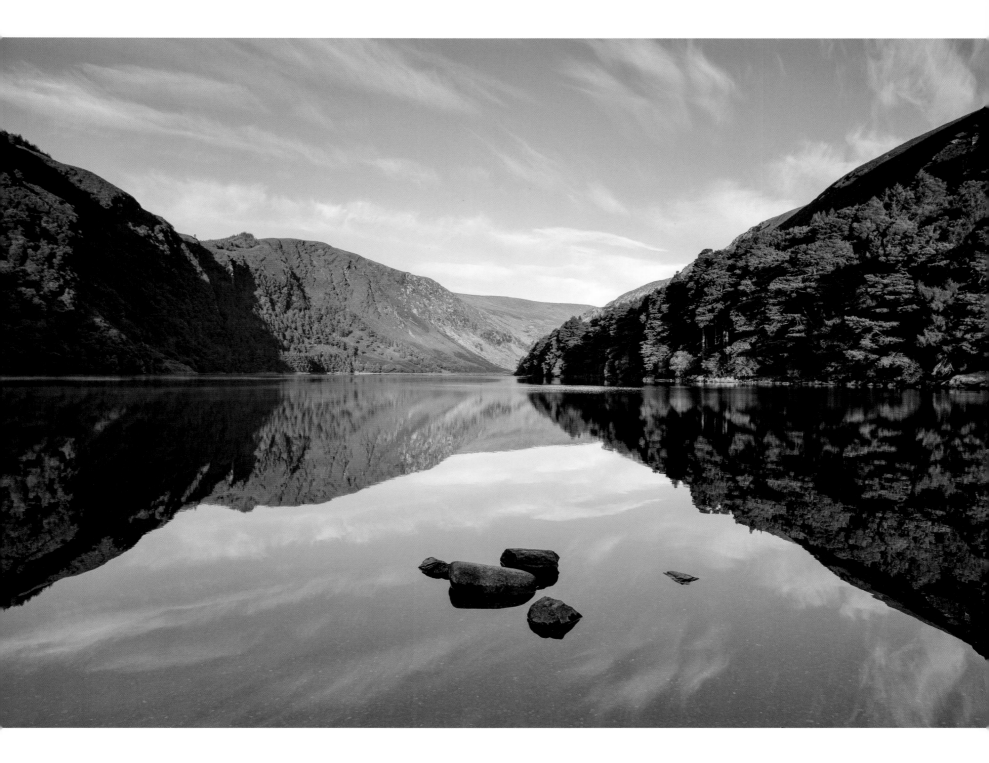

Steep cliffs rim Lugnaquilla's South Prison, one of three corries that bound the summit of Wicklow's highest peak.
All three corries were gouged from the granite bedrock by the glaciers of the last ice age.

Above: Winter sunset over the Wicklow Mountains. The flat-topped peak with the building is Turlough Hill,
whose summit reservoir forms part of Ireland's only pumped-storage hydroelectricity plant.

Opposite: Feral goats roam freely in the upper reaches of Glendalough valley, along with a large herd of hybrid sika-red deer.

Above: Winter rime ice coats the summit cairn of Lugnaquilla, at the top of Leinster's highest mountain.

Opposite: Winter snow encases Lugnaquilla's South Prison. Cosmogenic dating and pollen analysis indicate that glacial remnants from the last ice age persisted here until 11,800 years ago.

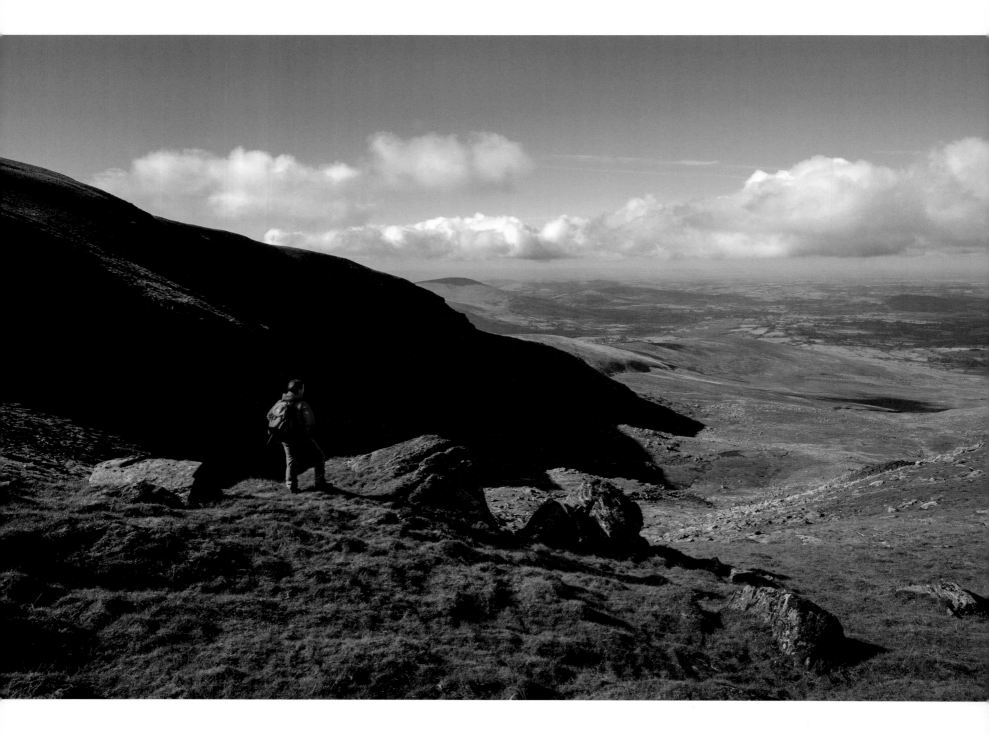

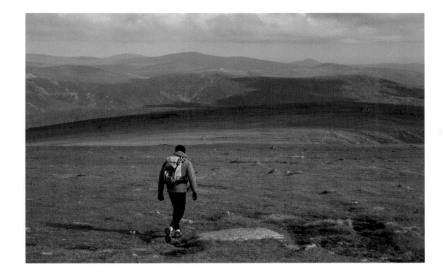

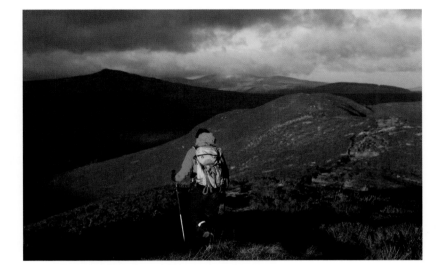

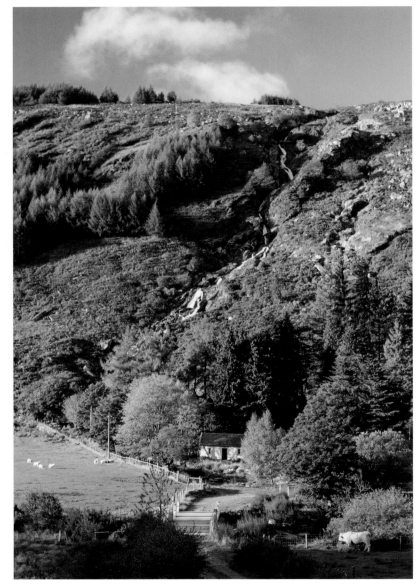

Above, clockwise from top left: Heading north across the summit plateau of Leinster's highest mountain Lugnaquilla;

Carrawaystick Waterfall in Glenmalure;

On the Derrybawn ridge above Glendalough in the Wicklow Mountains National Park.

Opposite: Looking out across the North Prison of Lugnaquilla.

The Comeraghs

Corrie, coum, com, coomb, cwm, cirque. A smorgasbord of terms to describe the enormous pockmarks left behind on our mountains by the abrasion of glaciers. The modern English term is corrie, but it derives from Scots Gaelic and before that, the Old Irish word *coire* meaning a cauldron or hollow. In Wales *cwm* is used, and the word cirque is derived from French and widely used outside Ireland and Britain. But in Ireland the correct term is com, anglicised in place names to coum and coom. Nowhere are these words more frequently used than in the Comeragh Mountains of County Waterford, home to Coumshingaun, Coummahon, Coumtay, Coumgaurha, Coumduala, Coumaraglin Mountain, and the Nire Valley Coums.

Take the road south from Carrick-on-Suir, wending through the Clodiagh Valley to a forestry plantation on a broad watershed. There is an inconspicuous little parking area on the right, with a track leading through the gloam of old pines to a stile and a rocky mountain path snaking up through rough sandstone outcrops and patches of wind-stunted gorse. A well-trodden path is just as likely worn into the turf by running shoes as walking boots.

A little higher up and the path weaves through broad hillocks of grassed-over rock debris – old moraine, the spoil heaps of corrie formation, pushed out from the site of excavation by Pleistocene bulldozers. Here and there lie larger boulders, some

Coumshingaun in the Comeragh Mountains is celebrated as Ireland's finest example of a corrie lake.
Viewed from above or below, it is hard not to be impressed by the drama of this natural amphitheatre.
In the far distance is Mount Leinster and the Blackstair Mountains.

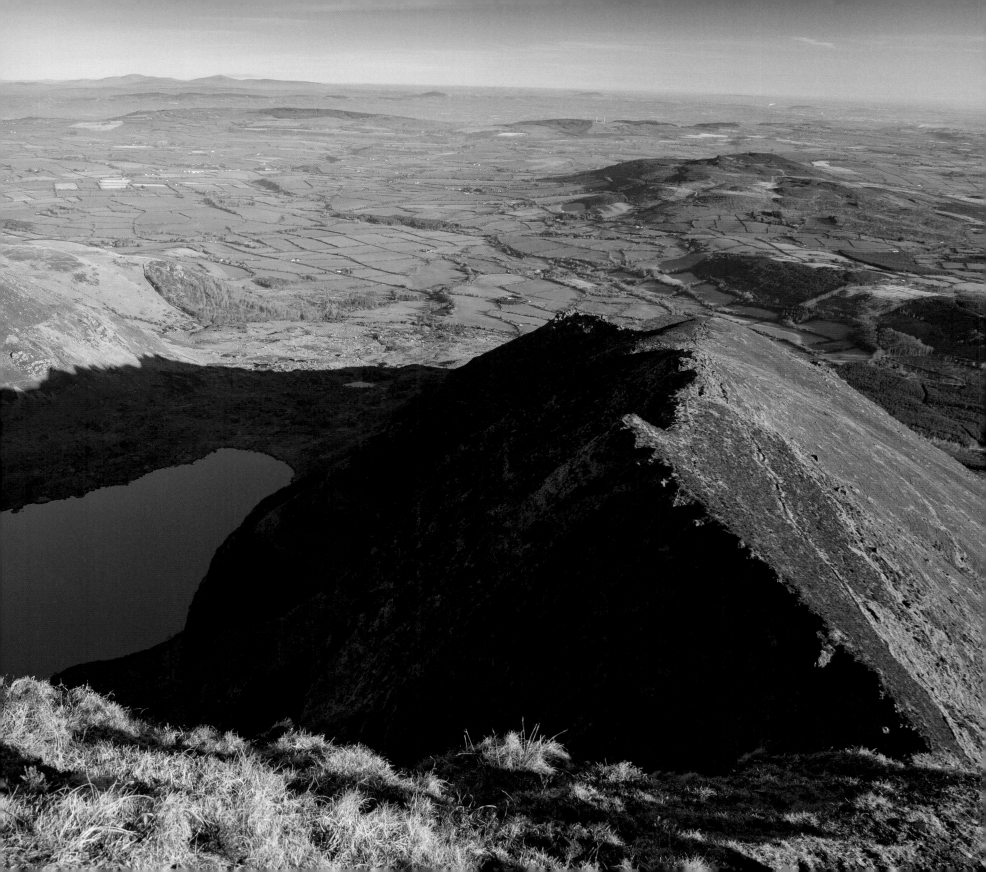

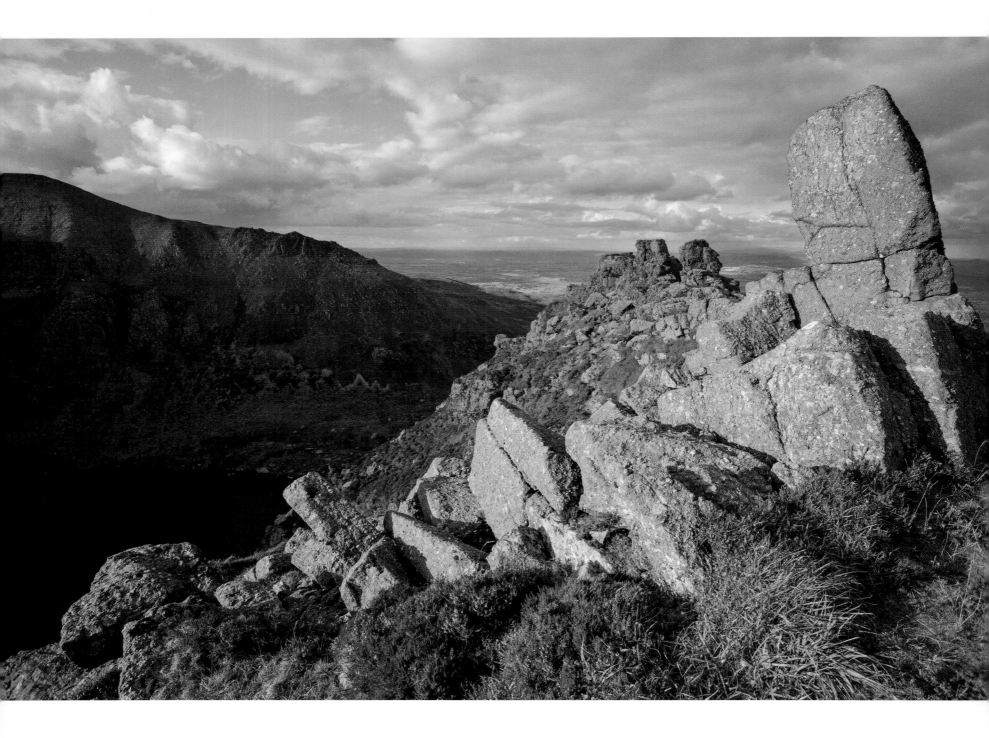

almost house-sized and weighing several hundred tonnes, resting just where they were deposited by the retreating ice several thousand years ago. Perhaps forty-five minutes from the car park, Coumshingaun comes into view, a final steep pull over the last moraine wall revealing the dark waters of the corrie lough and the magnificent 400m-high cliffs that encircle it. Without doubt, the finest example of a corrie in Ireland.

Boulder-hop across the lake's outlet stream to join an informal path climbing the steep, grass slopes at the south-eastern end of the corrie. After thirty minutes' effort you are rewarded with access to the most stunning of arêtes. Not only were glaciers busy digging out Coumshingaun during the last ice age, they were also industriously carving out the neighbouring valley. Between the two, a sharp apex has formed, weathering into a striking array of blocks and tors, some of these conglomerate totems pointing skyward like giant fingers.

The Old Red Sandstone that forms the Comeraghs can be dated to the Devonian period between 350 and 400 million years ago, when eroded material from the Caledonian mountain ranges to the north was carried south and deposited in huge quantities. These ancient sediments were then lifted and folded into the sandstone mountains of southern Ireland, as the supercontinent of Pangaea came together during the Variscan Orogeny. The sandstone geology of the Comeraghs is especially complex, featuring several 'stages' or layers. The conglomerate evident around Coumshingaun is fascinating, and even has its own name: the Coumshingaun Formation. In places it looks just like pebbles from a stream bed that have been cemented together, and in other parts it has been weathered into all manner of crevices, fissures and caves. Indeed, a traumatised First World War veteran, Jim Fitzgerald, spent many years living wild as a hermit in the caves around Coumshingaun.

Perhaps like no other mountain range in Ireland, the Comeraghs' most interesting features and greatest views are to be found on their flanks. The summits themselves are cast in a supporting role, sometimes barely distinguishable from each other. Just around the corner from Coumshingaun is Coummahon, home to one of Ireland's finest waterfalls. Just as Coumshingaun has become a mountain location inhabiting the popular imagination, similarly Mahon Falls is just as popular with day trippers and families as it is with seasoned hillwalkers. The nascent Mahon River rises deep in the thick blanket of peat on the roof of the Comeraghs and plunges down a 200m-high vertical staircase of waterfalls. In dry weather the river shrinks to an easily forded stream, the falls to delicate white ribbons. But after prolonged heavy rain, when the bog is saturated and myriad tributaries spring to life, the thunder of the falls reverberates through the valley, and the coum smokes with a drenching spray.

Rock pinnacles jut skyward from the southern rim of Coumshingaun.

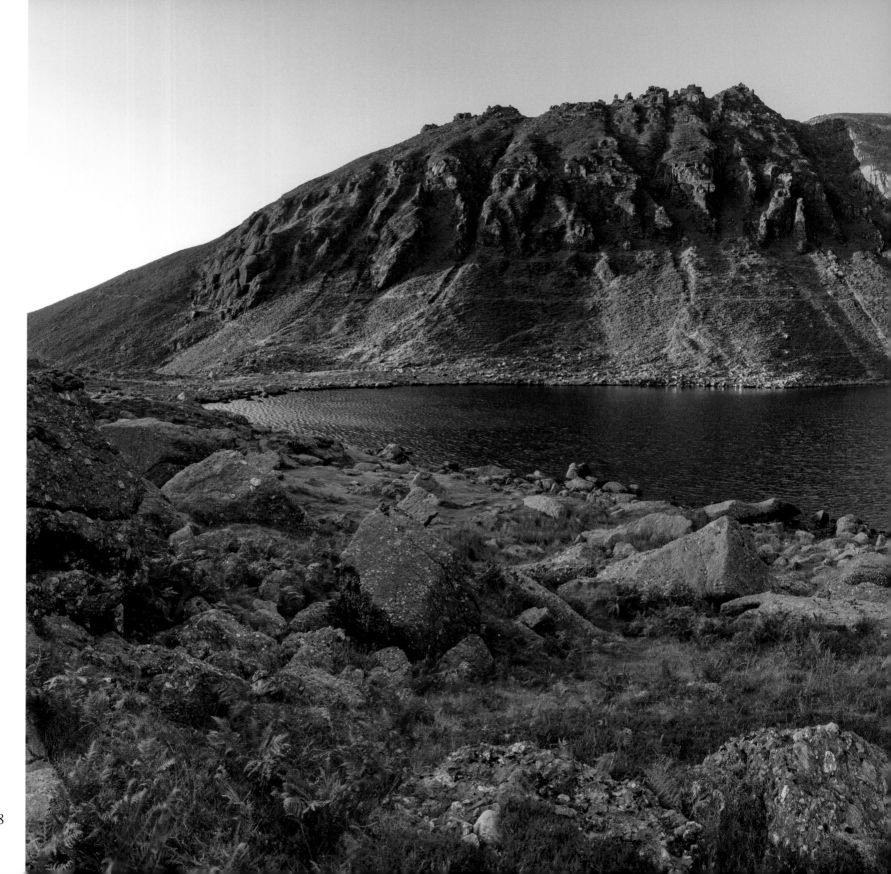

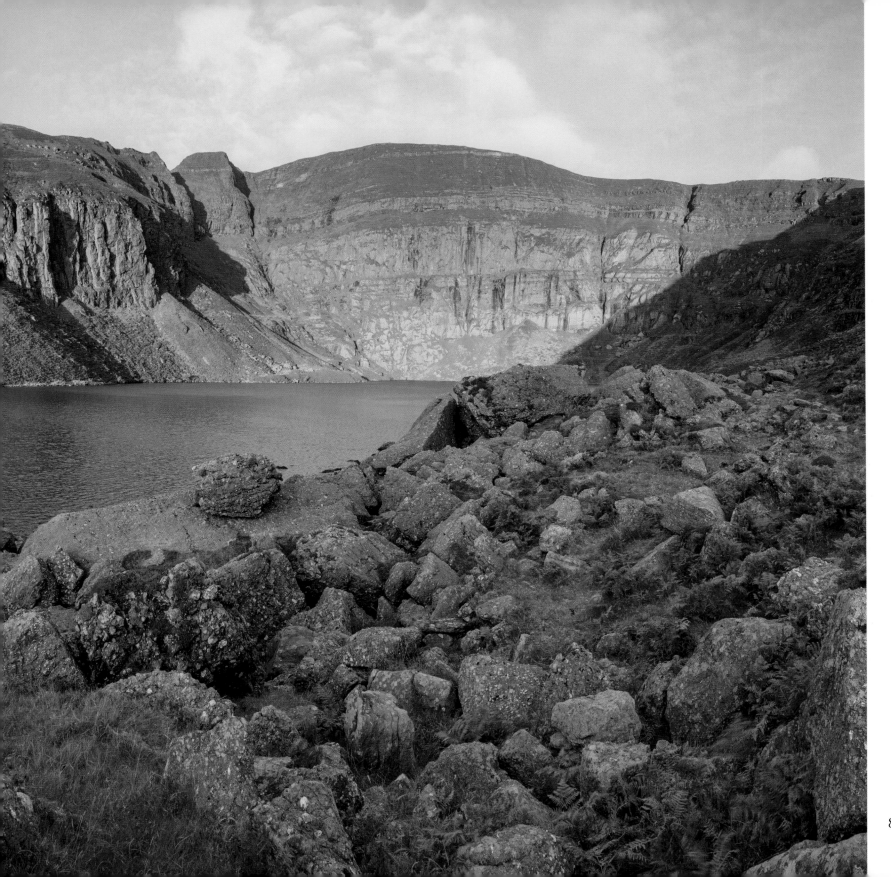

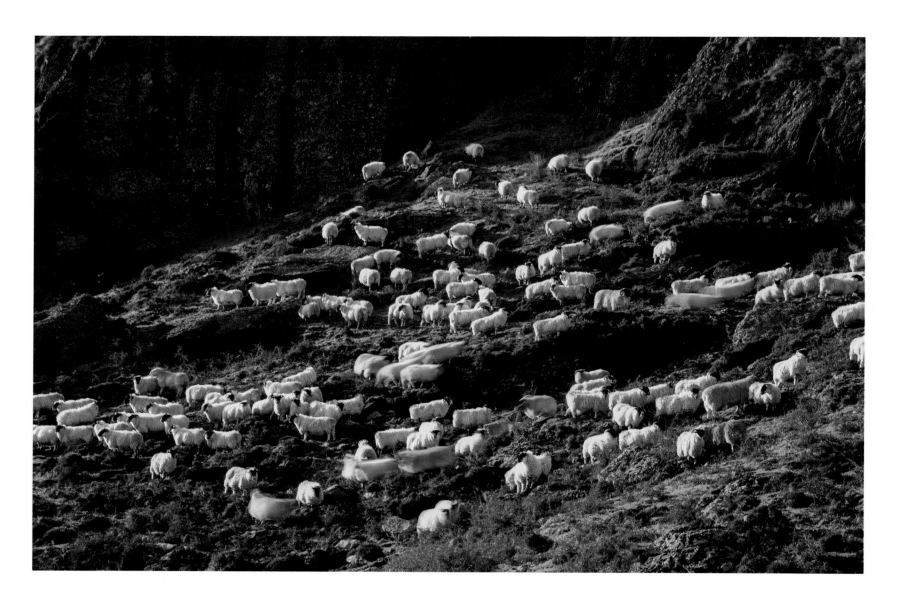

Above: Colourfully dyed hill sheep flock together on the slopes of the Comeragh Mountains.

Opposite: A torrent of water spills over Mahon Falls from the Comeragh plateau.

Previous pages: Dawn light illuminates the 380m-high headwall at the back of Coumshingaun.

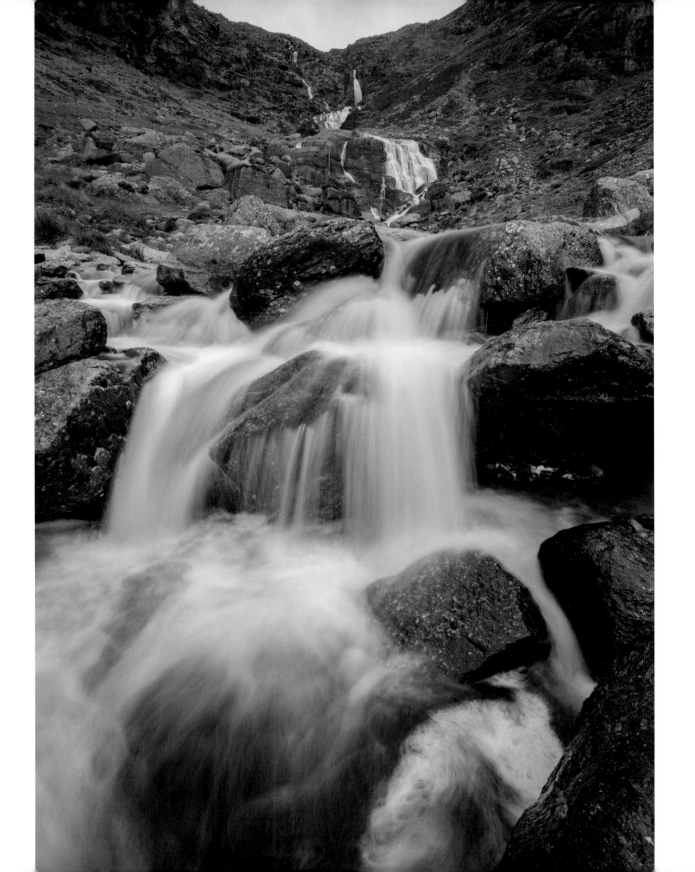

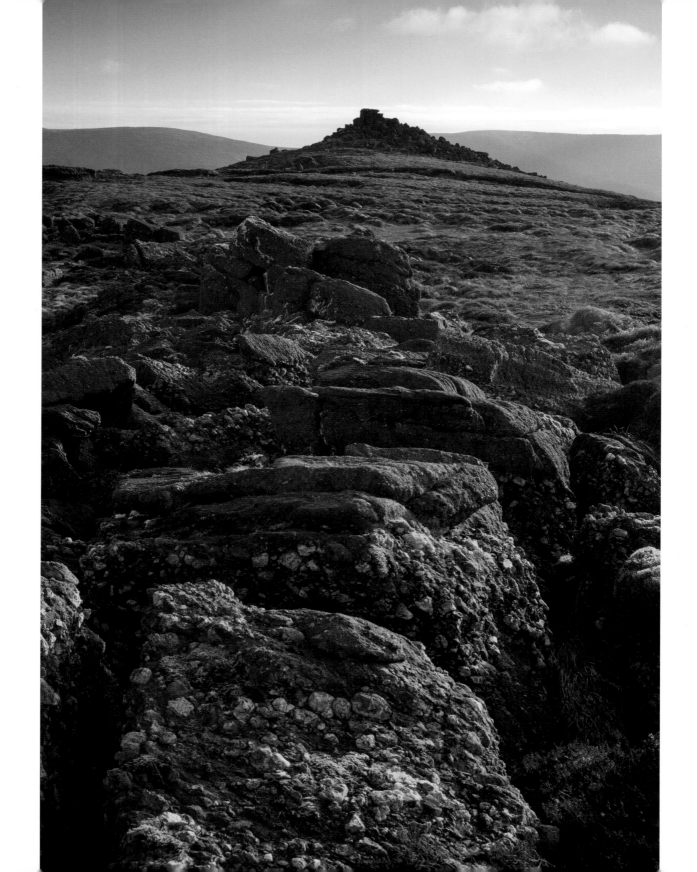

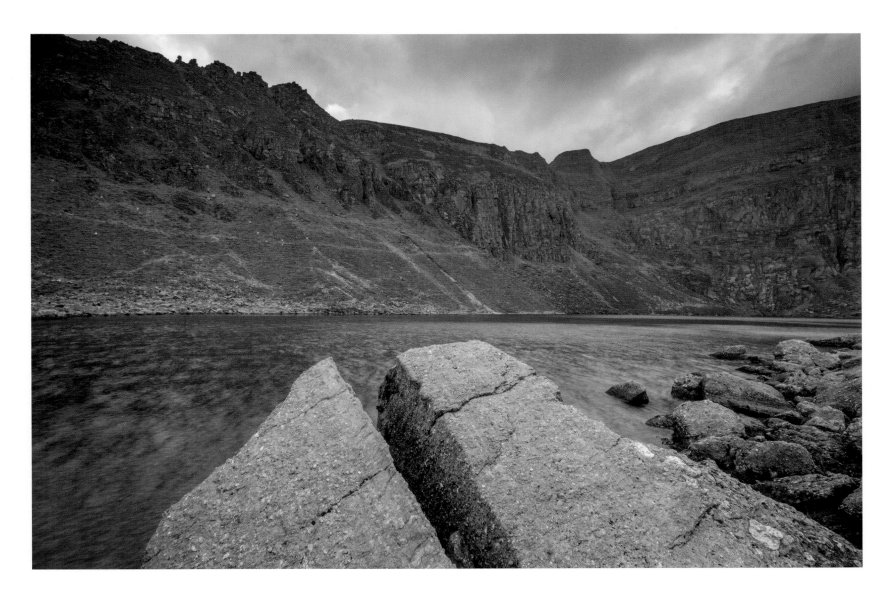

Above: Split boulder on the shore of Coumshingaun Lough. An old moraine constrains the water of this 700m-long lake, which is bottomless, according to local mythology.

Opposite: Bulbous outcrops of conglomerate rock decorate the Knockanaffrin Ridge.

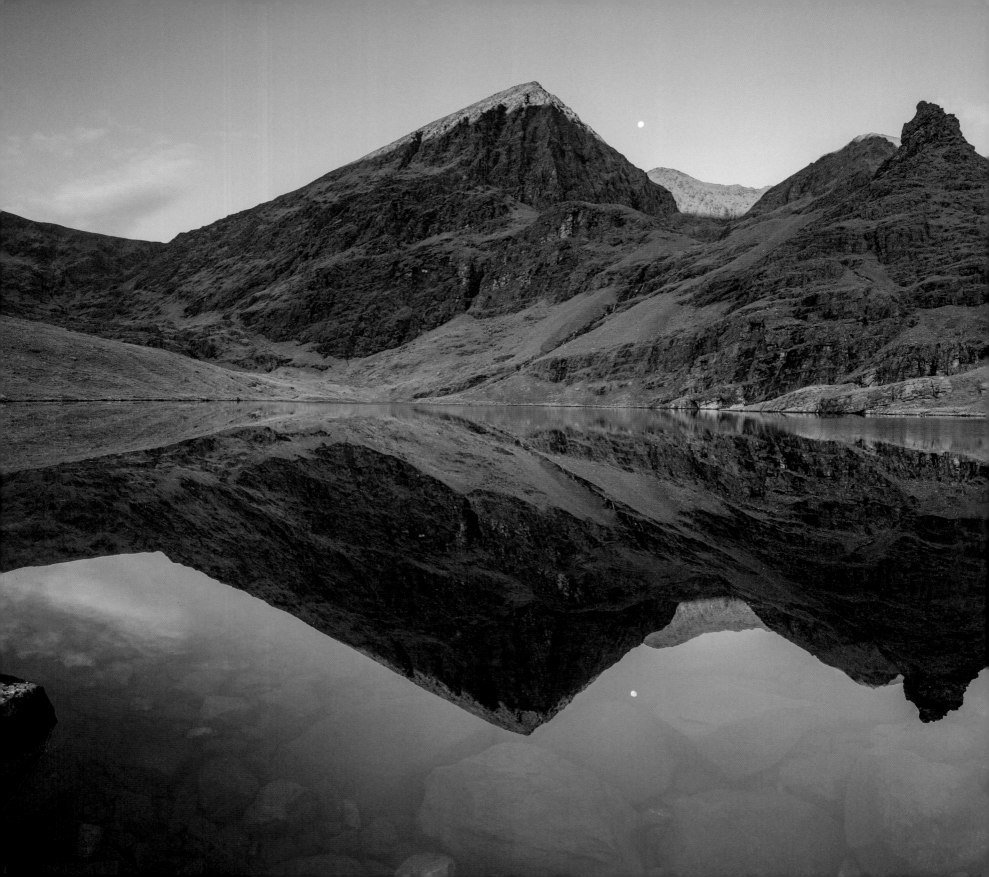

MacGillycuddy's Reeks

I never tire of the big reveal of the Reeks at Crinny. For 18km south-west of Abbeyfeale, the N21 road climbs through a familiar north Kerry landscape of low, boggy hills and marginal farmland. At Crinny the road crests the western escarpment of the Mullaghareirk Mountains and begins a long sweeping right turn as it descends towards Castleisland. Laid out below is a pastoralist's dream of patchwork farmland and rich, well-drained soil. Thirty kilometres beyond, the highest and most dramatic mountain range in Ireland rises like a wall.

The MacGillycuddy's Reeks, or the 'Reeks' as they are popularly known, voraciously devour superlatives. They are the highest range in Ireland, containing our eight tallest peaks and our only three summits above 1,000m. The big three, Carrauntoohil, Ireland's highest mountain at 1,038m, Beenkeragh (1,010m) and Caher (1,001m), gather in a conspiratorial knot at the western end of the Reeks ridge. This is the beating heart of Ireland's mountains. Nowhere else in the country can you encounter an almost alpine mountain experience, such rugged grandeur and other-worldly, far-ranging views.

The name, quirky and cartoonish, deserves some explanation. It originated during the eighteenth century, and is derived from the title of the MacGillycuddy family, a branch of the O'Sullivans, who owned large amounts of land in this part of Kerry. 'Reeks' has nothing at all to do with the odour of the mountains or their namesakes, but derives rather from the Old English word 'rick', describing a stack of straw or hay. This element of the name at least is shared with the prosaic but more apt Irish name *Na Cruacha Dubha*, meaning 'The Black Stacks'.

The first rays of dawn warm the summits of Carrauntoohil and Beenkeragh, and are reflected in the still waters of Lough Gouragh, in Hags Glen.

95

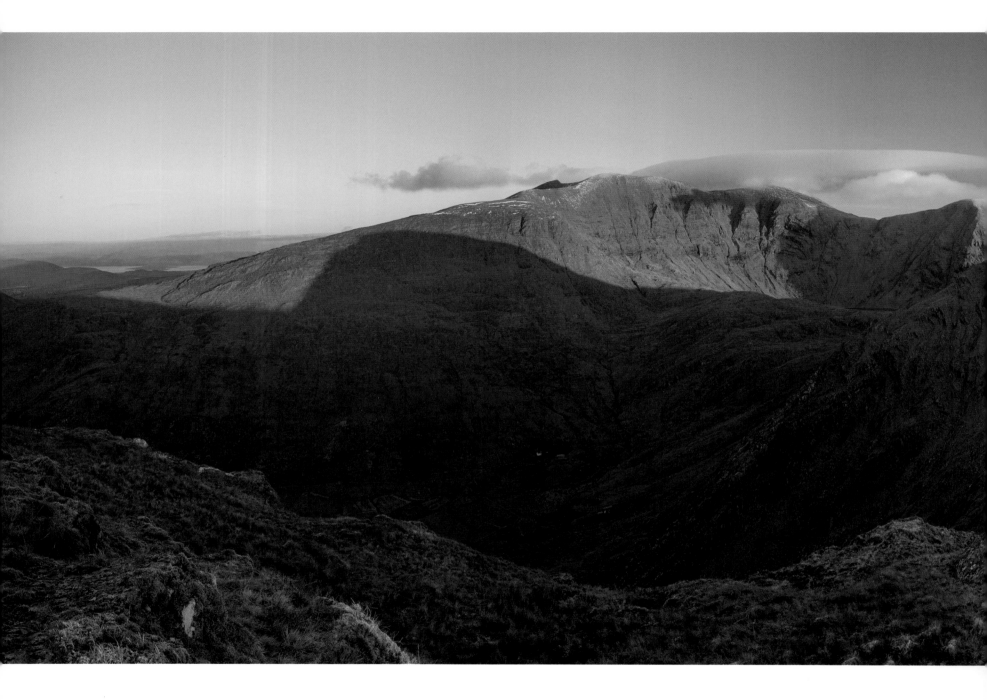

Dawn panorama from Stumpa Duloigh, looking across Broaghnabinnia and the Black Valley towards the MacGillycuddy's Reeks.

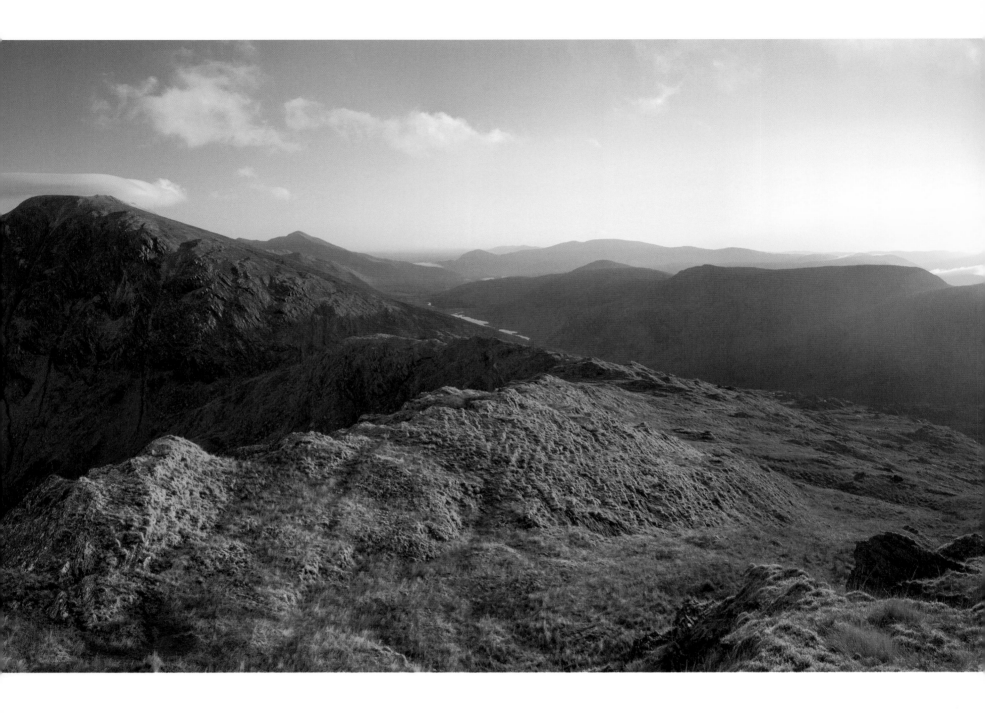

Curiously, the mountains and their naming were the subject of a section in the BBC's Green Book of 1949, a bureaucratic tome outlining what was and was not permissible content in comedy programming. 'Do not mention the McGillycuddy of the Reeks or make jokes about his name,' ran the stricture. Perhaps this title, which at best could be described as whimsical, is ill suited to bestow on our finest mountain range.

Enough of etymology; what about geology? The Reeks are made of Old Red Sandstone formed during the Devonian period between 350 and 400 million years ago, as eroded material from the Caledonian mountain ranges to the north was carried south and deposited in huge quantities. High on the ridge between Carrauntoohil and Beenkeragh you can see fossilised ripples, woven into the sediment by winds and waves before the evolution of the dinosaurs. These ancient sediments were lifted and folded as the supercontinent of Pangaea came together during the Variscan Orogeny, creating both the Reeks and the other east/west sandstone mountain ridges of Ireland's south and south-west. But it was the harsh hammer and chisel of glaciation that sculpted what we see today: the frost-shattered ridges, the shadowed corries, the deep valleys.

Kate Kearney's Cottage sits at the foot of one such valley. The Gap of Dunloe is an enormous glacial breach that divides the main Reeks ridge from the

Southern profile of the MacGillycuddy's Reeks, seen from Stumpa Duloigh.

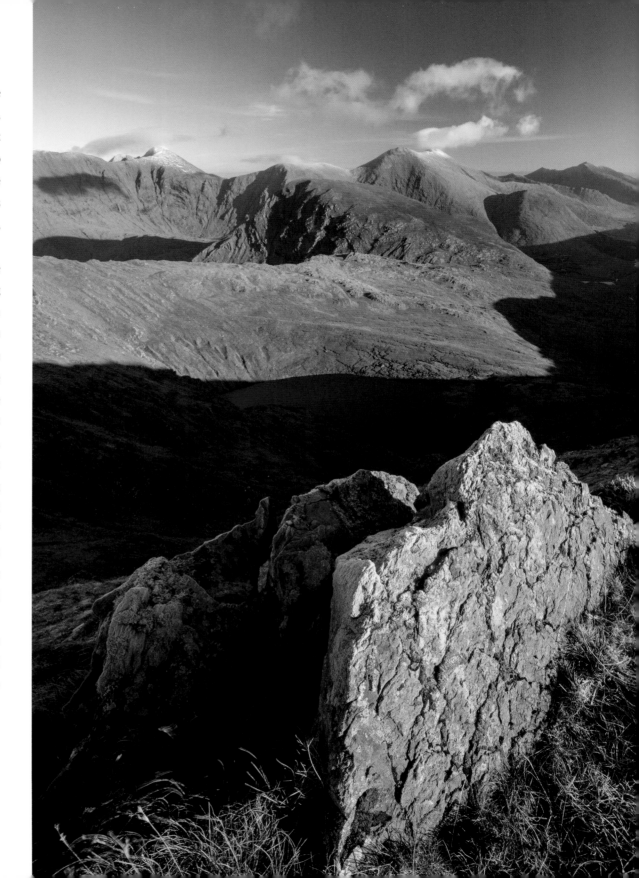

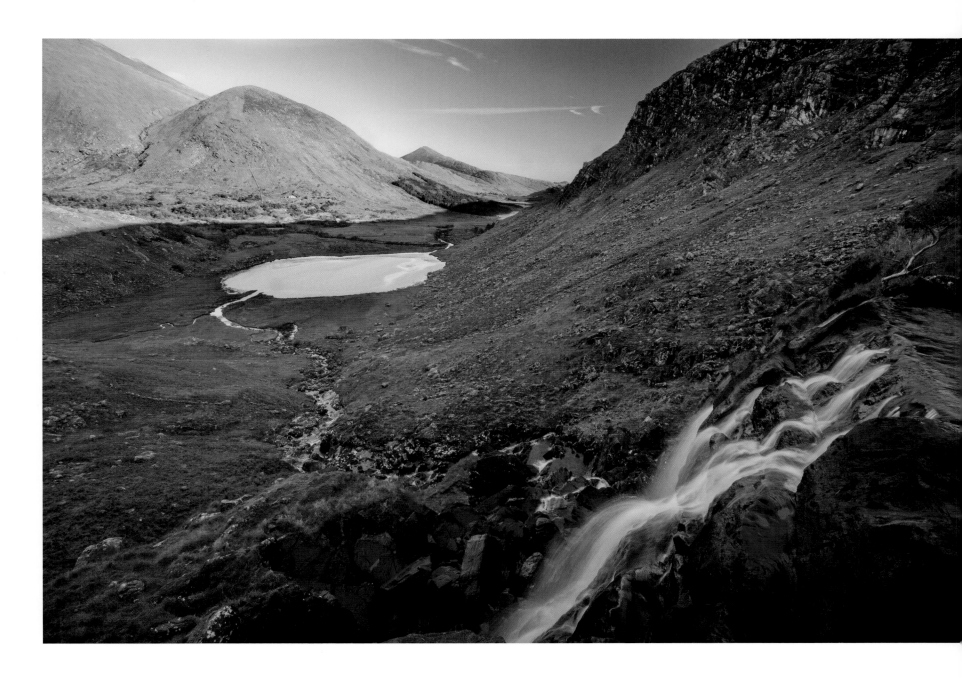

The Gearhameen River flows steeply into Lough Reagh on its journey to the Black Valley.
The lower slopes of the Reeks lie on the left of the photo.

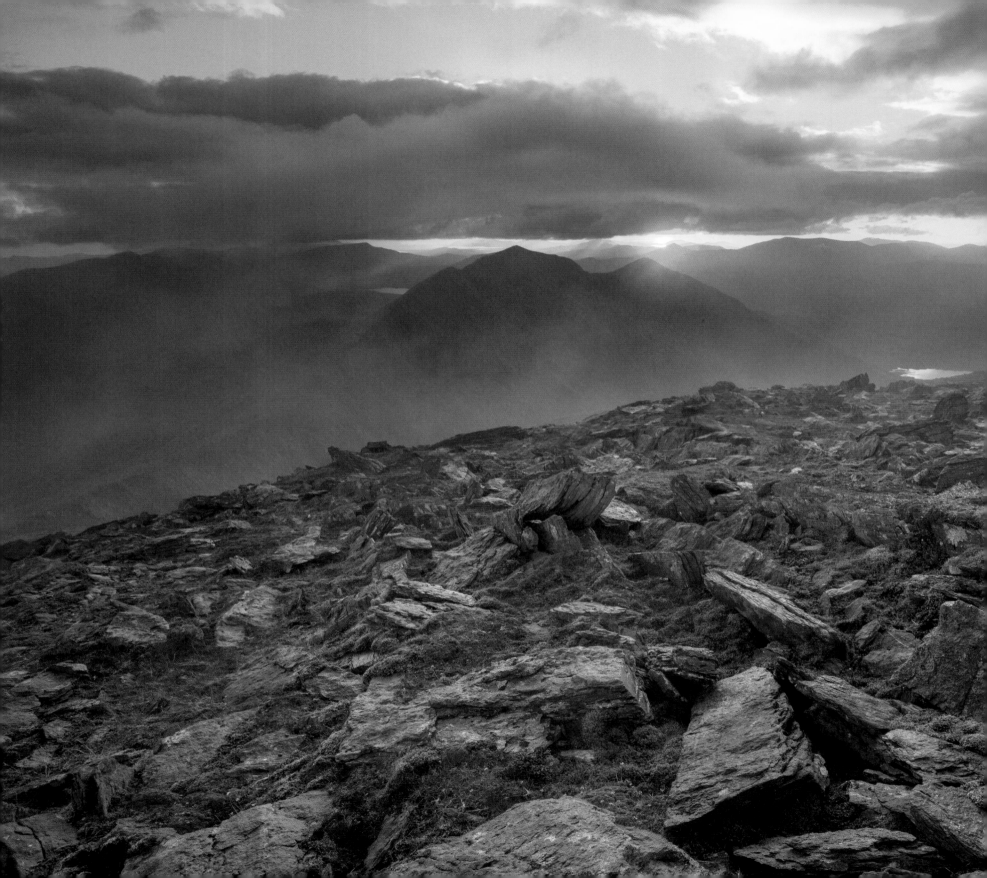

satellite summits of Purple Mountain, Shehy Mountain and Tomies Mountain. There is a dusty asphalt car park, the sharp scent of horse dung, the touting of jarveys, a gridlock of tourism – pony traps, cars, bikes and pedestrians – all climbing the narrow road leading up towards Black Lake and onwards under the shadow of the great valley walls. You can escape from the chaos onto a shy track leading west, switchbacking up Strickeen Hill and onto a broad, rounded shoulder. Ahead lies perhaps the greatest single day of mountain walking in Ireland – the traverse of the Reeks ridge.

From the first major summit Cruach Mhór, a twisting, knife-edged ridge links The Big Gun and Knocknapeasta. This test of nerve and determination serves as a rite of passage to the rest of the walk. Easier ground follows across Maolán Buí and Cnoc an Chuillin and then a descent to the big col beneath Carrauntoohil. Now a grating change of gear, the long ascent through the talus to the roof of Ireland, and the big decision: an easier finish across Caher, or the connoisseur's finish, scrambling over the ridge to Beenkeragh and down over Skregmore.

There are even harder tests in the Reeks for those who wish to seek them out. The north-east face of Carrauntoohil, frowning over Hags Glen, rises more than 600 vertical metres from the floor of the valley. It is seamed with gullies, buttresses, crags, ridges and just about any other topography that can complicate a mountain face. Through it weave lines of weakness, the classic rock-climbing routes Howling Ridge, Pipit Ridge and Primroses, as well as long winter climbs of snow and ice when conditions allow.

Late one September, with a good forecast and a chance to shoot some photographs, I set out from Cronin's Yard under the light of a head torch and the galactic arc turning slowly through the predawn sky, with Hags Glen echoing to a raven's *kraa*, and dawn light bloodying the upper ramparts of Carrauntoohil and Beenkeragh. The stillness of the coom: reflections in Lough Gouragh, the mountainsides mapped and transcribed in inverted perfection.

The first voices in the glen come as a trickle, then a stream of penitents, sometimes confident, purposeful and steadfast, more often halting and unsure – their first time on this mountain, on any mountain. A choice of routes – the Zigzags, the Devil's Ladder, Brother O'Shea's Gully, the Heavenly Gates. I join the line of walkers climbing the rock steps above Lough Gouragh. I pass them out and find a slot of solitude on the trail, scrambling across rough sandstone slabs, picking my way around the shores of Ireland's highest lake, Lough Cummeenoughter. A long, switchback climb through the sliding scree of Brother O'Shea's Gully, then the final effort to the summit cross, a revelation of views unfolding all around.

I settle down in a wind shelter, a rough enclosure of stones just high enough to lie behind. My pack provides some padding, a down jacket some warmth. I deploy a raincoat as a protective blanket. Lying in my makeshift bivouac I feel the warmth of the sun on my

The sun sets behind Caher, as seen from the summit of Carrauntoohil.

face, the tiredness of the ascent rising up through my limbs. Around me I hear the breeze in the rocks, the click of camera shutters, snatches of conversations, the rock-clattering footfalls of walkers arriving and leaving, the dissonant sounds of the summit melding into a hypnotic white noise. I doze off for a while and awake to fine pellets of hail pattering off my face and raincoat.

The afternoon hurries on, replaying now like a time-lapse movie of memories. The crowds make for home, leaving me alone on the summit. The shadows deepen and reach out across the farmlands of the Laune Valley. To the south, ridge upon ridge, the mountains of Iveragh bow like supplicants. The sun comes and goes, blue skies contending with billowing shower clouds, drifting their grey jellyfish tendrils of rain across the mountains. Rainbows materialise and then dissolve, hues change and shift. The sun sinks into the west as I go about my business, camera in hand, attempting to cram this enormity of space and light into a small box of metal, plastic and glass. The sun sets and I delay a little longer, waiting for the earth shadow and the possibilities of the blue hour.

Finally I pack up and begin the descent, skittering down the rocky trail, the rocks already dipped in the muddy blue hues of twilight. Lights twinkle across the lowlands but I always like to see how far I can get before switching on the head torch. On this evening I reach the bottom of the Devil's Ladder. Tired and aching now, the world closes in to the circle of my torchlight, and I stumble back down the track to Cronin's Yard.

A faint rainbow moves along the northern slopes of Beenkeragh, Ireland's second highest mountain. Seen from the summit of Carrauntoohil.

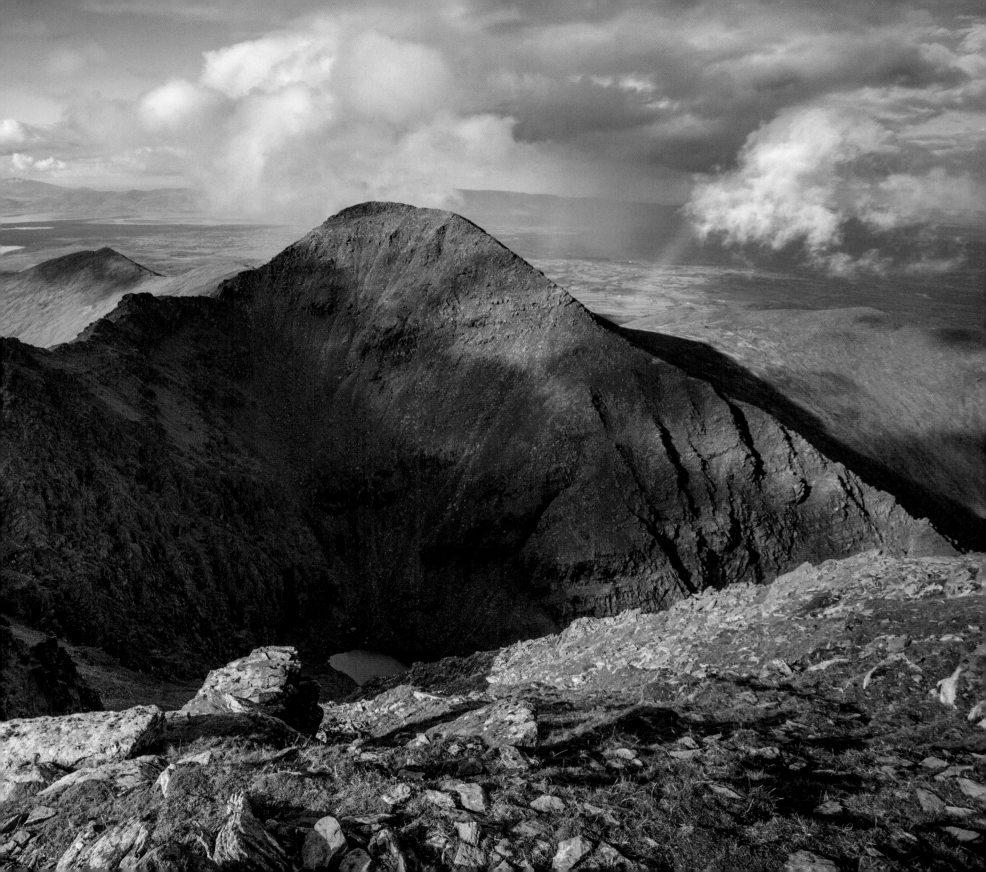

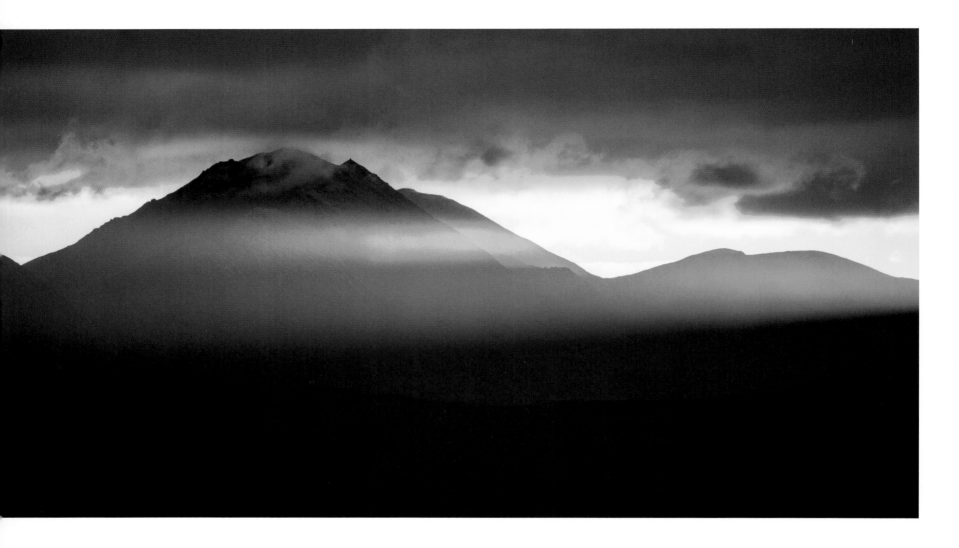

Above: Crepuscular rays over the MacGillycuddy's Reeks.

Opposite: Lough Cummeenoughter is Ireland's highest lake, lying at an altitude of 707m.
The water collects in a hanging valley midway between Carrauntoohil and Beenkeragh.

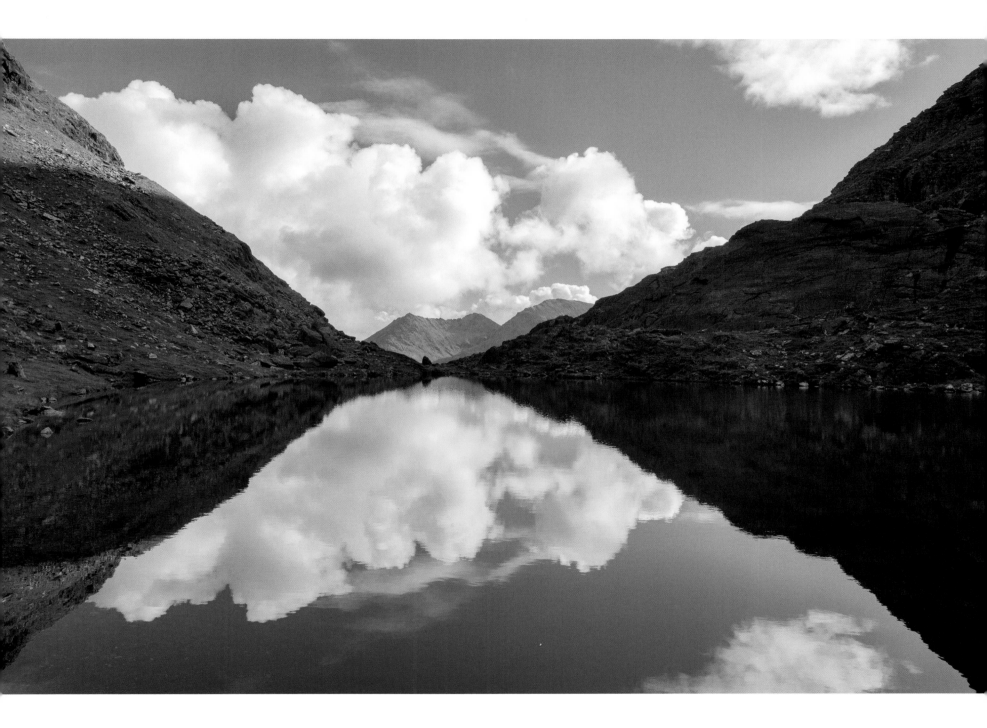

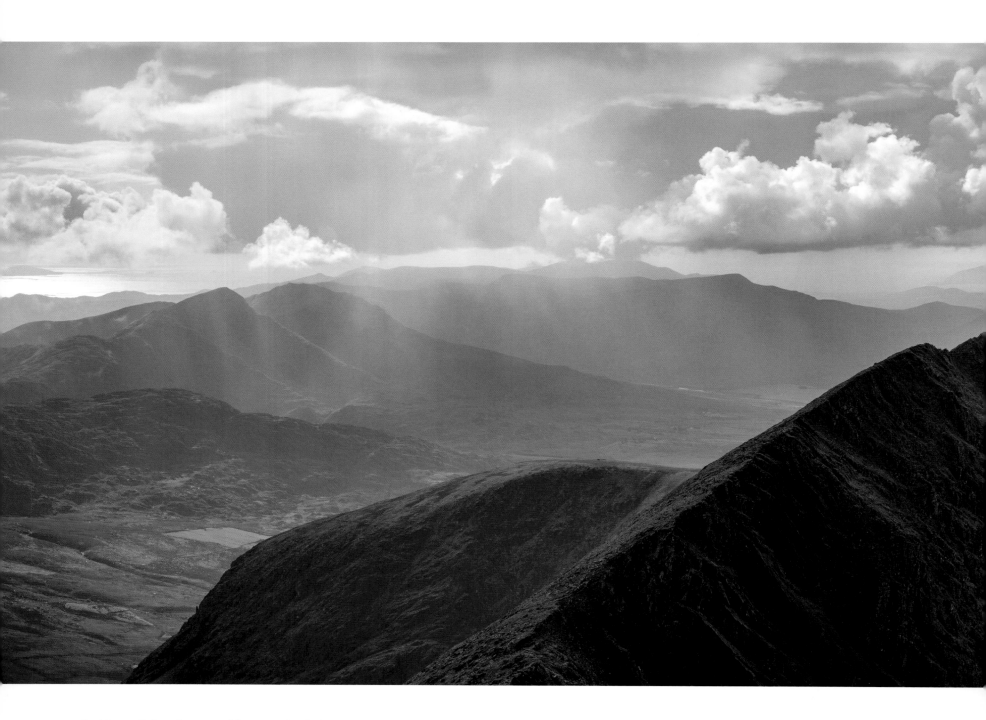

Looking south from Carrauntoohil across Ireland's third highest summit Caher and the Iveragh Peninsula.

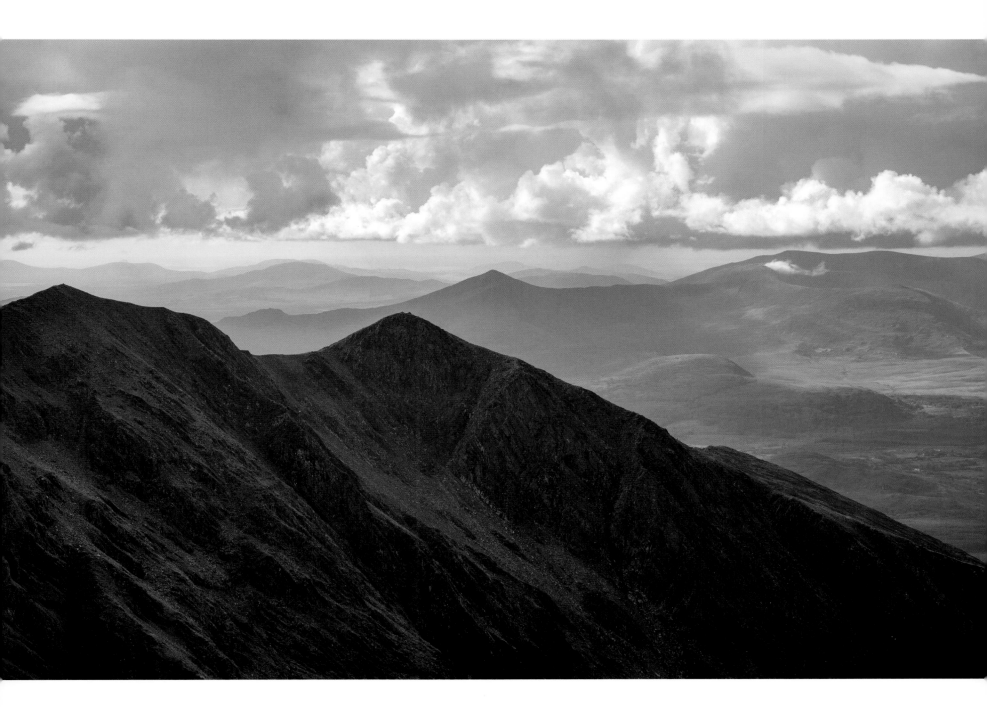

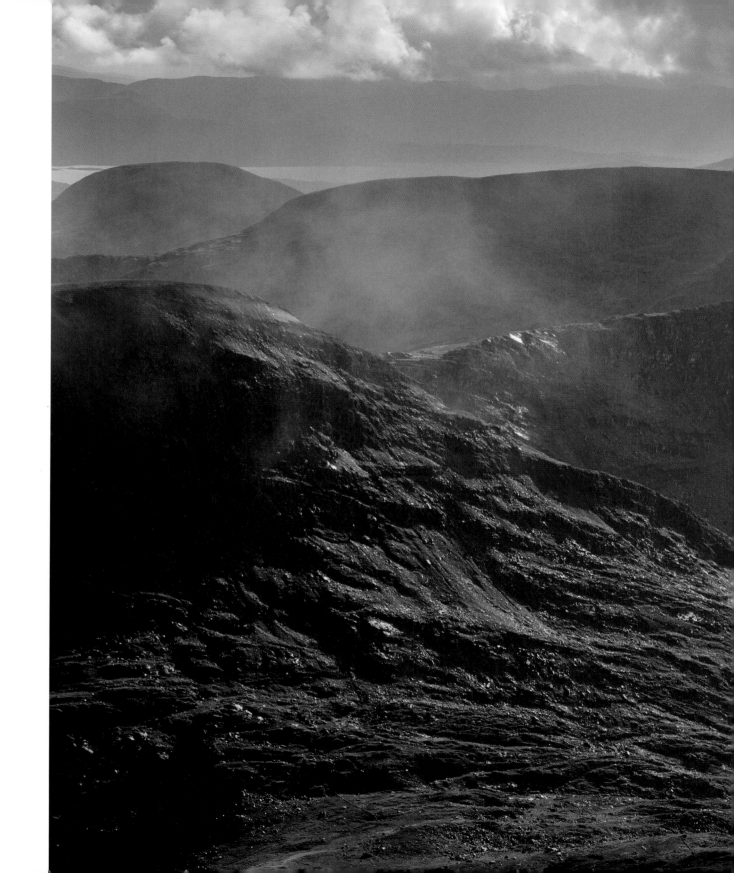

The view south from Carrauntoohil
towards Stumpa Duloigh.

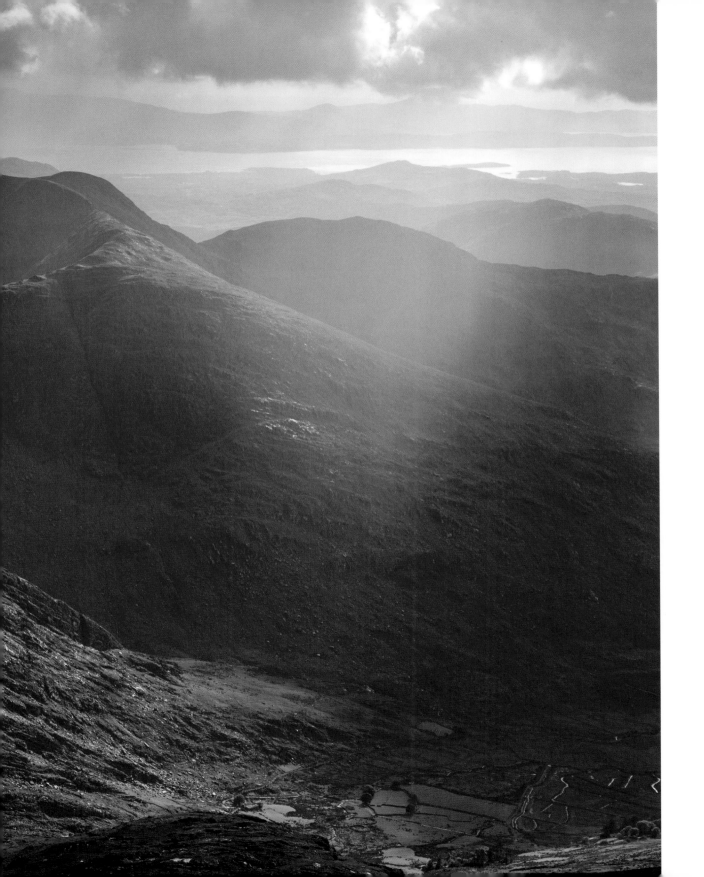

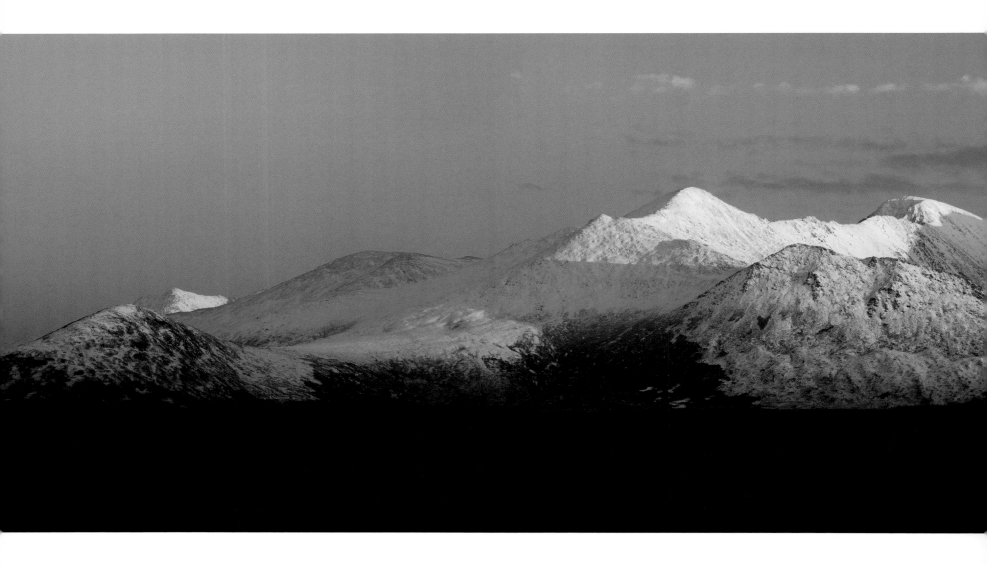

A winter sunset lights the snow-plastered slopes of Ireland's three highest mountains.
From left: Beenkeragh, Carrauntoohil and Caher.

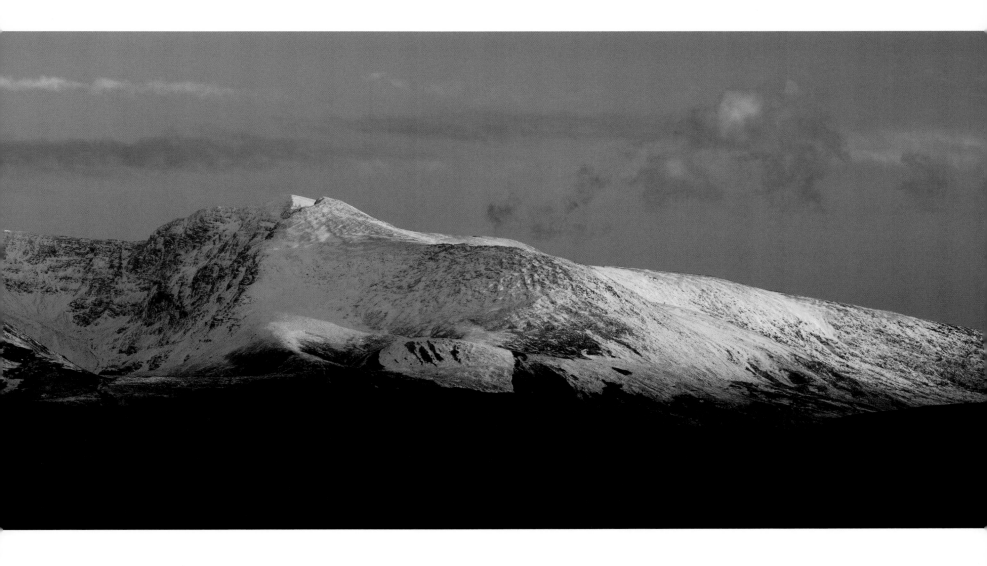

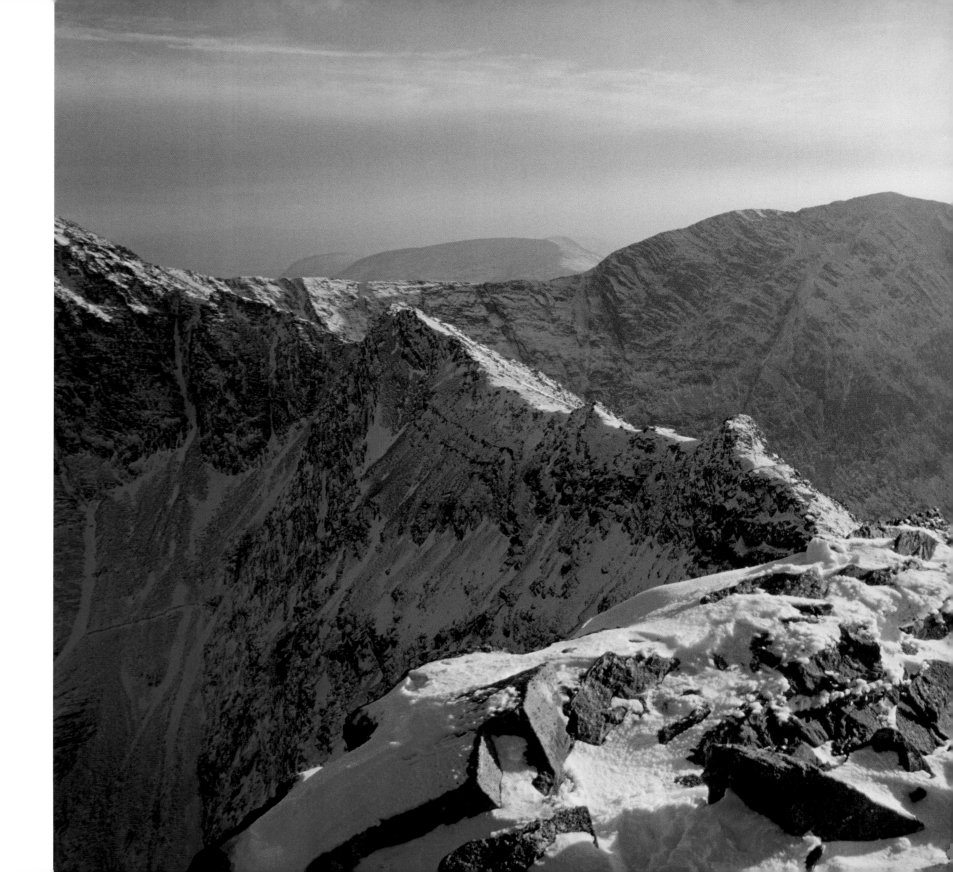

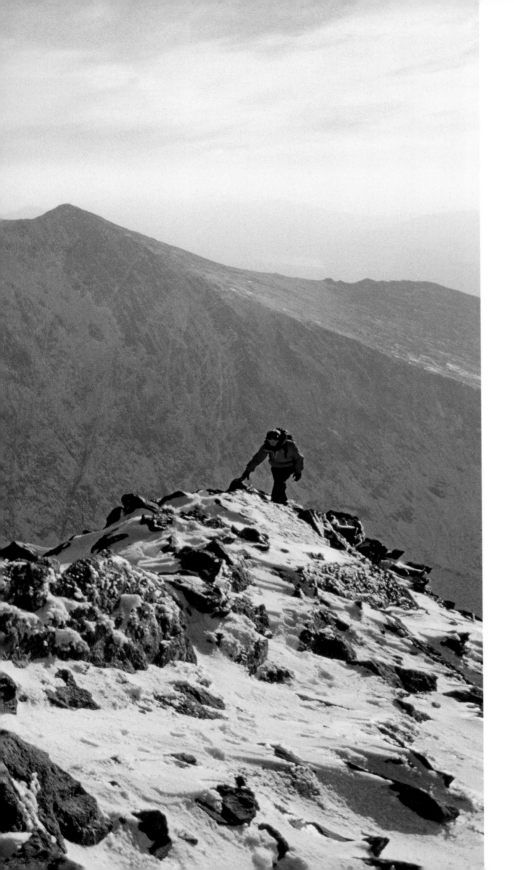

Left: A winter walker tackles the Beenkeragh Ridge, a sharp arête of rock that connects the mountain to Carrauntoohil. Caher lies across the valley. Experienced walkers can visit all three of Ireland's highest summits in a single day as part of a classic route known as the Coomloughra Horseshoe.

Next pages: The Upper Lake in Killarney National Park is always a scenic spot from which to view the Reeks.

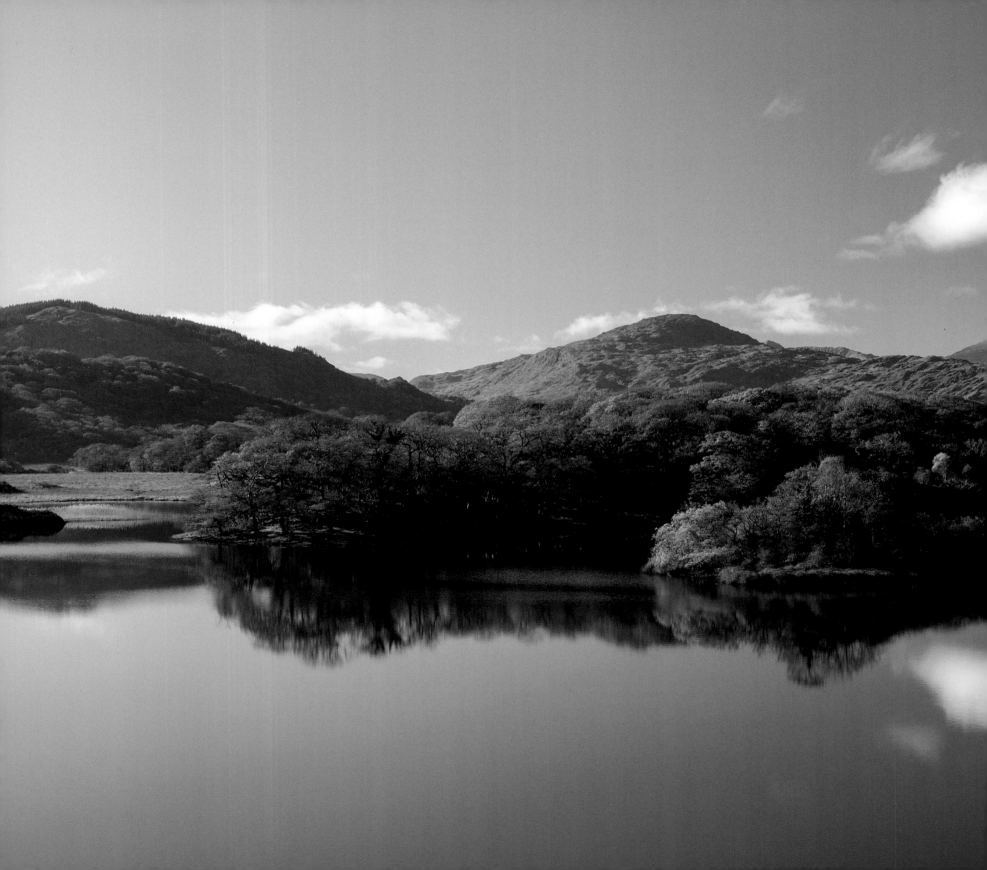

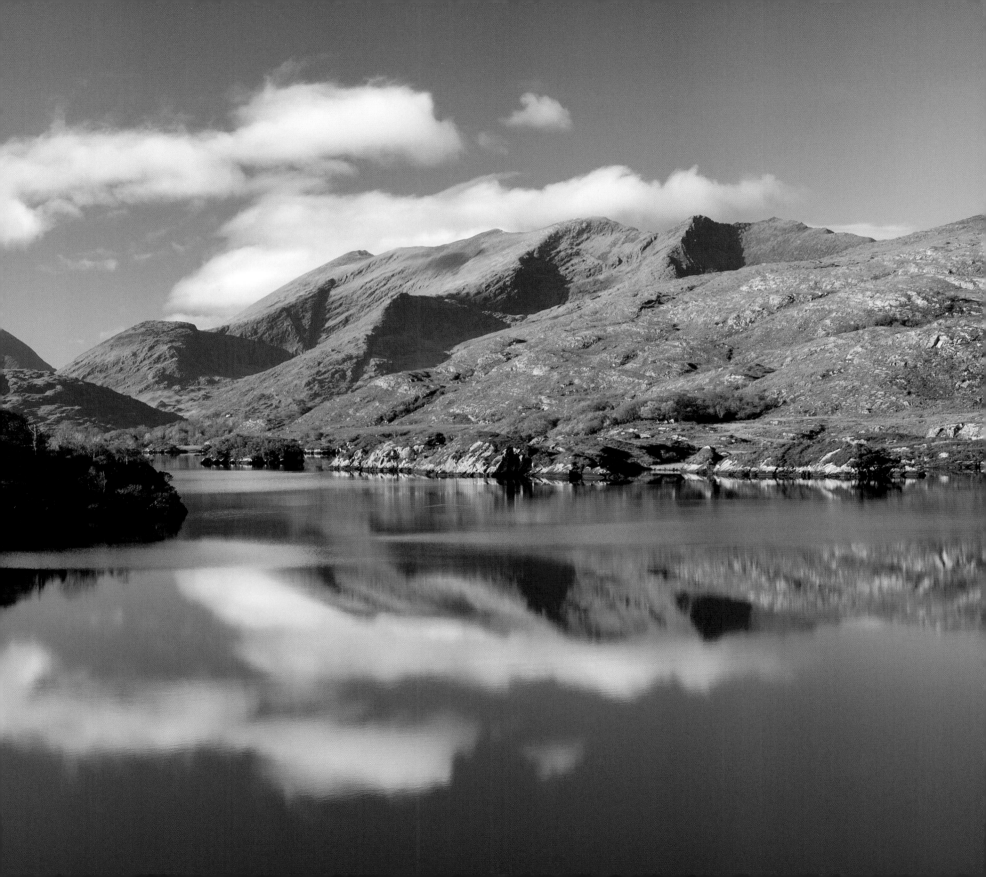

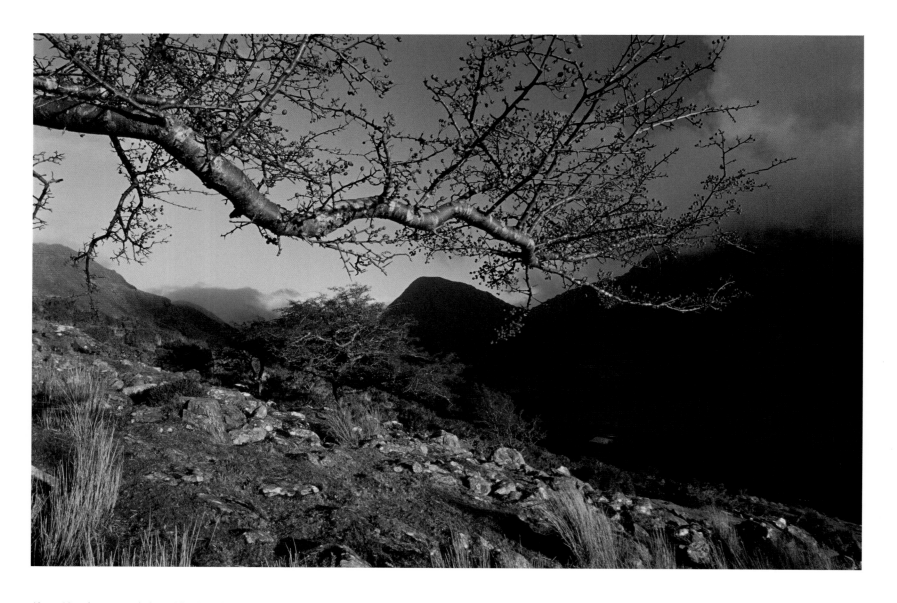

Above: Hawthorn trees laden with winter berries bring colour to the lower slopes of Glencar. The distinctive triangular mountain at the head of the valley is Broaghnabinnia.

Opposite: Reflection of the Gap of Dunloe in the waters of Black Lake, with Purple Mountain on the left and Cnoc na dTarbh on the right.

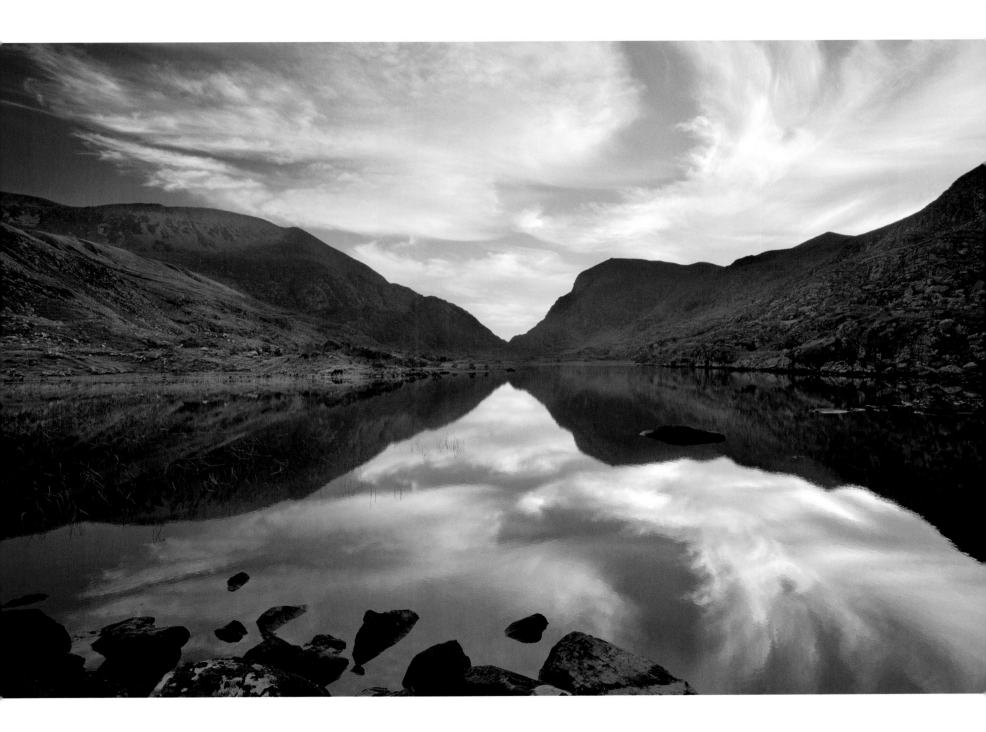

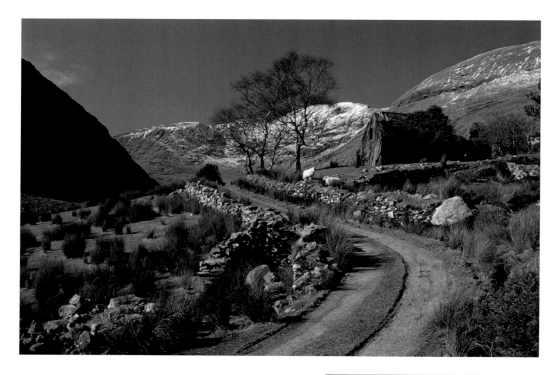

Above: A derelict cottage sits at the head of the Black Valley, with the snow-dusted slopes of Caher rising behind.

Right: Morning mist over Lough Leane and Killarney town. Killarney's proximity to the MacGillycuddy's Reeks makes it a major gateway to the mountains.

Opposite page: Climber high on Howling Ridge on the north-east face of Carrauntoohil.

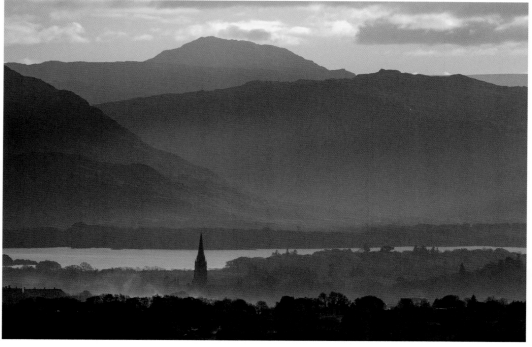

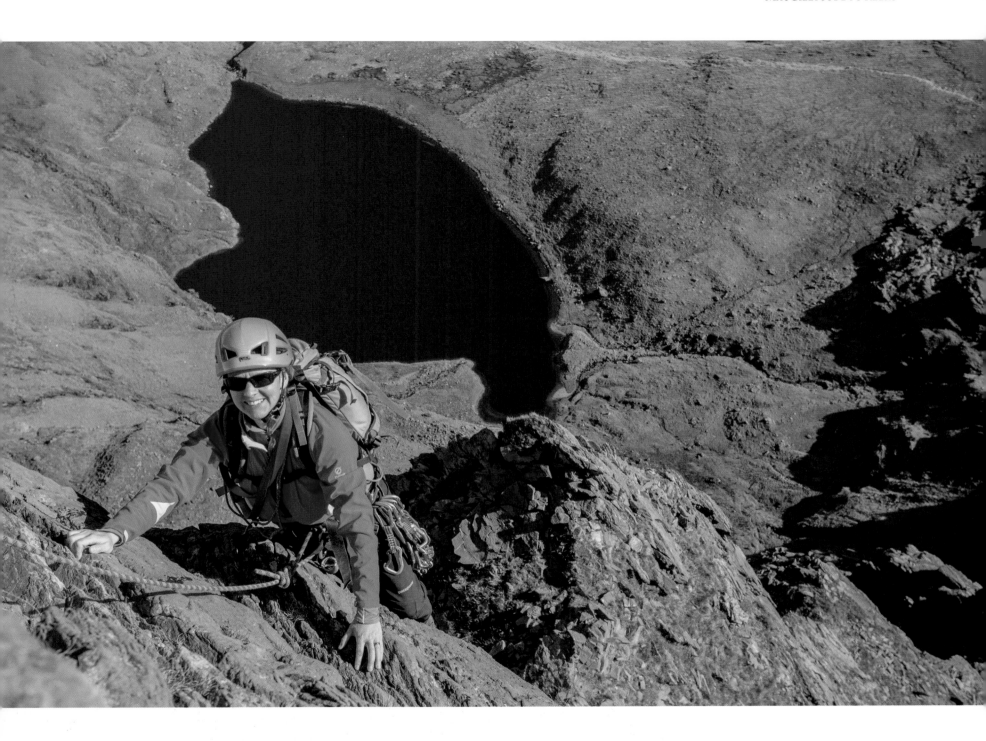

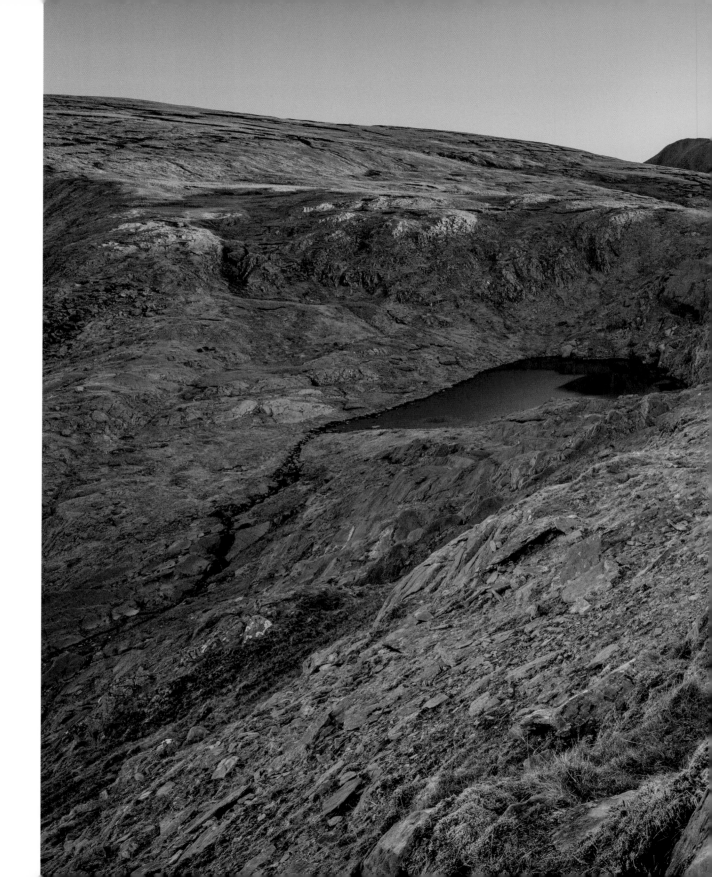

Wildest Iveragh: slabs of sandstone overlook an unnamed corrie lake near the summit of Knockmoyle. The Reeks are just visible in the distance.

Next pages: Morning light on the rugged slopes of Coomcallee in the far south-west of the Iveragh Peninsula.

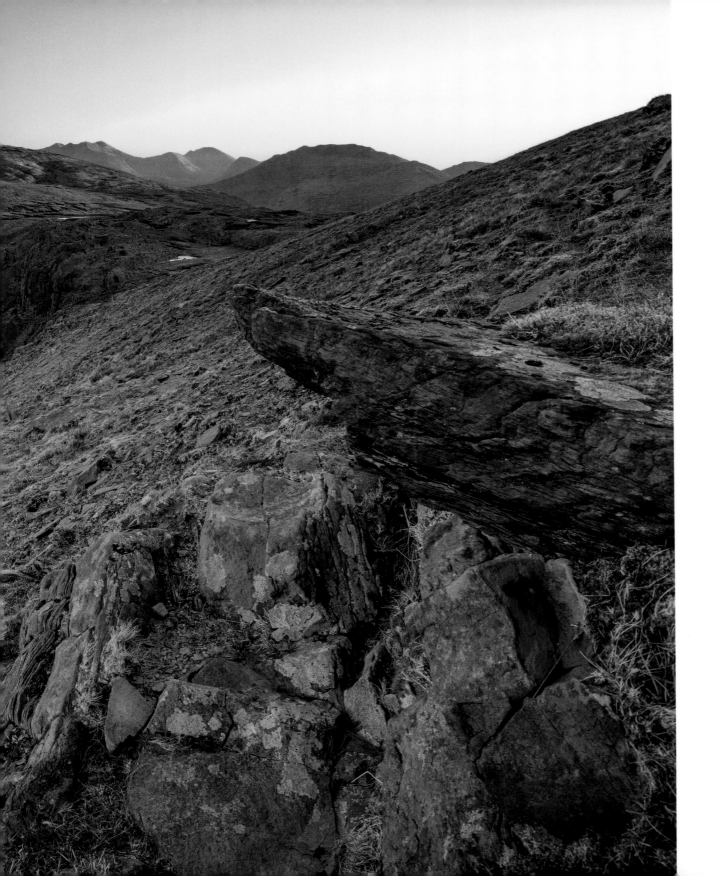

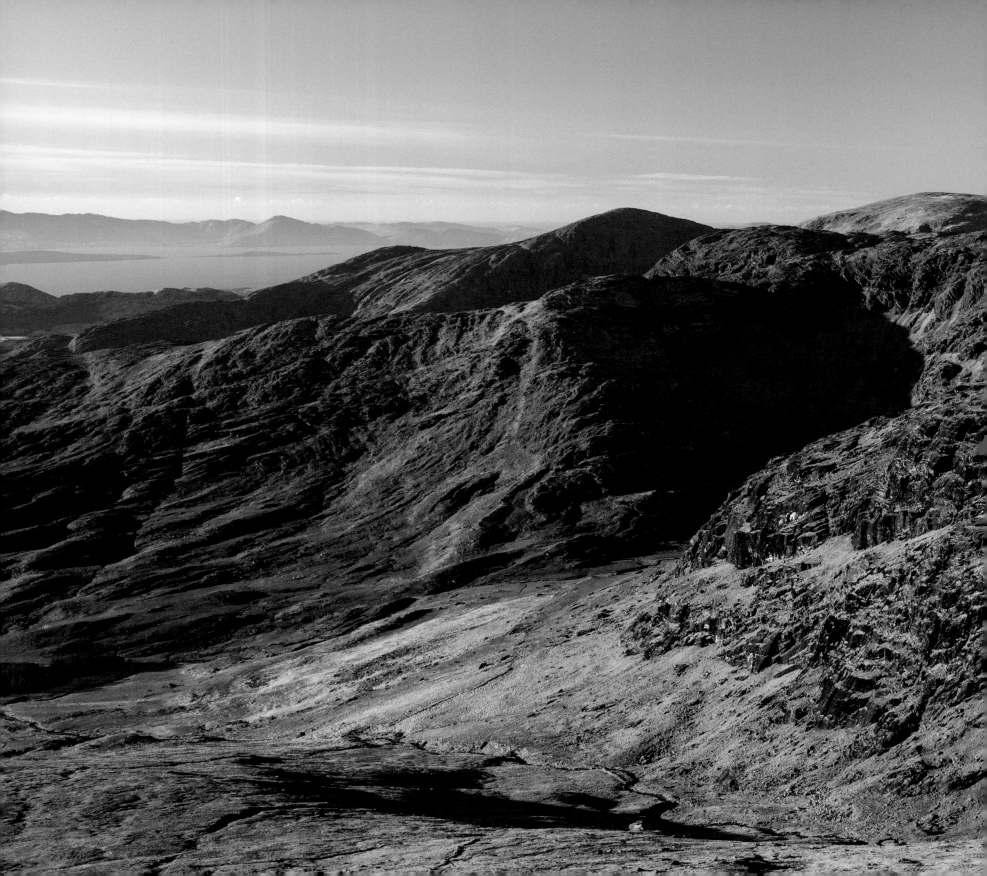

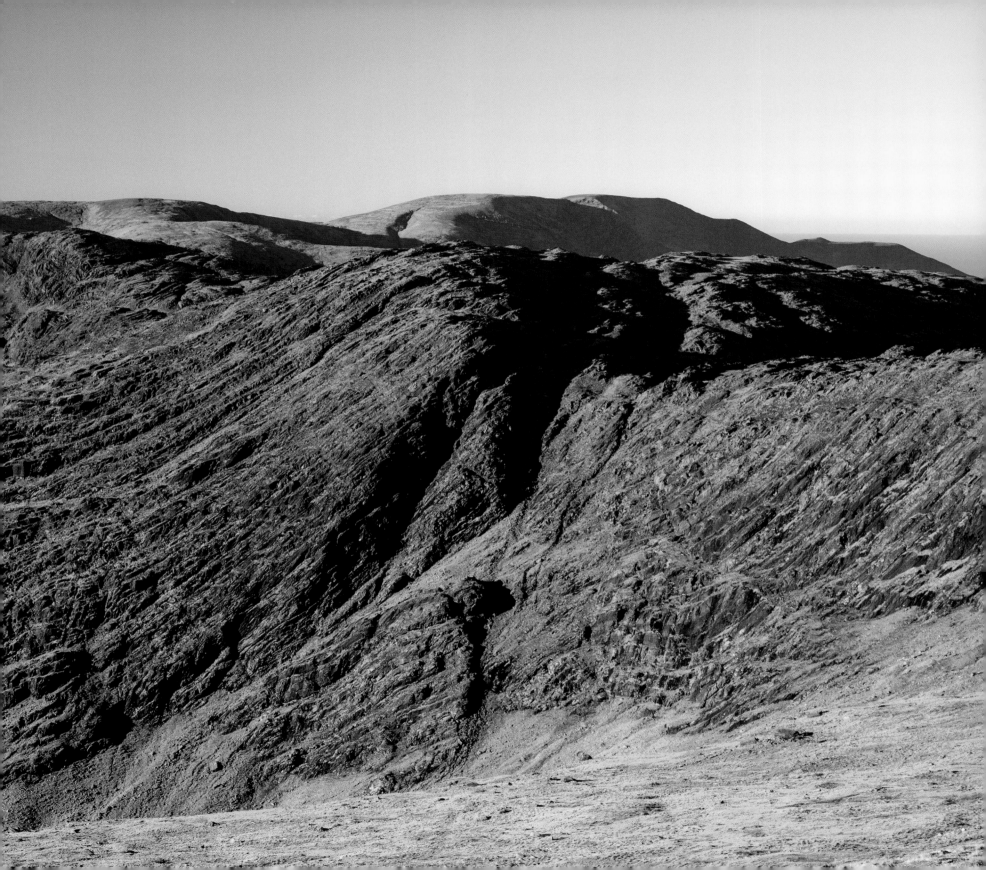

Brandon

A group of men stand together on a high, rocky summit, surrounded by raven-soaring space. Below them stretches a verdant peninsula – cliff-ringed and surrounded by a vast, troubled ocean. Their woollen clothing blows raggedly in the piercing wind. They gather around one man, drawn to his powerful, singular aesthetic, looking west, always west, beyond the map of the known world. What lies beyond the vast blue horizon, they wonder – *Tír na nÓg*, the Land of Paradise, the Promised Land of the Saints – or just cold, fear and a lonely death?

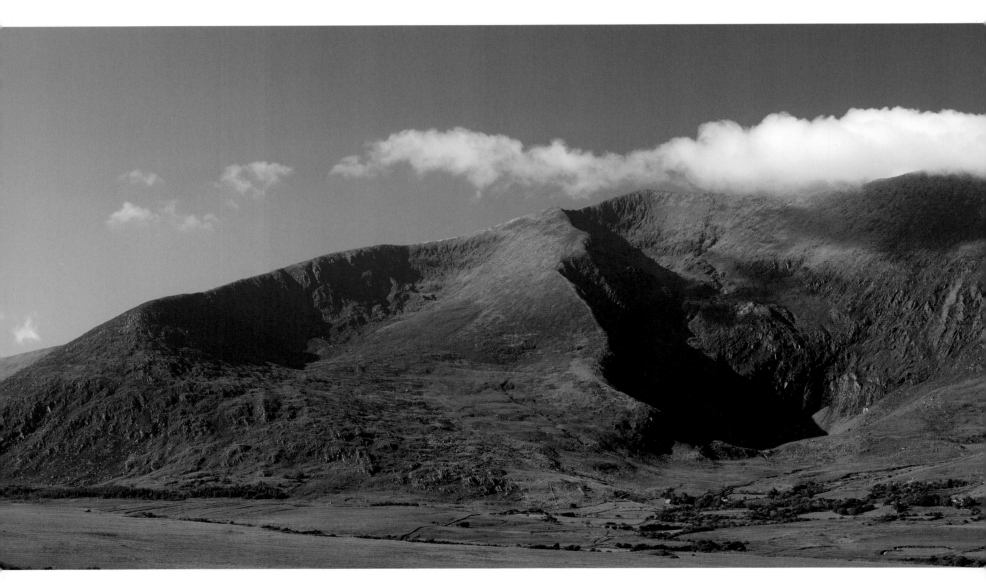

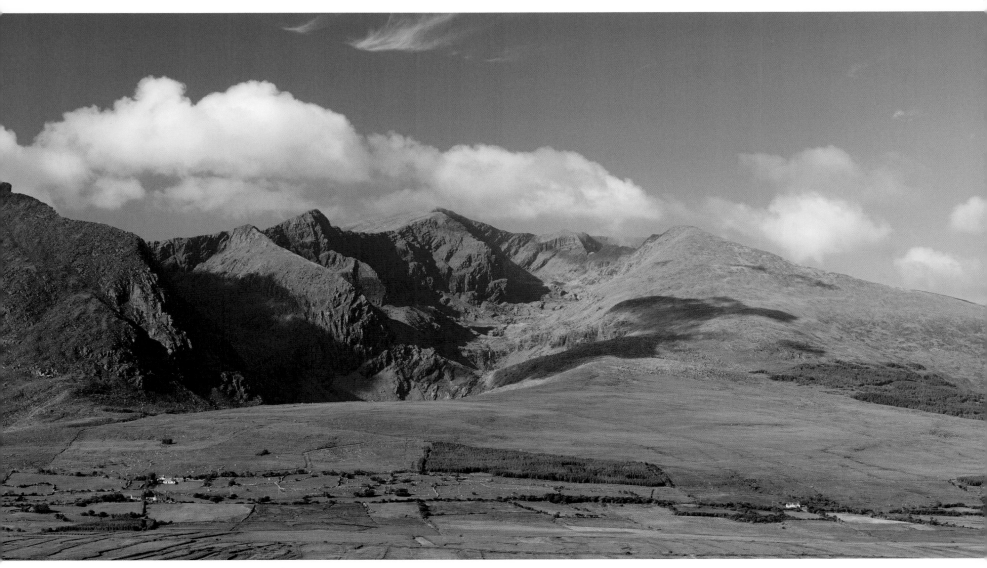

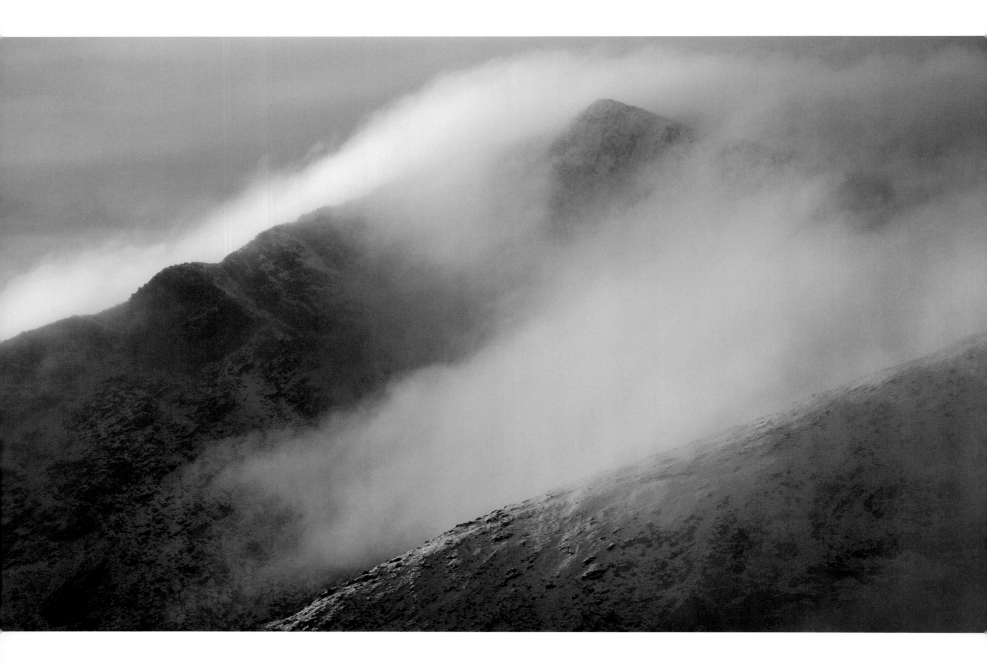

Ephemeral beauty: Brandon Peak just visible through banks of early-morning mist.

Previous pages: Panorama of the Brandon massif, showing all the corries that cut into the eastern side of the range.
The summit of Brandon itself is on the right of picture.

I find it easy to picture St Brendan looking out from Brandon Mountain in preparation for his legendary navigation across the Atlantic in the sixth century. A flight of the imagination perhaps, but it seems certain that he would have stood on Brandon's summit at some point. The hardships involved would have appealed to his monkish sensibilities, and accounts of his life say he spent three days on the summit and was visited by an angel. It is known that the mountain, which now bears Brendan's name, was an important site of ritual in pre-Christian times, a significance adopted by the Church and perpetuated in a traditional pilgrimage to the mountain's summit along the *Cosán na Naomh* ('The Saint's Road').

At 952m high, Brandon is the culmination of a long spine of sandstone mountains that runs the length of the Dingle Peninsula, Ireland's most westerly finger of land. This mountain chain also includes the Slieve Mish Mountains, whose highest summit is Baurtregaum (851m), and several other notable peaks such as Stradbally Mountain, Beenoskee and Slievanea. Despite their individual merit, these peaks live in the shadow of Brandon. Outside the MacGillycuddy's Reeks it is Ireland's highest and most spectacular mountain massif.

The massif itself is comprised of several summits, linked by a high and often narrow ridge almost 8km long. It runs north to south, from Masatiompan whose northern flanks fall precipitously into the Atlantic, to Gearhane (*An Géarán:* 'The Fang'). For much of this distance the eastern flanks of the massif have been eaten away by glaciation into a series of enormous corries and spectacular black crags.

Immediately below the summit of Brandon, a trio of tarns pool amidst a wilderness of sandstone slabs and boulders. Little outlet streams find their way down to a second tier of loughs, which spill in turn into a series of successively lower and larger lakes like a string of beads on a thread. These 'paternoster' lakes are an indelible footprint of glaciation, and in the Irish mountains, in particular on Brandon, we have some of the finest examples in the world.

Brandon's proximity to the coast forces moisture-laden oceanic air to rise abruptly, condensing into a pall of cloud that can hang over the summit for days on end. Getting a fine, clear day on Brandon can often feel like the holy grail of Irish walking, but it is a quest worth pursuing. Is there a finer view of the Irish coast than that from the top of Brandon, looking across the tip of the Dingle Peninsula – the patchwork fields, the wave-worried headlands of Ballydavid and the Three Sisters, and the defiant Blaskets rising from the Atlantic? The human landscape of Ireland must have changed beyond recognition from early Christian times, but it remains a vision of such grandeur and beauty that surely Brendan and his acolytes would still approve.

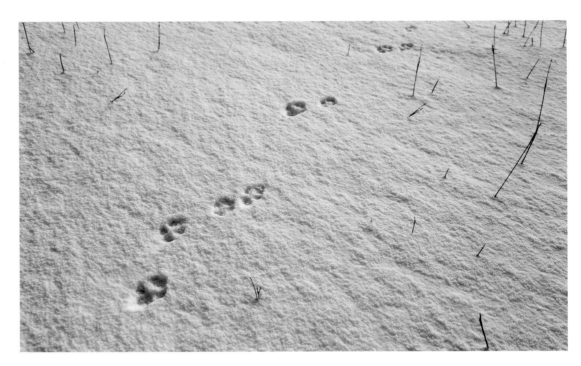

Where wild things roam. Fox footprints cross the snow high on the mountain.

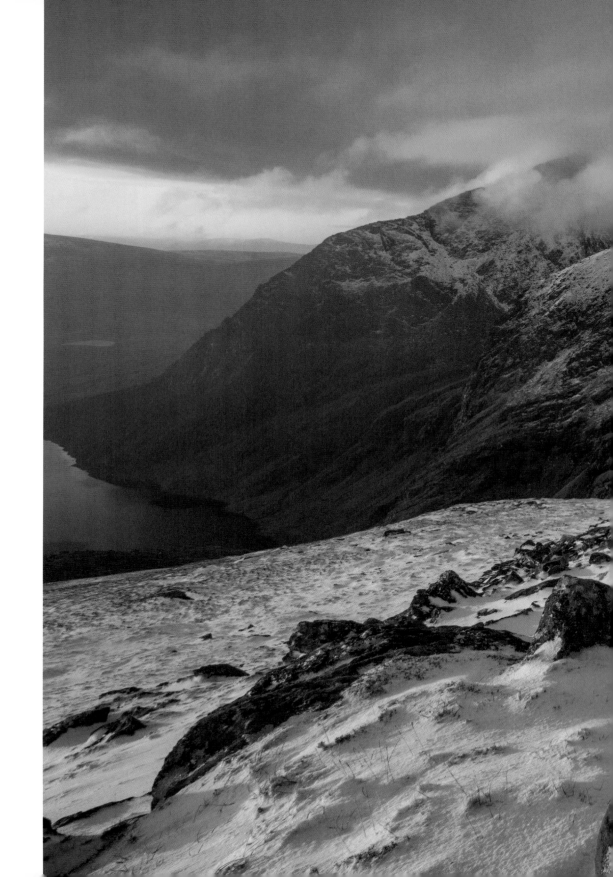

Winter sunrise over Brandon Peak. The lake at the base of the mountain is Loch Cruite, the largest of the paternoster lakes that spill down through the corries below the summit.

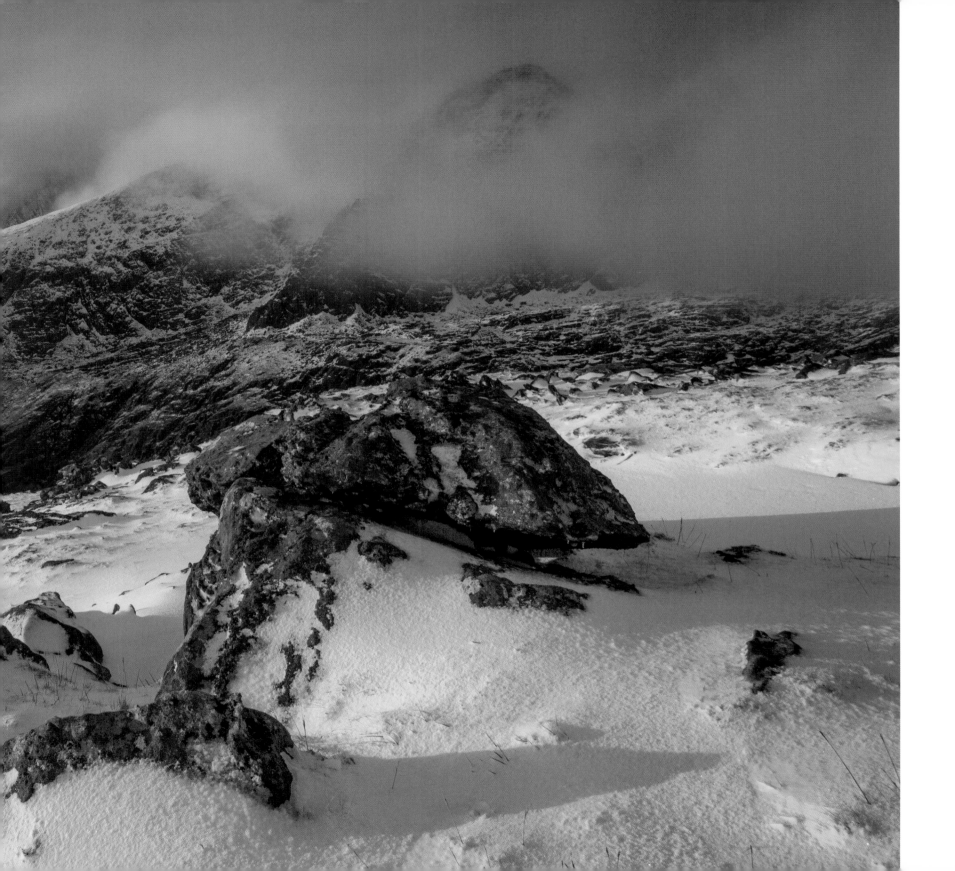

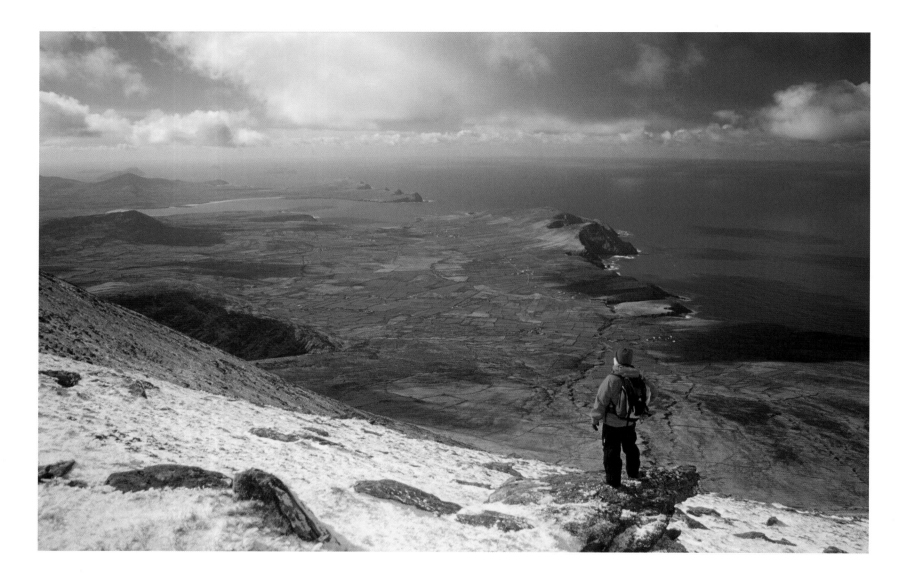

A walker enjoying the spectacular coastal view west of Mount Brandon, undoubtedly one of the finest to be seen from any mountain in Ireland.

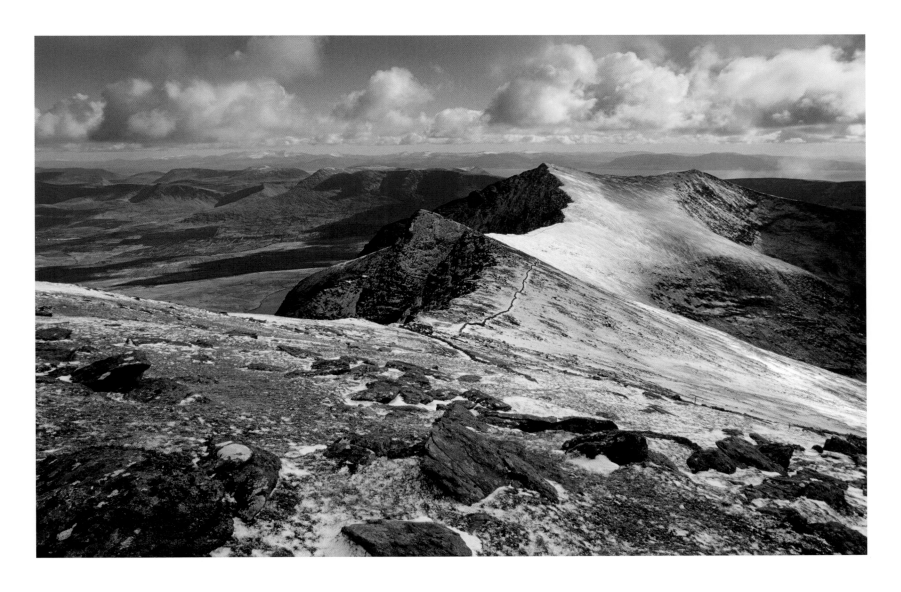

A wintery Brandon Ridge stretching south towards Gearhane.

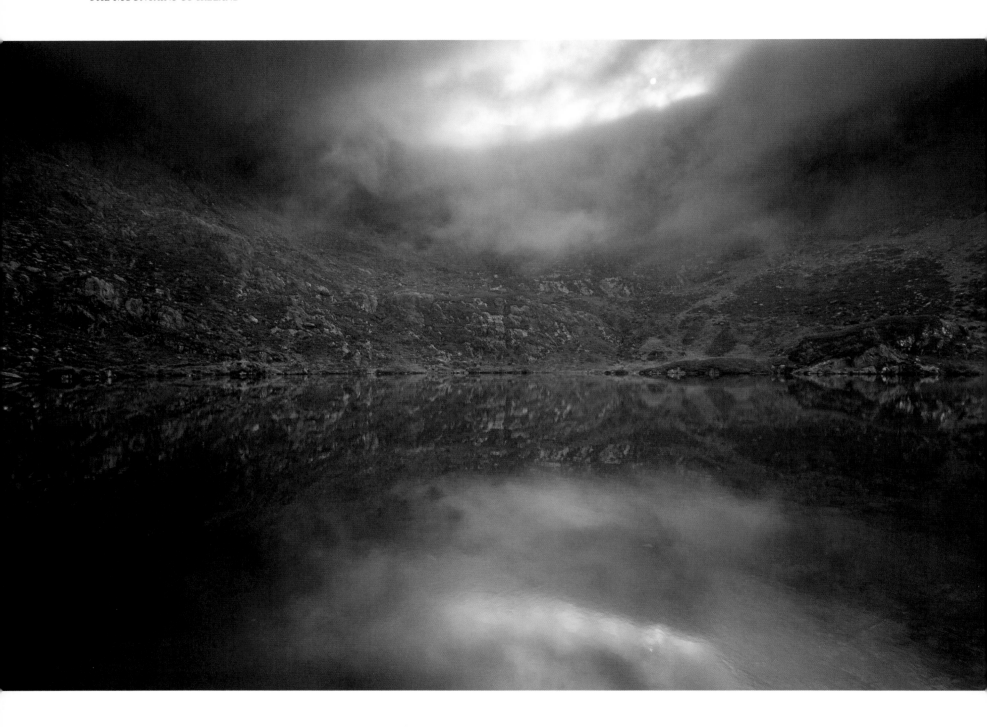

Mountain mists create a mystical atmosphere at Lough Doon, beneath Slievanea.

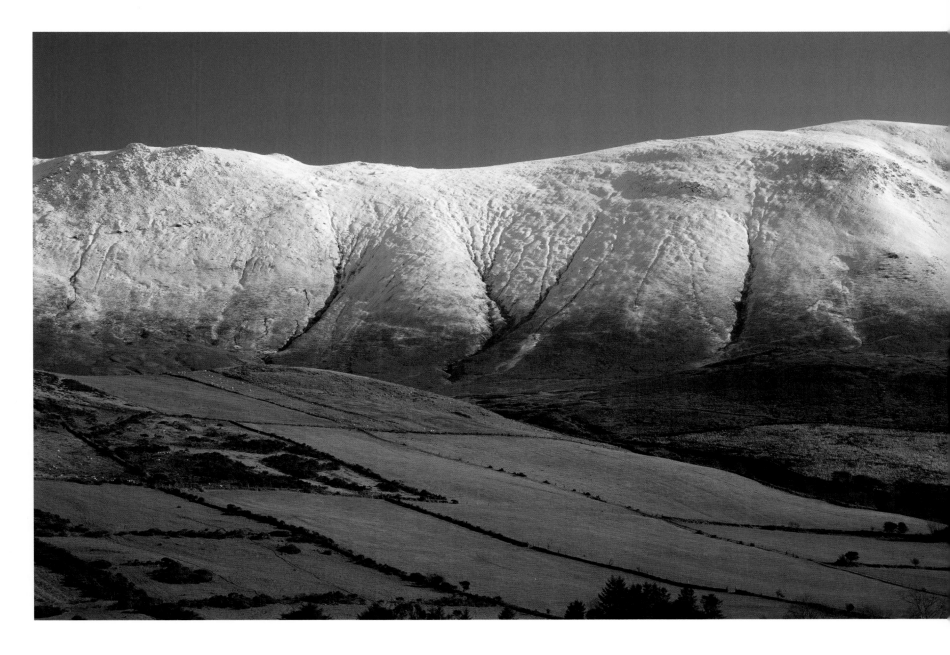

Green and white: fertility still glows from the lower slopes of Caherconree, in the Slieve Mish Mountains, despite the wintery blanket that cloaks the summit.

Beara

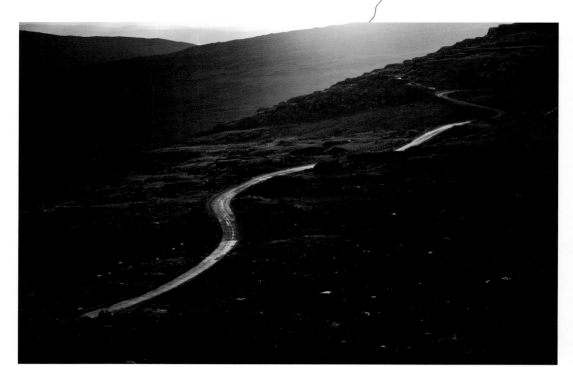

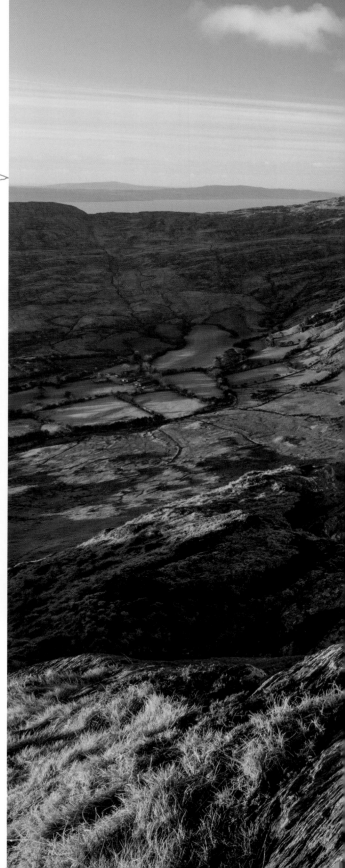

Above: A ribbon of modernity cuts across ancient hillsides. The twisting road that climbs to the Healy Pass, on the Beara Peninsula.

Right: Coomgira and Hungry Hill, the highest summit in Beara's Caha Mountains.

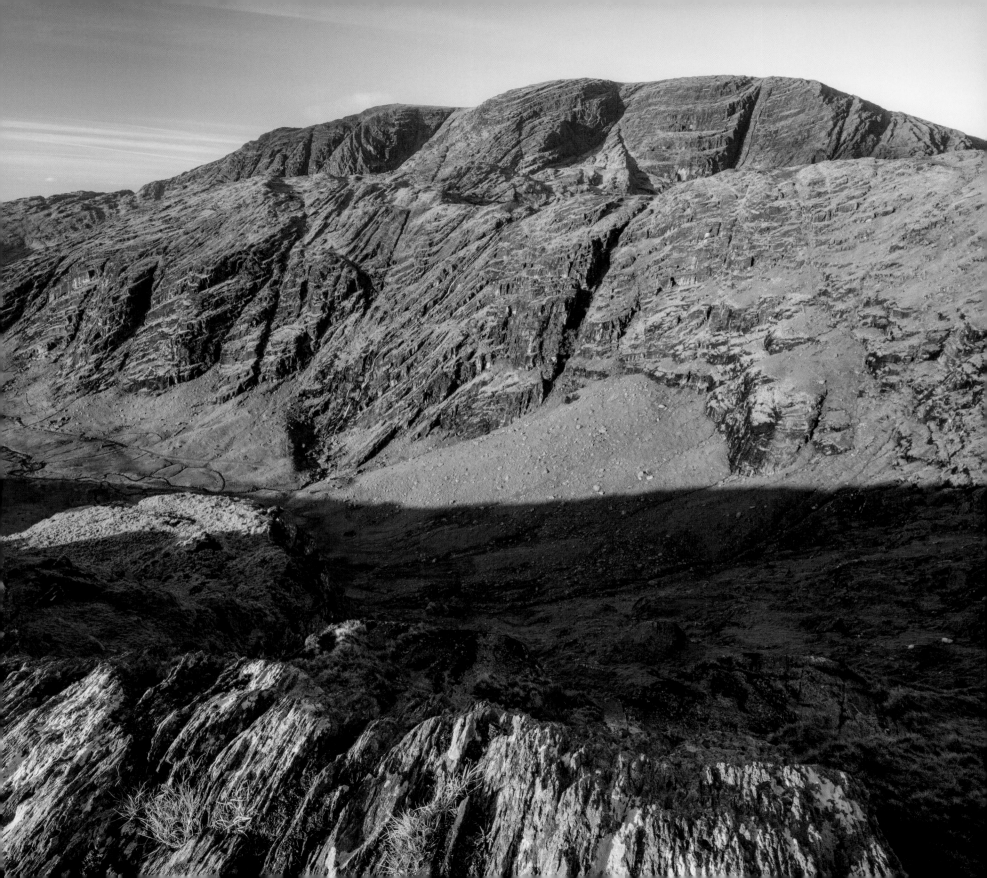

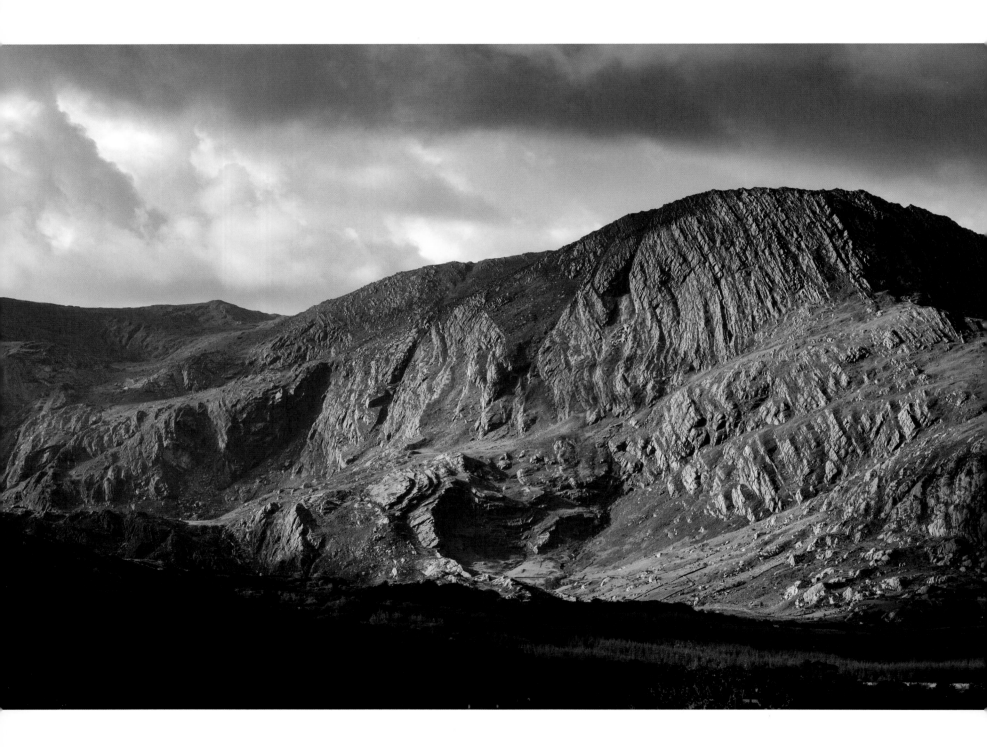

Left: Bones of the mountains laid bare: folded and twisted beds of sandstone rock on Coomacloghane Mountain, on the Beara Peninsula.

Right: Mountain life: a remote farm clings to the slopes of the Glanmore Valley, on the Beara Peninsula.

Next pages: The day's first rays of sunlight hit Hungry Hill, high above Coomgira on the Beara Peninsula.

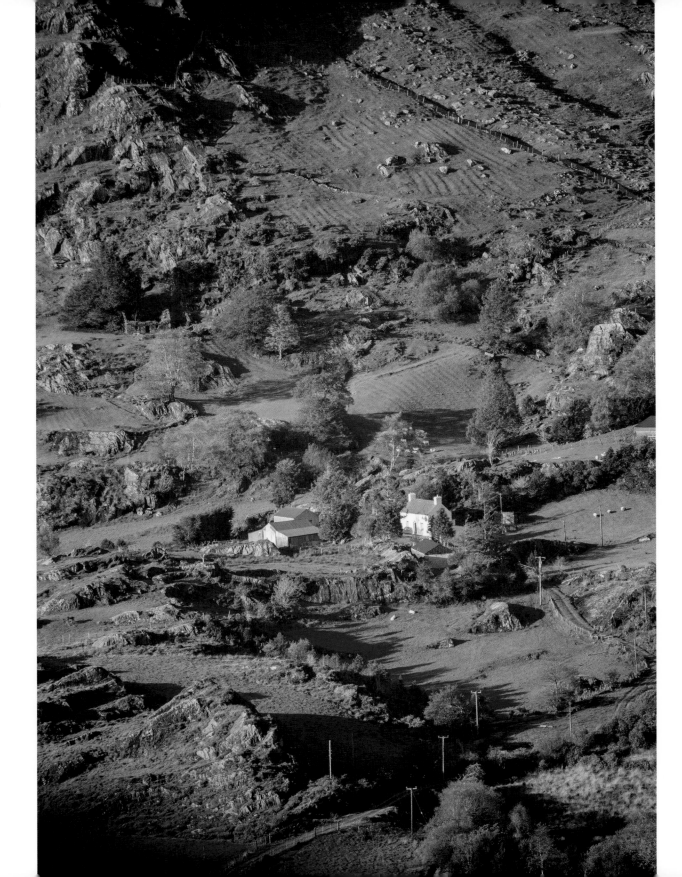

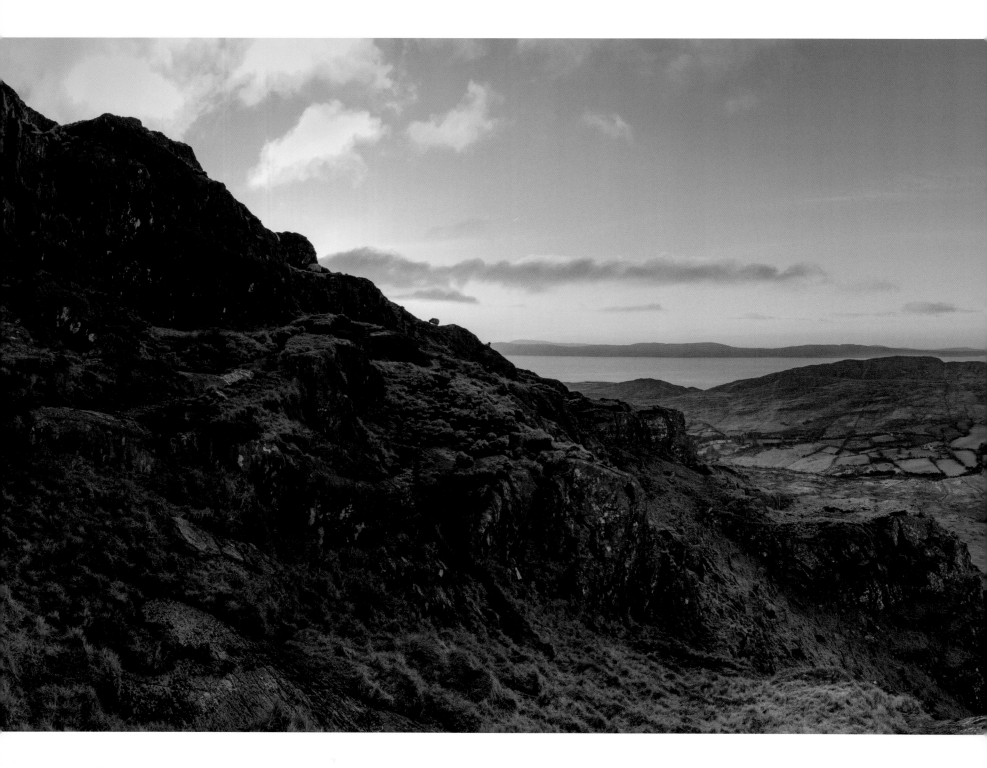

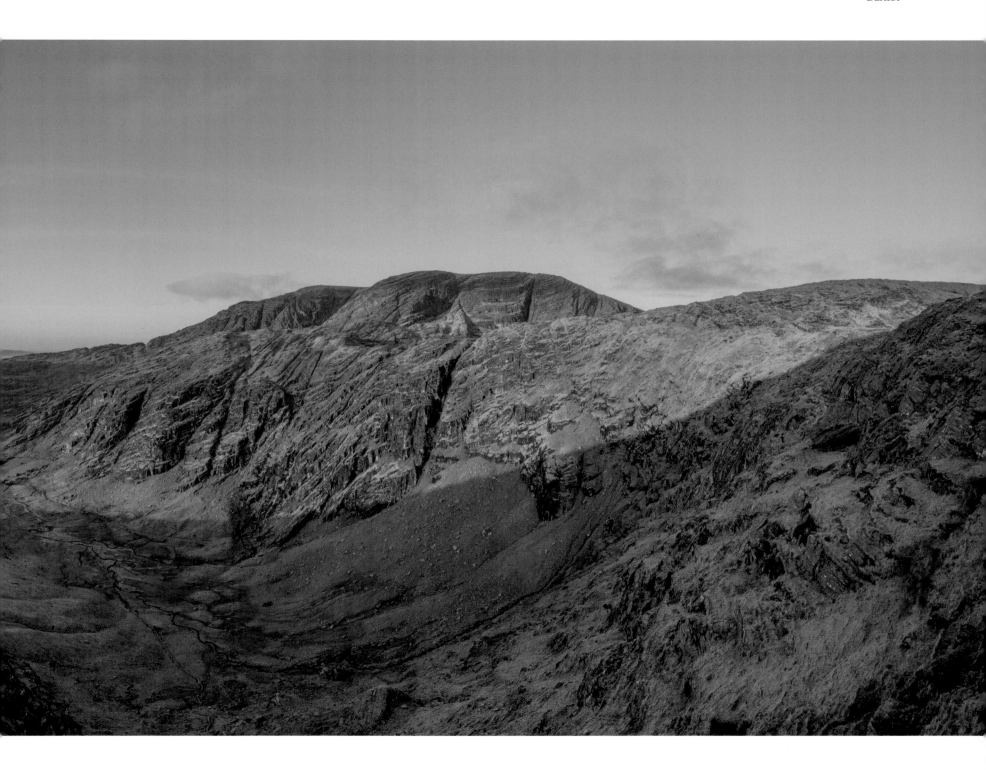

The Galtees

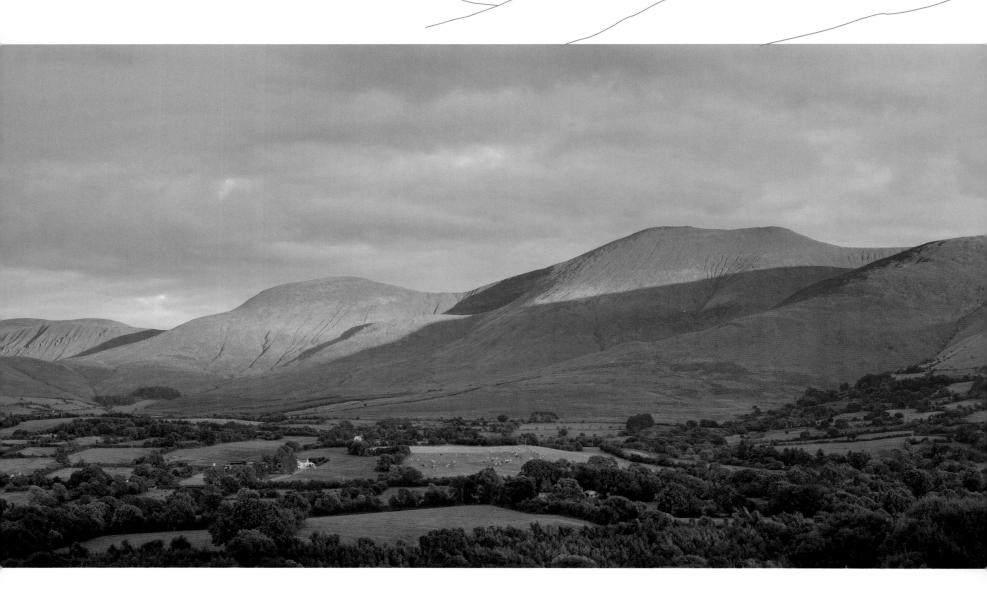

Evening panorama of the Galtee Mountains. The highest peak in the range – Galtymore – rises to 917m and is the fourteenth highest summit in Ireland. It lies just left of centre in the photo.

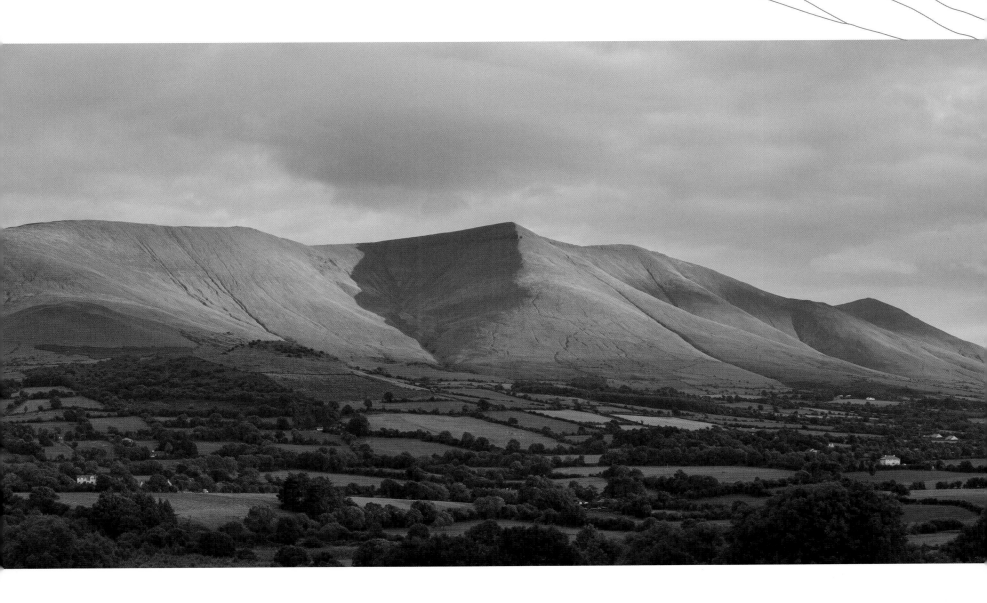

Left: Common Butterwort is one of Ireland's native mountain flowers. Behind its delicate beauty lurks a darker purpose: it is carnivorous, trapping and absorbing insects through its sticky leaves.

Right: Rising ridges: evening light on the lower slopes of the Galtee Mountains, in County Tipperary.

Next pages: Verdant farmland beneath the Galtee Mountains, as seen from the south.

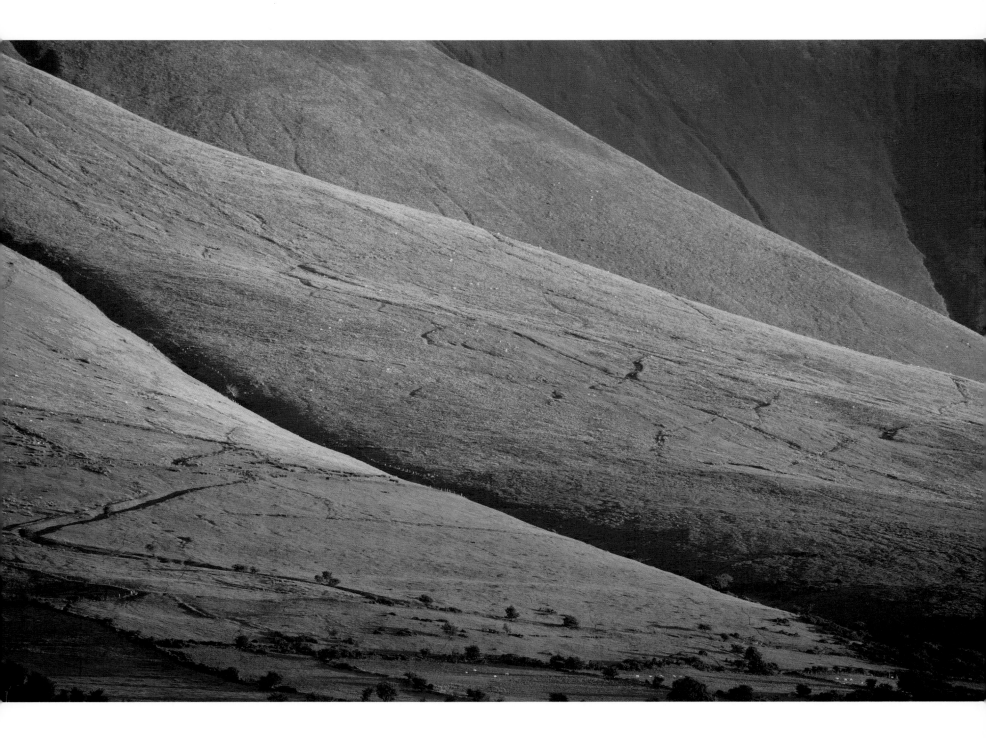

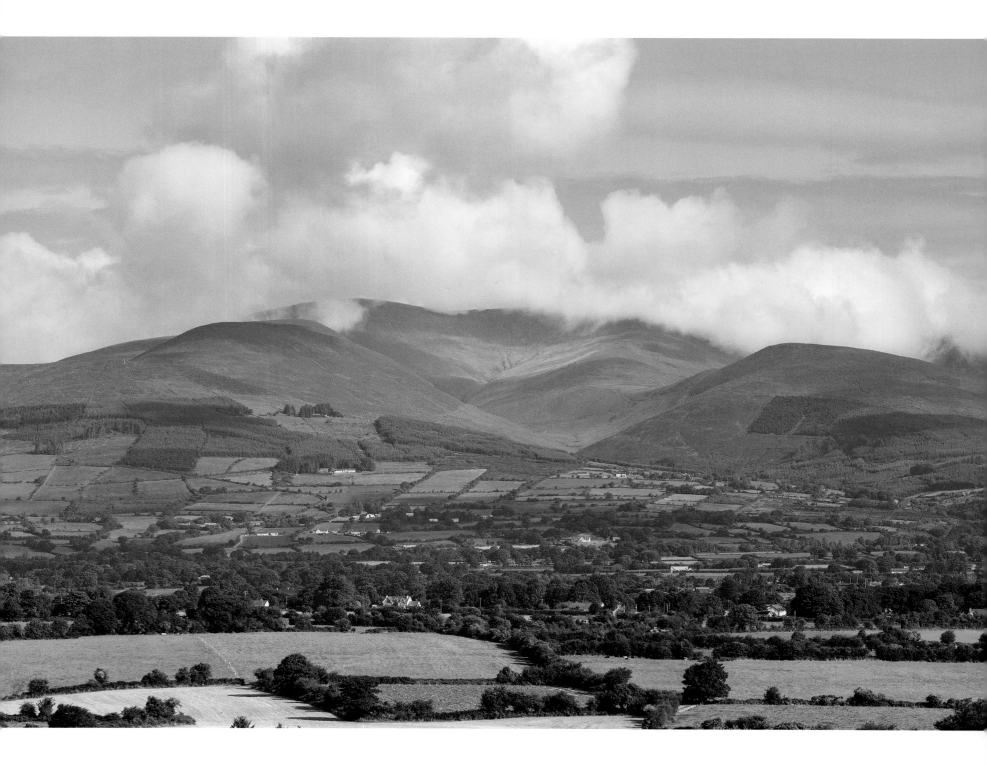

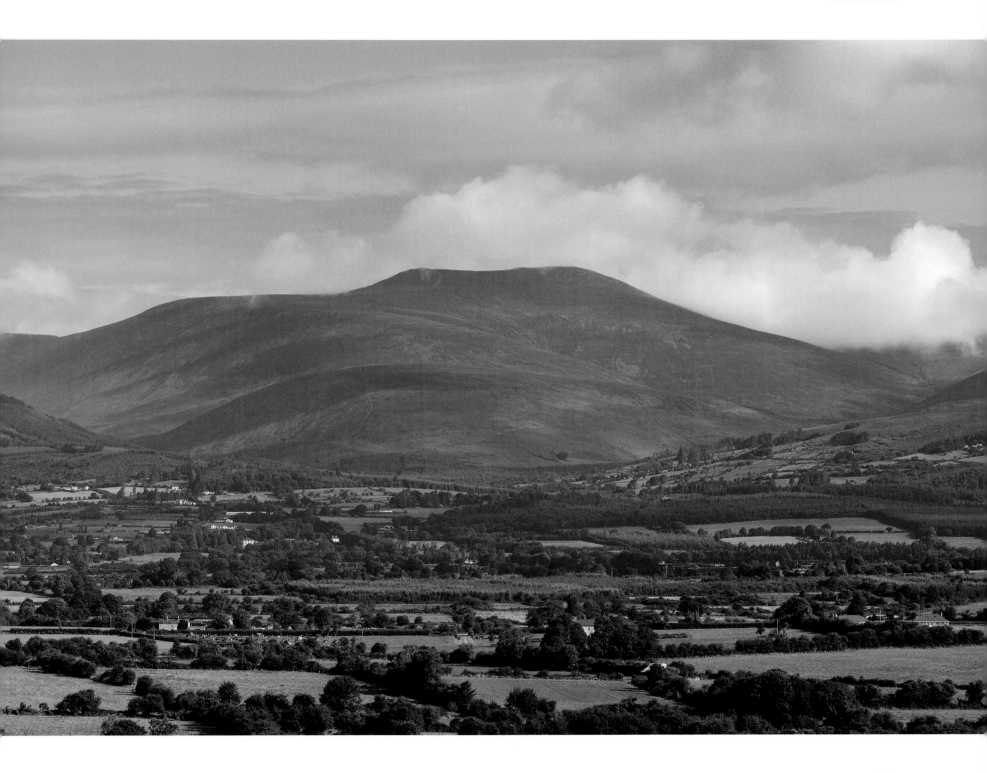

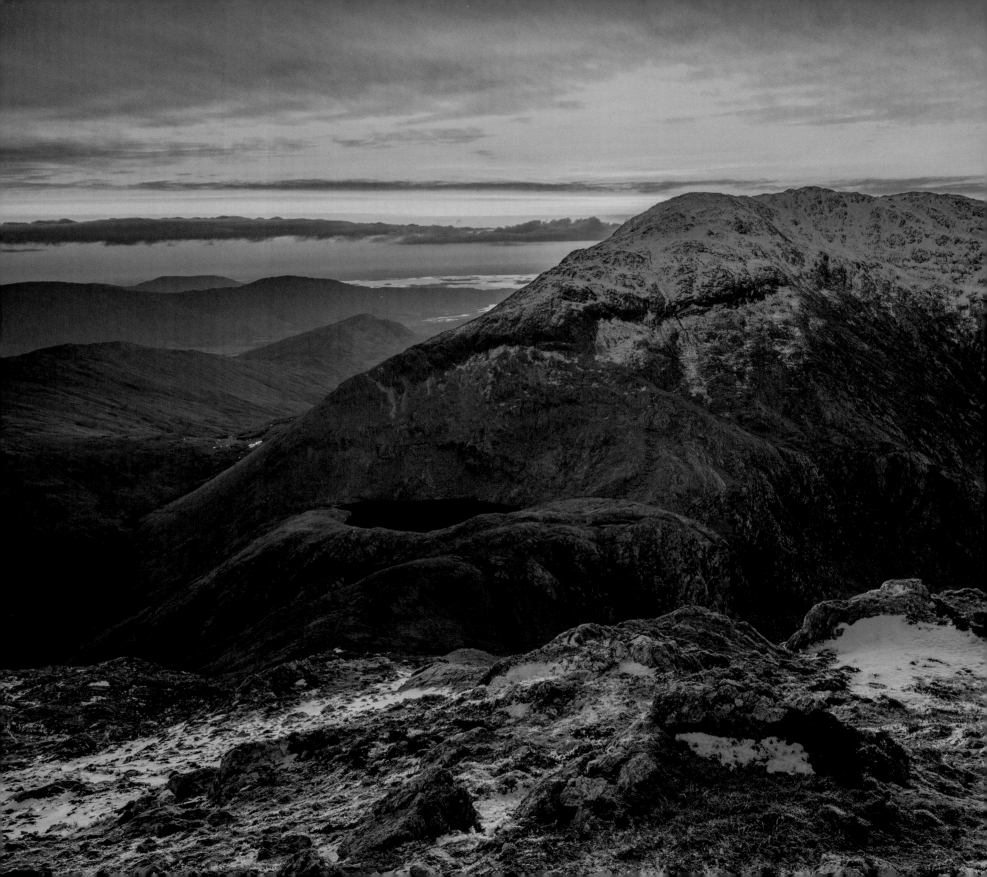

CONNACHT

Connemara

Nowhere in the collective imagination is there a landscape so redolent of old Ireland: the thatched and whitewashed cottage, the stacks of turf, a sweep of bogland beneath brooding grey mountains, the plaintive cry of the curlew on the seaweedy shore, a curragh pulled up on a white-sand beach. But as in the rest of Ireland, the modern world encroaches, and today, although the canvas of mountain, moor and coast is much as it ever was, our brushstrokes upon it have not been so sympathetic. Today you can still find vignettes of the romantic past, but this picture is fast disappearing.

What endures, unchanging on our limited timescale, are the mountains. The Connemara hinterland is dominated by two sibling ranges, the Twelve Bens and the Maumturks, which share the same Dalradian quartzite geology. These are in turn related to a family of quartzitic mountains running north and east through Croagh Patrick and the Nephin Begs of County Mayo, into north Donegal. Like all the main ranges of north and west Ireland, they were pushed up by tectonic pressures created by the collision of the ancient continents of Laurentia and Avalonia during a period known as the Caledonian Orogeny.

Quartzite is an implacable rock, forged from sandstone in the colossal heat and pressure of mountain building. It is so resistant to weathering that little soil can form, often leaving quartzite mountains bare and rocky. This is just so in Connemara, where

A winter sunrise colours the sky above Barrslievenaroy, in the Maumturk Mountains.

silver-grey screes and slabs of bare rock cover the higher summits of both ranges, making them arguably the most rugged in Ireland. In surrounding valleys the underlying schist drains poorly, accommodating thick blankets of peat. From some angles the mountains look like giant grey molars erupting from boggy gums.

The Twelve Bens range is roughly star-shaped. At its core lies Benbaun, whose modest 725m summit is the highest in Connemara. Radiating out from this core are several high ridges, each with two or three summits punctuating their skylines. This complex arrangement has made them a popular walking range, notwithstanding the demands of the rugged terrain. Several obvious horseshoe walks are possible, foremost of which is the classic Glencoaghan Horseshoe – one of the toughest but most rewarding circular mountain excursions in Ireland.

But there are easier ways to get a sense of the Bens. Diamond Hill is a relatively lowly outlier, a striking pyramidal summit rising above the village of Letterfrack. Perhaps it takes its common name from the glint of sunshine on the marble intrusions that decorate its upper slopes, but it has become the focal point of Connemara National Park, which incorporates the north-western quadrant of the Bens. A well-constructed flagstone path has popularised Diamond Hill's ascent for the general public. With steep flanks and fabulous views, this 'hill' has the feel of a much bigger mountain, and there are few other places in Ireland where it is so easy to experience that summit feeling firsthand.

There is evidence throughout Connemara of early human interaction with the mountains. In Gleninagh, on the eastern side of the Bens, is a well-preserved stone row, aligned to where the sun sets into the saddle between Bencollaghduff and Bencorr on the winter solstice. Even today, with superstition suppressed by technological obsessions, the view into the Bens from Gleninagh is deeply inspiring: the summits proud and implacable, the great shadowed buttresses brooding over the glen. It is not hard to appreciate why our ancestors were drawn to the power of this place.

Separated from the Bens by the Inagh Valley, the Maumturks (also sometimes Maamturks) derive their name from the Irish Sléibhte Mhám Toirc or 'Boar Pass Mountains'. The Irish term for a mountain pass – maum – features prominently in the cartography of the range: Maumeen and Maumahoge are two significant breaches in their obdurate ramparts. Maumeen was once a trading route and site of rituals for Celtic peoples, later assumed by the early Church as a place of pilgrimage. Today it is marked with a tiny chapel and a statue of St Patrick.

In contrast to the star-shaped Bens, the Maumturks form a long line of summits, rising from the bog near Maam Cross and marching north-west towards Killary Harbour. Most walkers take them in manageable portions, using the 'maums' to access well-defined sections of the chain and returning along the valley. However, in April each year a few hundred hardened walkers tackle the Maamturk Challenge, navigating the entire range in a single knee-jarring day.

The Maumturks singular topography is complicated at the northern end. There is a kink in the chain that connects the main Maumturk range to a parallel range of smaller and altogether more rounded and grassy summits above the village of Leenane. These interlopers are of a different species: sandstone, shale and mudstone hills that belong instead to the ranges that dominate Joyce Country and south Mayo.

Opposite: View across Lough Inagh to the Twelve Bens.

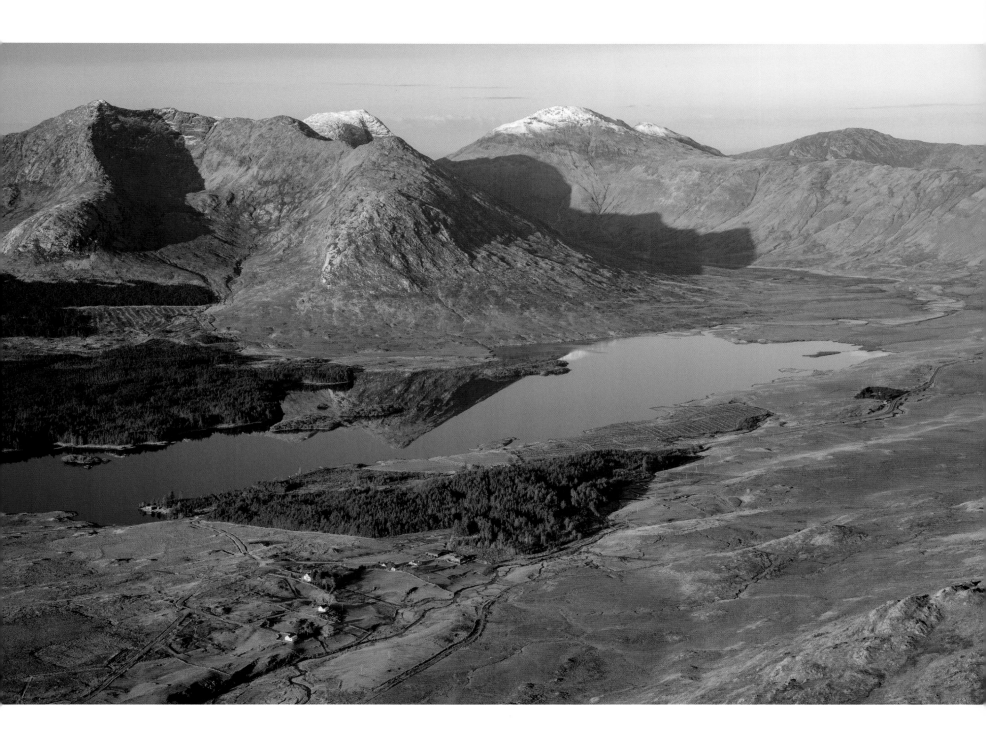

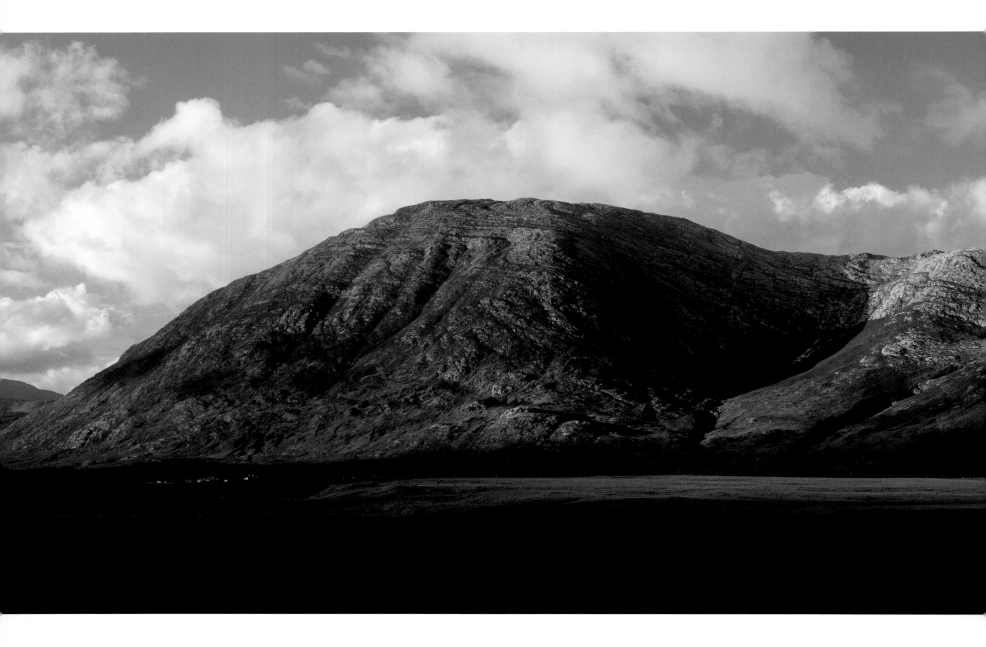

Panorama of the central Maumturk Mountains rising above the Inagh Valley. The Maumturks consist of a quartzite ridge some 25km long, with many summits renowned for their rugged, rocky terrain.

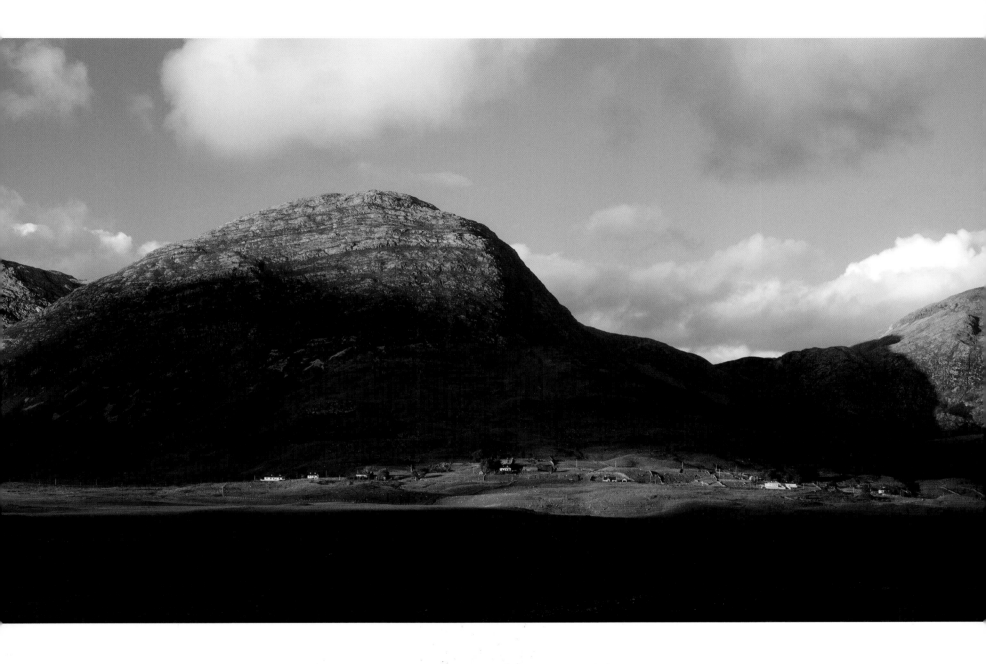

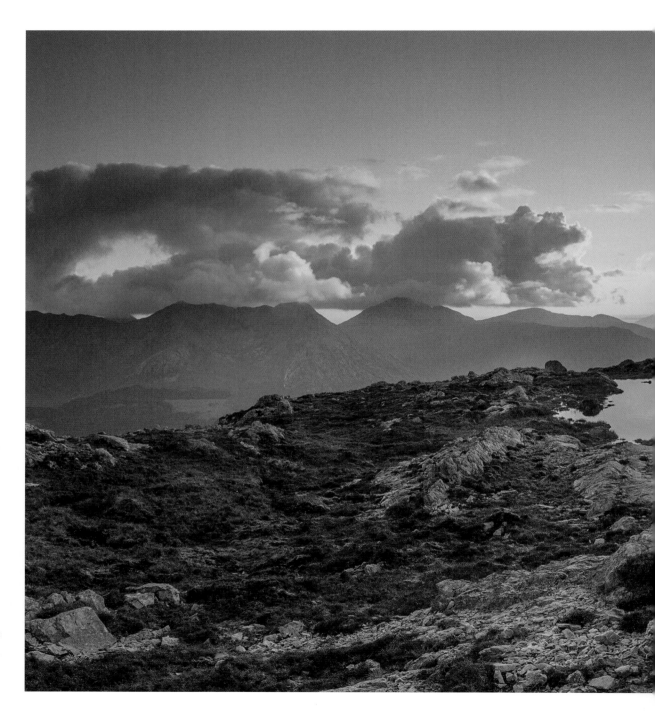

The sun sets over a garden of boulders and pools
that epitomise the summit of Knocknahillion,
in the Maumturk Mountains.

Next pages: Winter panorama of Letterbreckaun and
the northern half of the Maumturk Mountains. In the
far distance you can see from left to right: Mweelrea,
the Sheeffry Hills, Croagh Patrick, Nephin and
Devil's Mother.

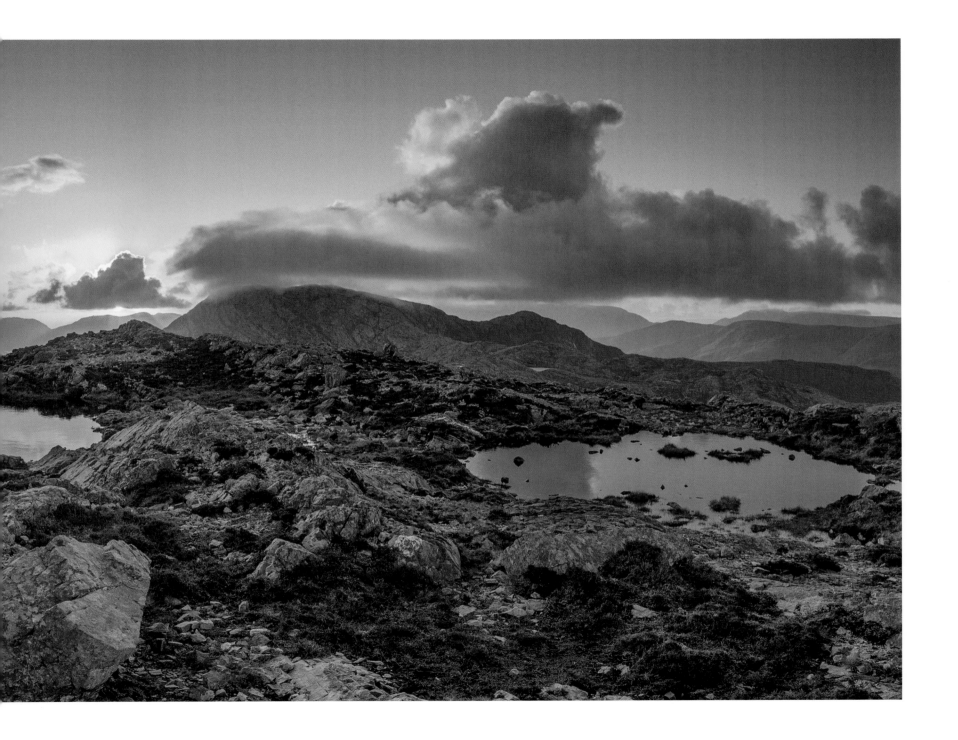

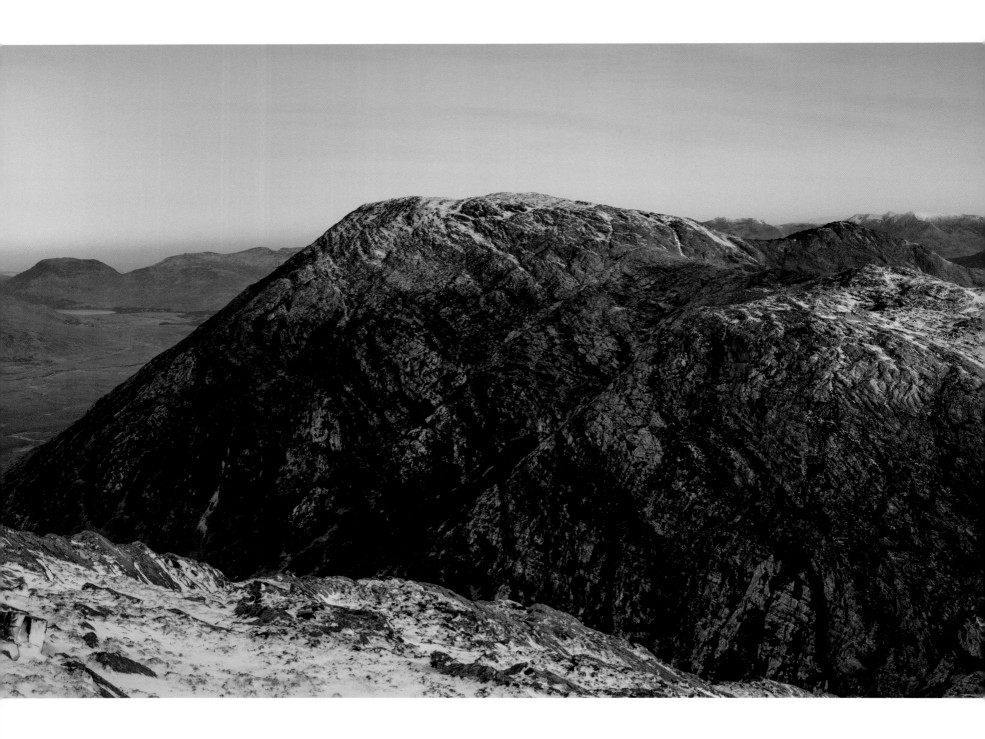

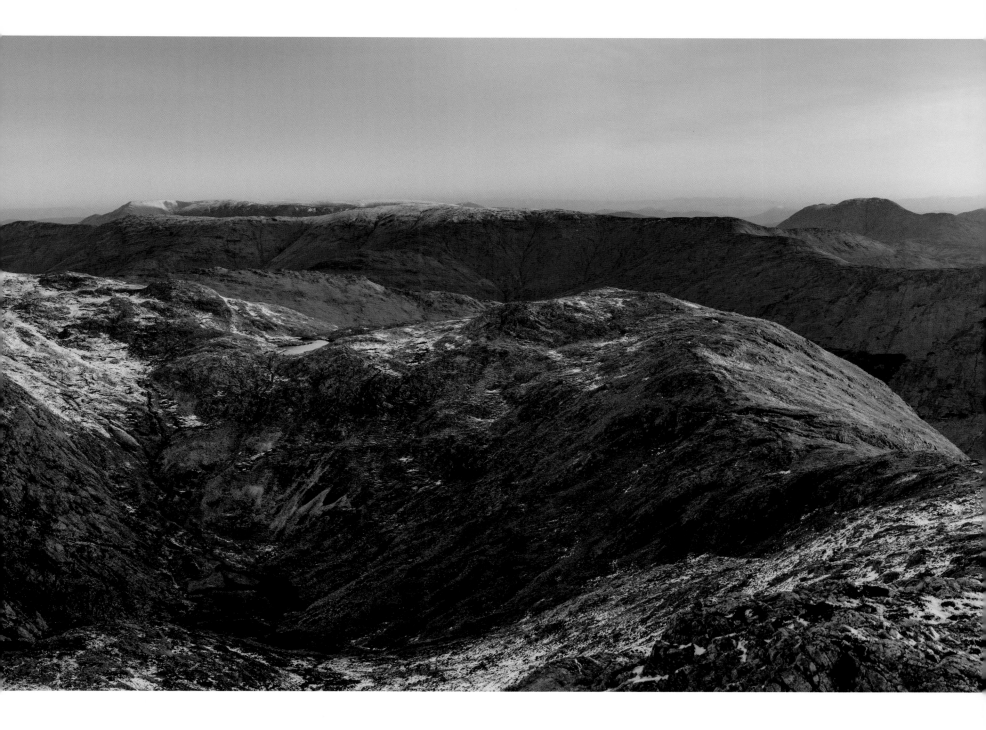

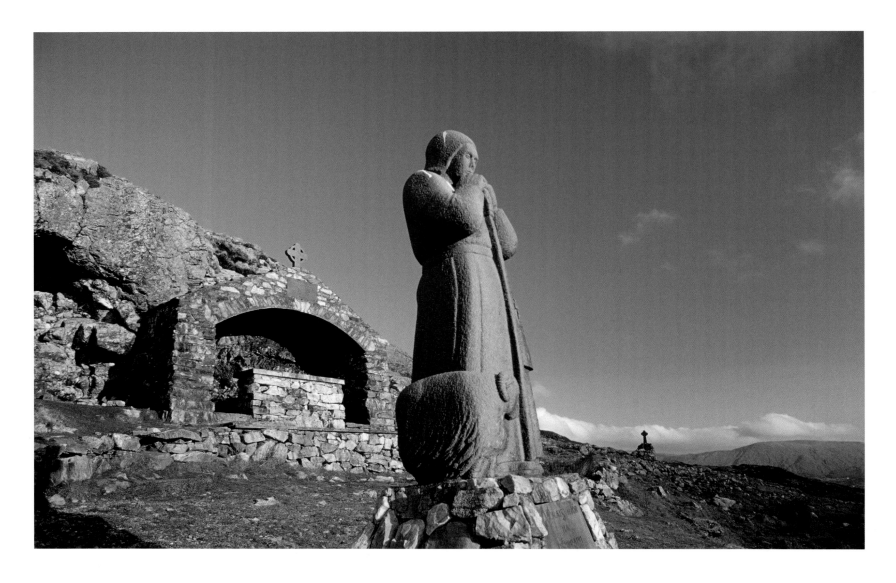

Above: Outdoor worship. A statue of St Patrick keeps watch over Maumeen, one of the main passes that cut across the Maumturk Mountains. Already an important pagan site, in the fifth century Ireland's patron saint was said to have blessed all of Connemara from here. During Penal times the pass was used as a clandestine Catholic church, and it remains the focus of an annual pilgrimage.

Opposite: View across Maumahoge, another major pass across the Maumturk Mountains.

Next pages: A rainbow arcs across the Twelve Ben mountains, with the Maumturks silhouetted beyond.

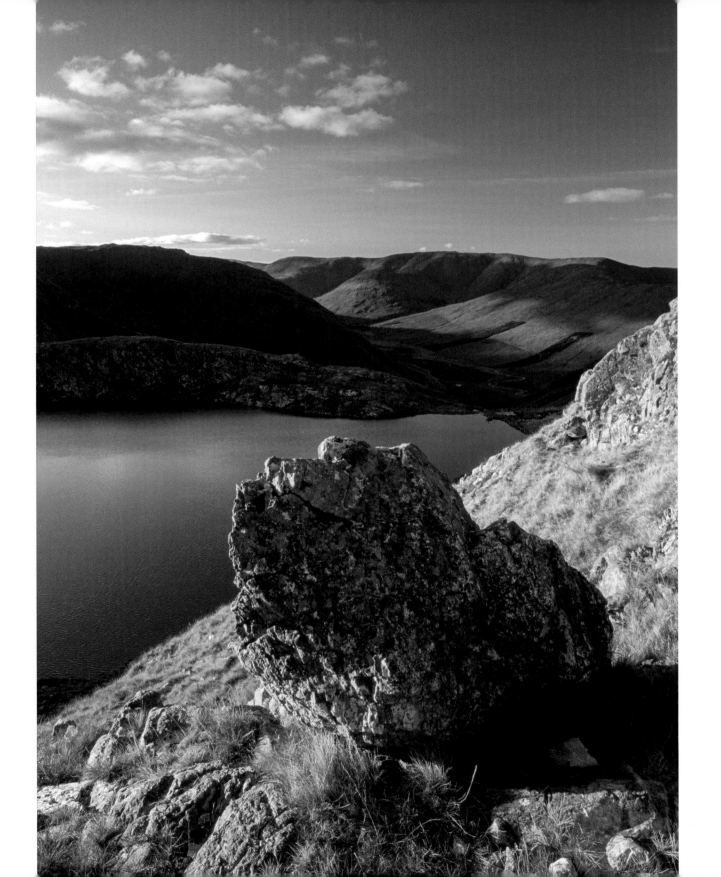

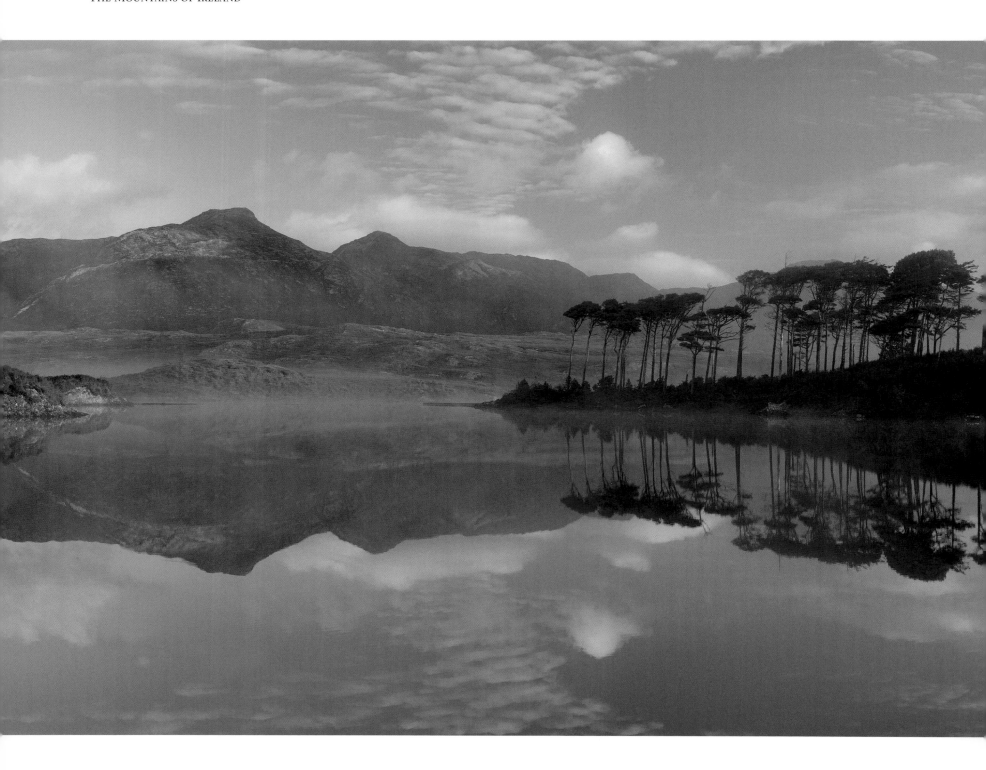

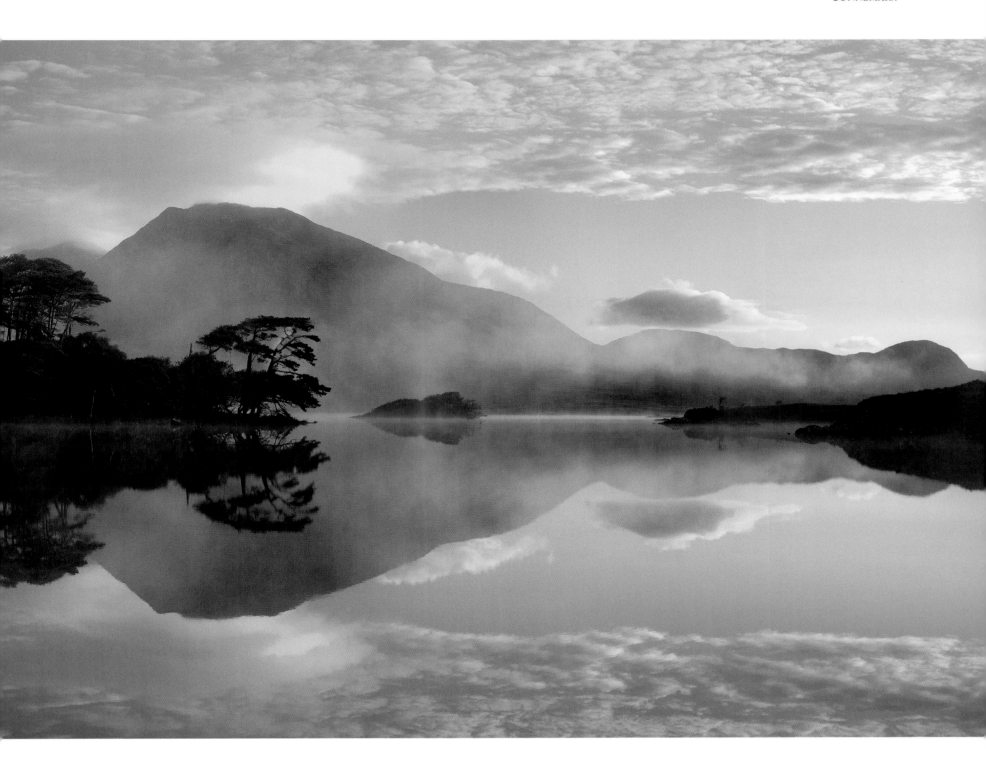

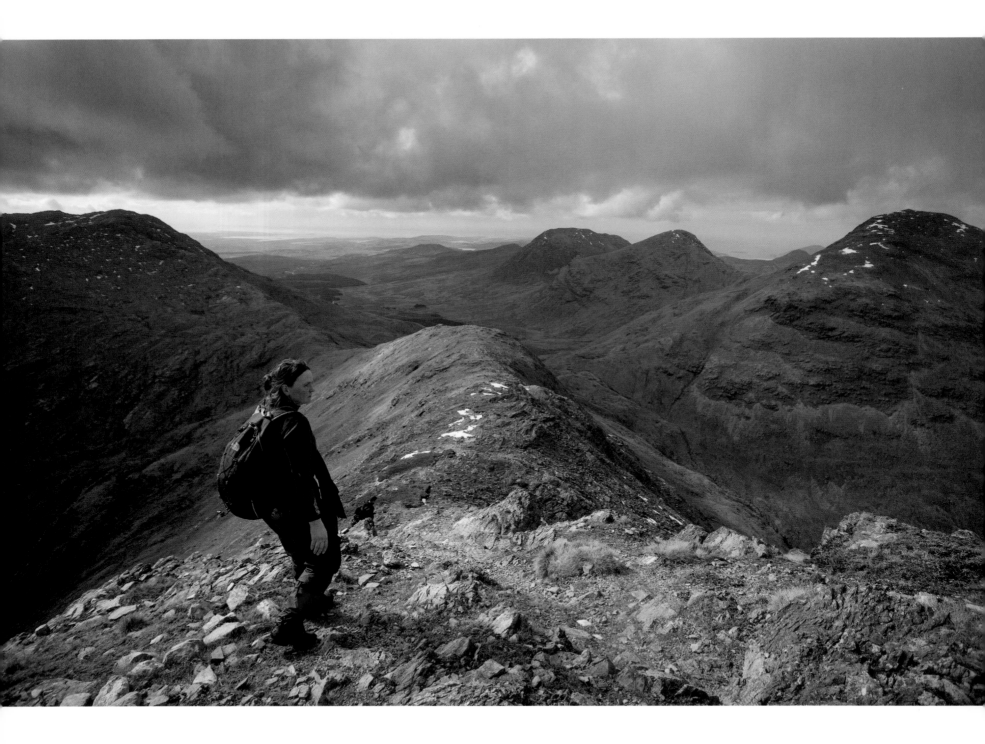

Above: Ever-higher ridges stacked one behind the other in the Twelve Bens, Connemara. The curious sunlit ridge, top left, is known as 'Carrot Ridge' and is a classic rock-climb.

Left: Walker descending the narrow ridge between Bencollaghduff and Maumina, in the Twelve Bens. The range has a reputation as one of the most challenging and rugged in Ireland, its tight cluster of barren peaks exuding a stark scenic austerity.

Previous pages: The Twelve Bens reflected in the still waters of Derryclare Lough at 6 a.m. on a magical late-August morning.

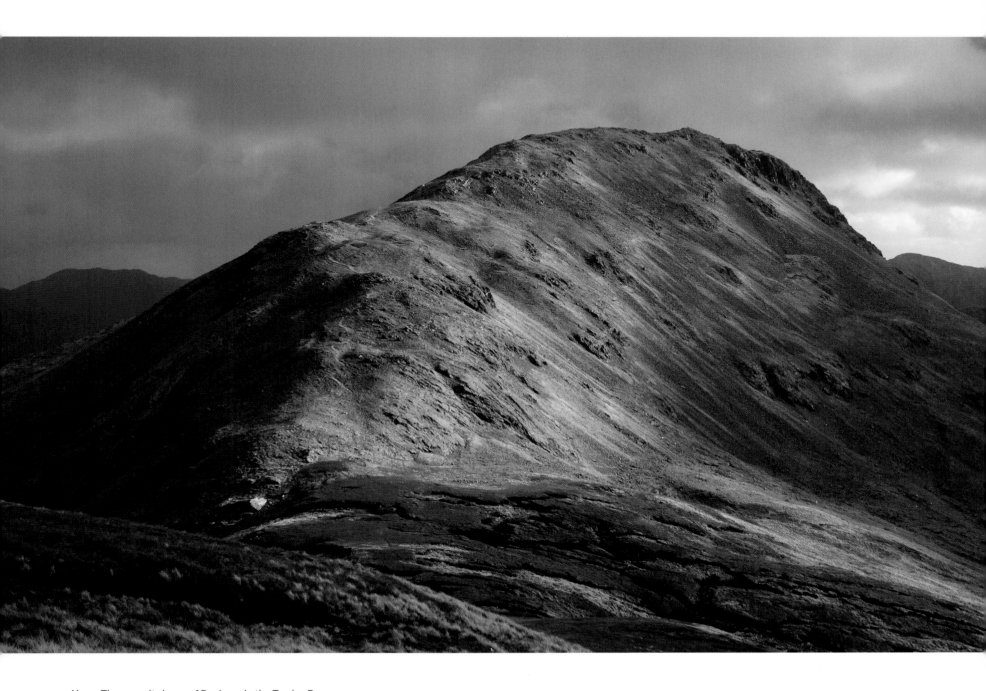

Above: The summit slopes of Benbaun in the Twelve Bens.

Opposite: Coins left as votive offerings at a small shrine, Maumina, Twelve Bens.

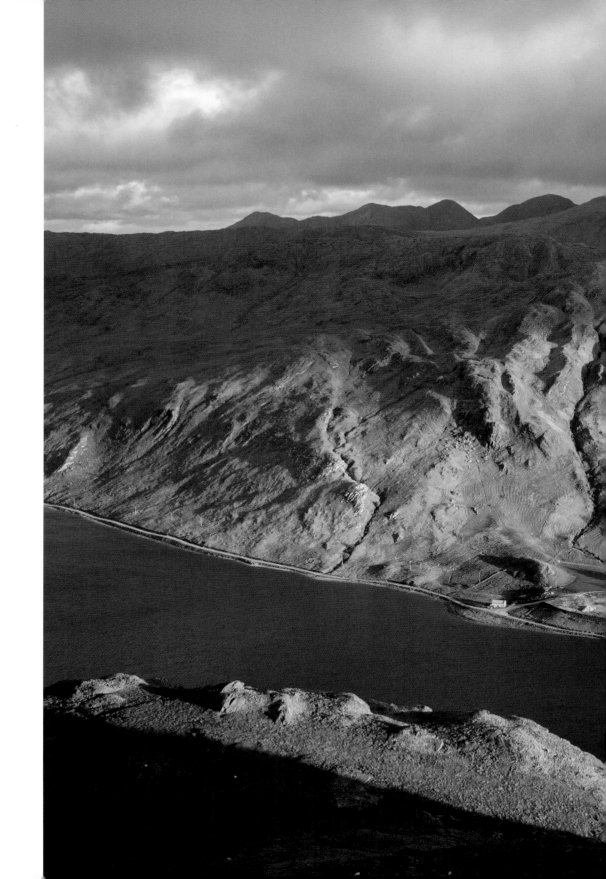

Looking across Kylemore Lough to the Twelve Bens.

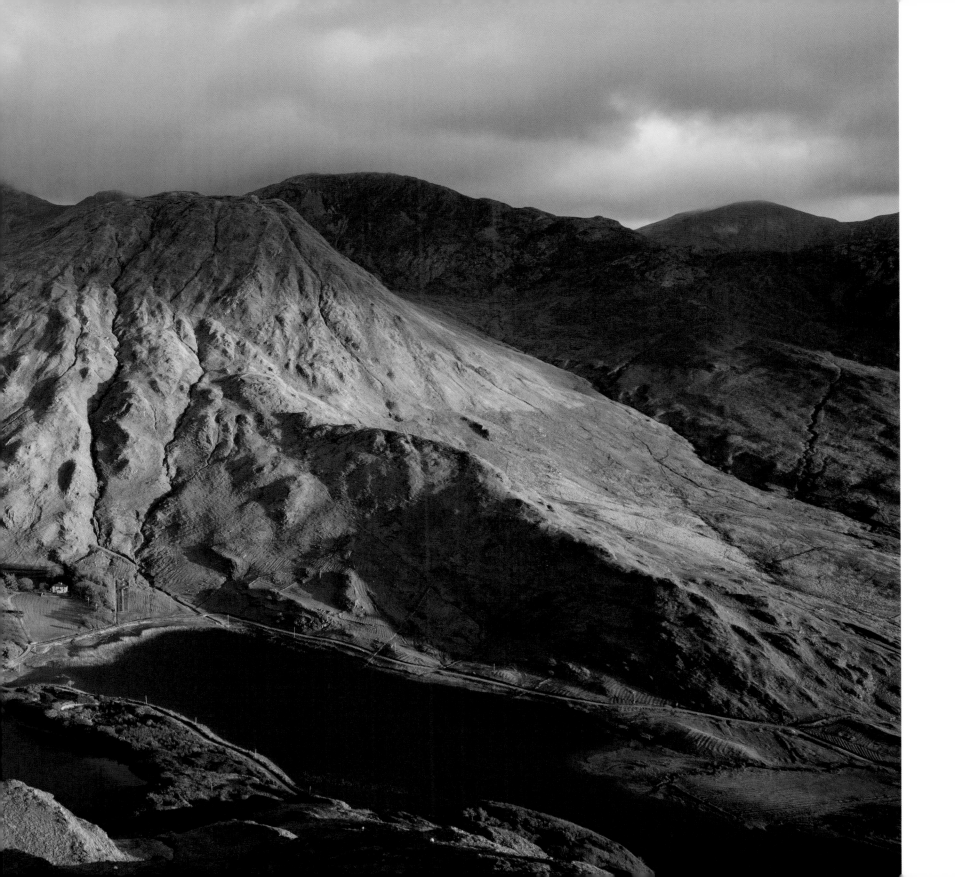

Mayo and Wild Nephin

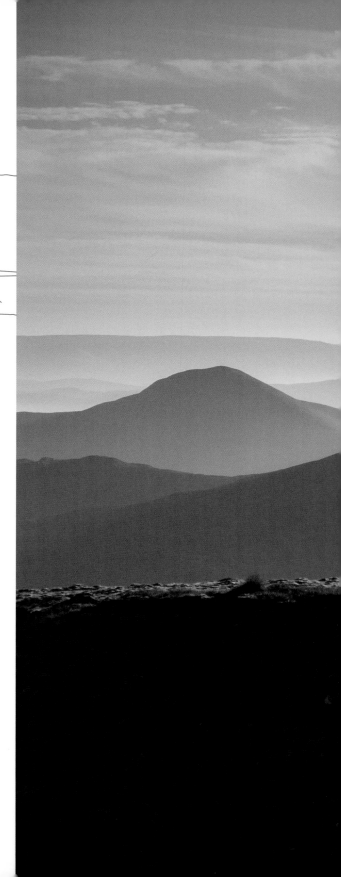

Sometimes, in a south-westerly gale, violent squalls of hurricane ferocity funnel through the Doolough valley. They come in a cyclical rhythm, every few minutes the gale abruptly amplifies, strong enough to lift towering clouds of spray from the lake and send them in swirling vortices far down the valley. I watched just such tempests from the safety of my car one January afternoon, open-mouthed and white-knuckled, gripping the steering wheel as the car bounced wildly on its suspension. There was no doubt that anyone unlucky or foolhardy enough to have been outside would have either clung limpet-like to the earth or been rag-dolled down the valley. I thought too of the despairing men, women and children, walking through the wind, rain and sleet on the night of 30 March 1849, weakened and starving from the worst ravages of the Great Famine. Commanded by authorities indifferent to their fate to present themselves for inspection at Delphi Lodge if they wanted to receive relief supplies of grain, an undetermined number succumbed to hunger and exposure in this mountain valley.

I normally visit the mountains in good conditions. Cold weather is fine, and a covering of snow can be ideal, but wind, cloud and foul weather are rarely servants of successful outdoor photography. So it comes as something of a shock to be reminded of just how ferocious the weather can be, even in our own modest mountains. Not that the peaks surrounding Doolough are especially modest. Mweelrea, the Sheeffry Hills and Ben Creggan all converge on Doolough, with flanks so precipitous and oppressive

Open spaces: striding across the summit ridge of Slieve Carr, the most remote mountain in Ireland. In the middle distance are the summits of Glennamong and Corranbinna. In the far distance are some of the other great mountains of Connacht, including, from left to right, Maumtrasna, the Sheeffry Hills, Croagh Patrick and Mweelrea.

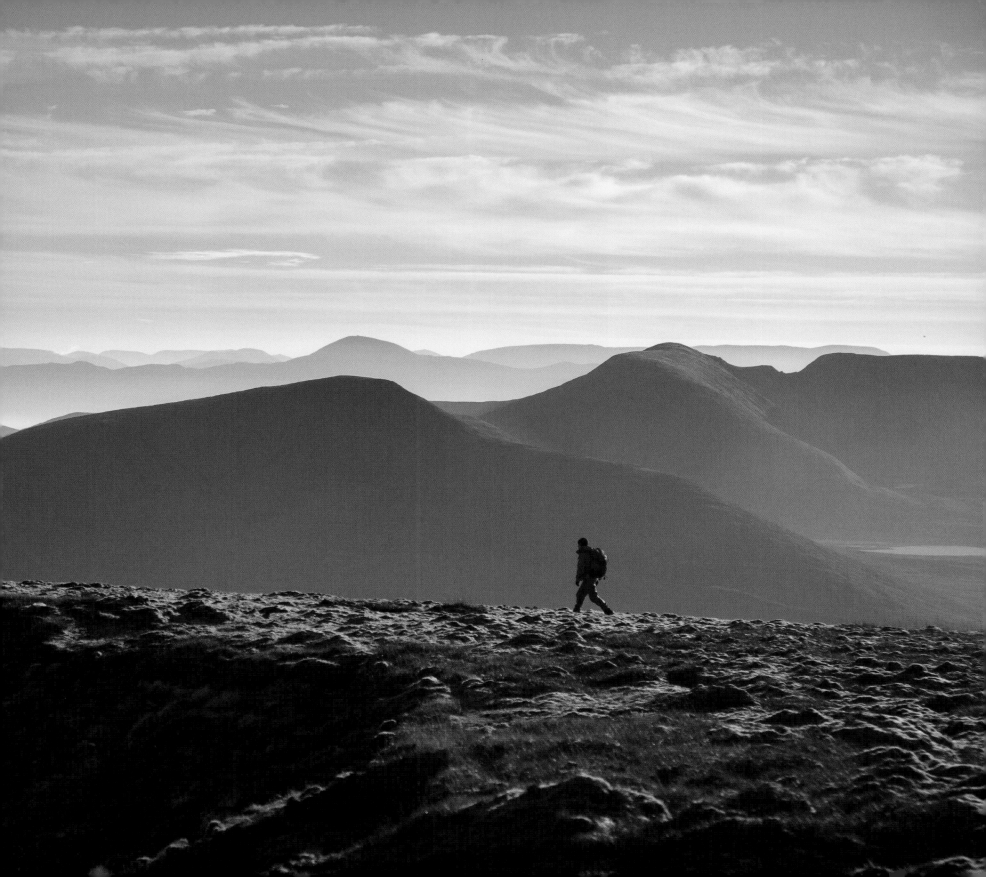

that they seem likely to collapse into the black waters at any moment.

At 814m, Mweelrea is the highest mountain in Connacht, a magnificently glaciated sprawl of ridges and corries dropping straight into the Atlantic on its southern and western sides. Only Brandon Mountain in Kerry can rival Mweelrea for its heady combination of mountain austerity and beautiful coastal scenery. Mweelrea is dominated by Lugmore, 'the big hollow', a vast, lakeless corrie that broods over Doolough. It is one of our largest corries, and a journey around its rim, crossing Ben Bury and Ben Lugmore, is one of the great experiences of Irish walking.

Mweelrea's sandstone geology is shared with almost all of the other mountains of south Mayo. To the east across Doolough is the long, narrow ridge of the Sheeffry Hills. To the south-east are the pyramidal Ben Creggan and Ben Gorm. Beyond these are yet more steep-sided sandstone summits including Devil's Mother, whose English name is derived from an act of cartographical censorship – it should actually be *Magairlí an Deamhain* or 'The Devil's Balls'. Further east again is the vast plateau of Maumtrasna, ringed with steep, ravined flanks and corries, trailing a dark history of blood, lies and politics. The Maumtrasna Murders of the nineteenth century and their political ramifications (they brought down a British government) are well worth looking up.

South Mayo's geological outlier is Croagh Patrick, which has more in common with its quartzite siblings on Achill Island and in the Nephin range to the north. Familiarly known as 'The Reek' (from the Old English

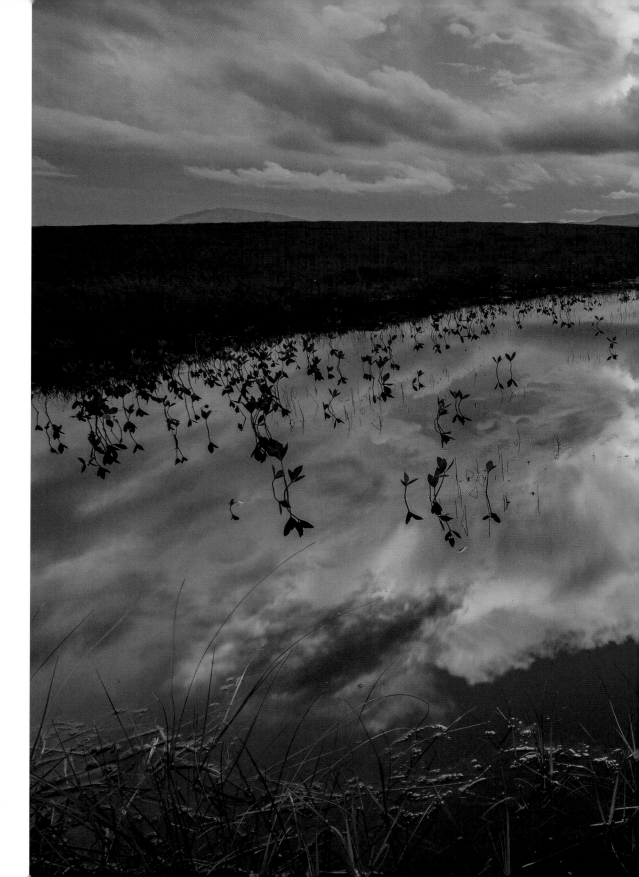

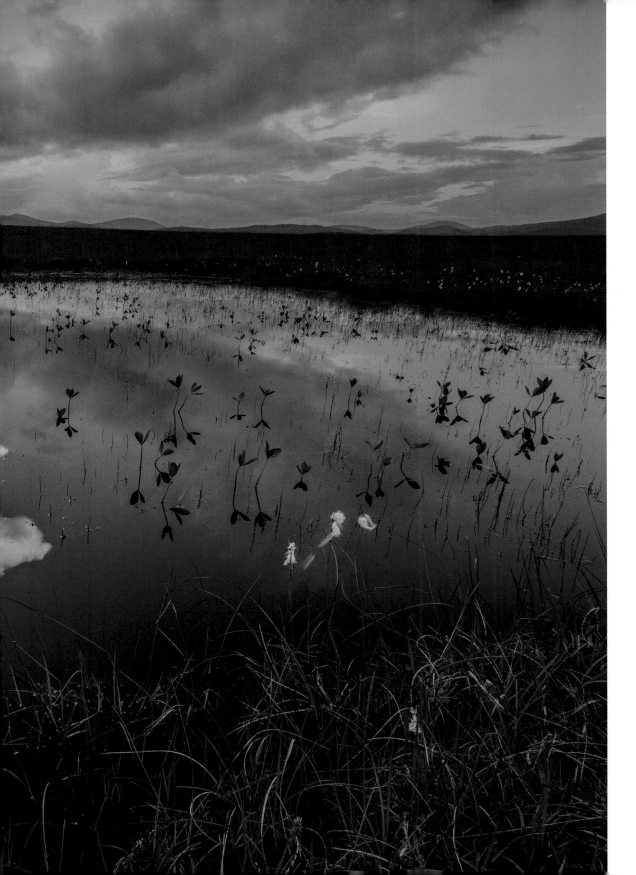

word 'rick', meaning a stack of hay), Croagh Patrick also bears the moniker of Ireland's Holy Mountain, with an appropriate testament of scars. A site of pilgrimage since early Christian times, it is still climbed by tens of thousands of the faithful every year, some in bare feet, and the majority on a single Sunday in July. It is also the focus of several adventure races, numerous charity walks and a thriving local tourist industry. It is, in short, an overworked cash cow, showing the accumulated impact of many millions of footsteps in the hugely eroded path, visible from many miles away, that scars the entire north-eastern side of the mountain.

Perhaps in bearing this burden of popularity, Croagh Patrick has been a blessing in disguise for the mountains of the Nephin Beg range. With the exception of Nephin itself, which is possibly the quickest and easiest Irish mountain of its size to climb, the rest of the Nephin range is probably climbed by fewer people in a whole year than stand on top of Croagh Patrick in a single day. Against this backdrop it was recently proposed to amalgamate 11,000 hectares of Ballycroy National Park and adjoining Coillte forestry into Ireland's first designated wilderness area – to be known as Wild Nephin.

I remember a solo trip to the summit of Slieve Carr (or Corslieve as it is also known) during the bitter cold of January 2010. This is Ireland's most remote

Evening reflections in a bog pool beneath the Nephin Beg Mountains.

mountain, accessible only after several kilometres of walking or mountain biking along lonely forestry trails. The car thermometer had read -13 °C that morning as I set out on my bike bearing a pedlar's-cart of equipment: an assortment of camera gear, an ice axe, an optimistic snowboard. I negotiated forest tracks covered by a treacherous layer of refrozen snow, then stashed my bike at the forest's edge and climbed onto the open mountainside and into a charge of winter sunshine. I climbed through one of the eastern corries, my feet no longer feeling the bottom of the deep, wind-drifted snow, lungs seared by the acidic burn of breathing hard in the cold air.

On the broad summit ridge I waded through 30cm of powdery snow to the huge summit cairn, a tomb built by our earliest ancestors as a final resting place for some king or queen, or perhaps for the great hero Daithí Bán of local mythology, from which to look out eternally over their kingdom. The average population density on our planet stands at around fifty people per square kilometre. Here I was on Ireland's loneliest summit with perhaps seventy square kilometres all to myself.

I strapped into my snowboard and set off down the shoulder, slowly at first on the gentle gradient but soon picking up momentum, weaving around some peat hags, hopping off others. I paused briefly on the lip of the corrie then dived in, swooping and carving through long exhilarating turns, unsettled here and there by the *thwock* of hitting a buried rock, stopping finally where the snow became crusty. I unstrapped, hoisted the board and set about the long, slow climb back to the summit.

Later in the afternoon as I stood high on the southern shoulder of the mountain waiting with my camera for the warming of the light on the snow, the blueing of the shadows, I fought an insistent, nagging voice telling me to descend. It was perhaps the voice of instinct, of the hillwalking rule book. I was keenly aware of just how remote my position was, how long the return journey in dark, freezing conditions, how the night renders the mountain landscape an indifferent minefield of trap and treachery. But I stood my ground, finally rewarded with the images I had wanted. Then I packed up and descended carefully into the banks of freezing fog gathering in the valley, by turns relieved, exhausted and humbled to have experienced the gamut of emotions that the mountains can evoke: determination, exhilaration, levity, loneliness, fear, but most of all wonder.

Winter cloud clearing from the col between Slieve Carr and Nephin Beg.

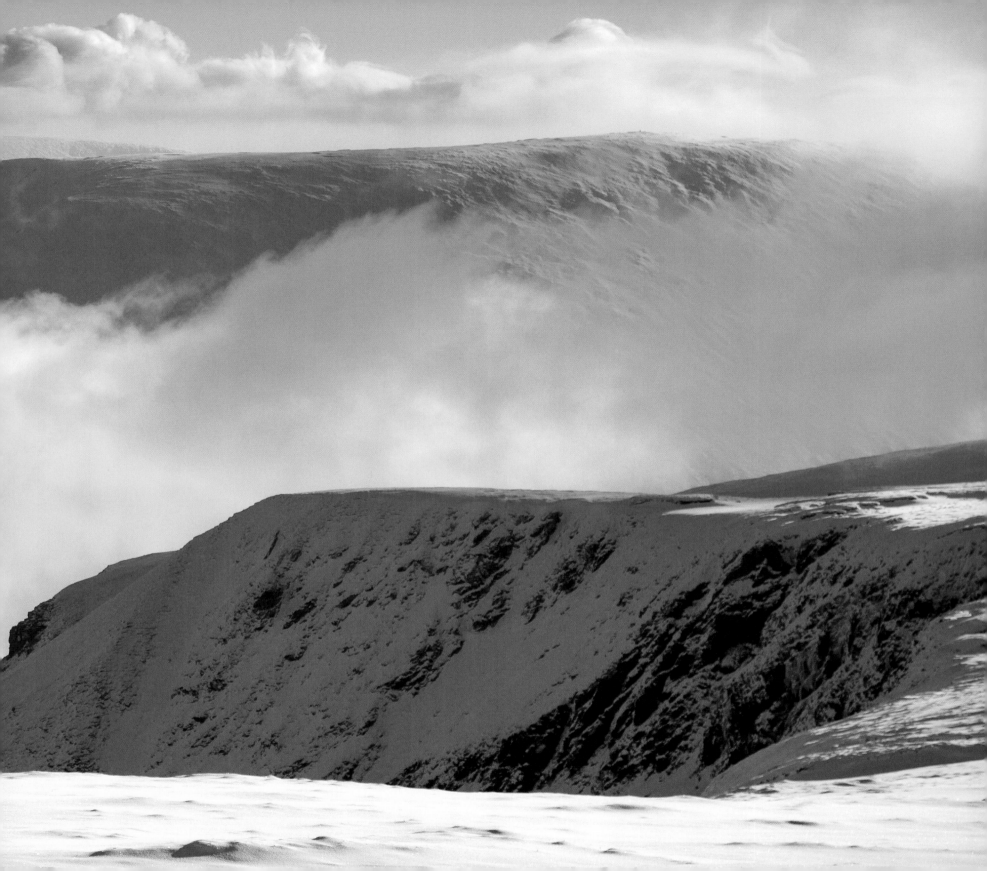

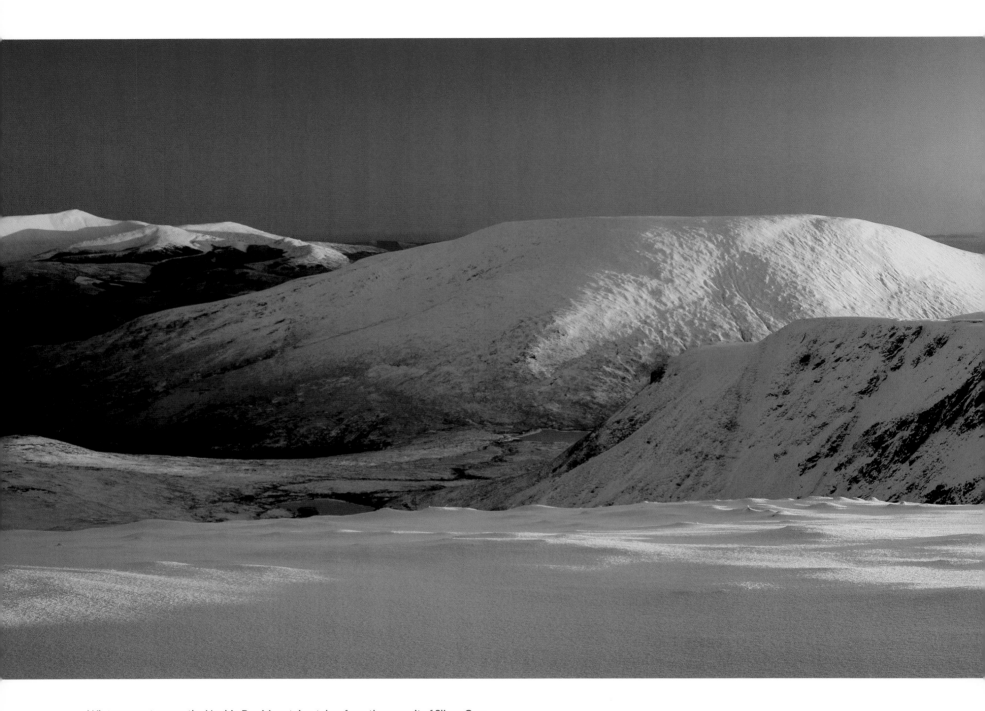

Winter sunset across the Nephin Beg Mountains, taken from the summit of Slieve Carr.

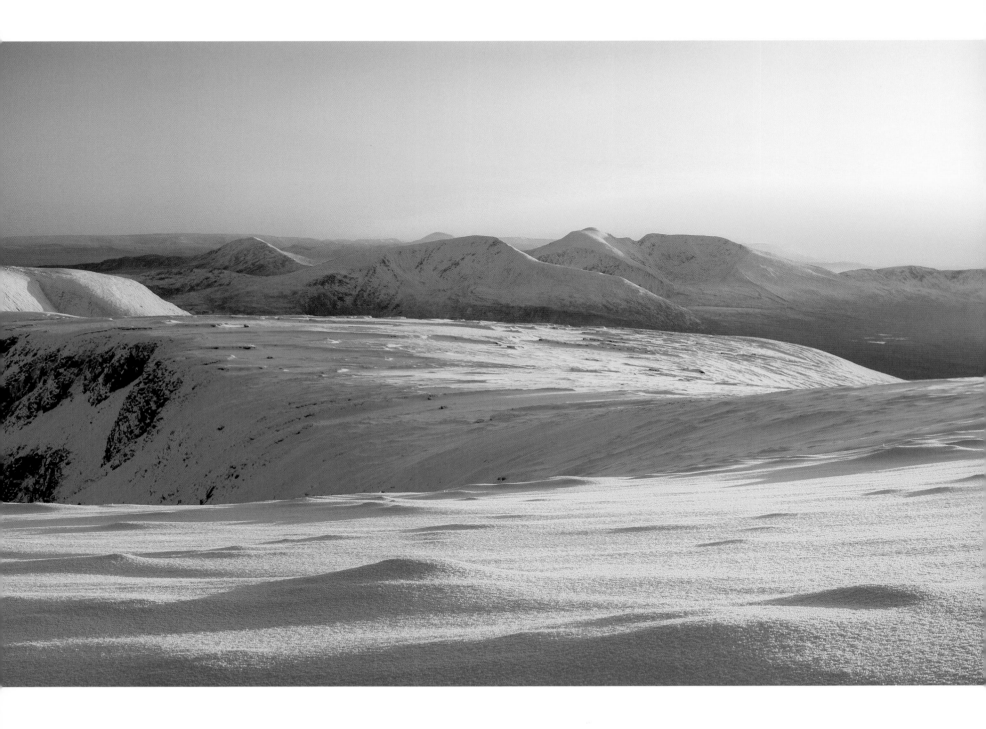

Bog pool in Ballycroy National Park,
with the summits of Glennamong and
Corranbinna rising beyond.

Next pages: The Owenduff River snakes
across a sea of bog beneath the Nephin Beg
Mountains. The area is part of Wild Nephin,
Ireland's first designated wilderness area.

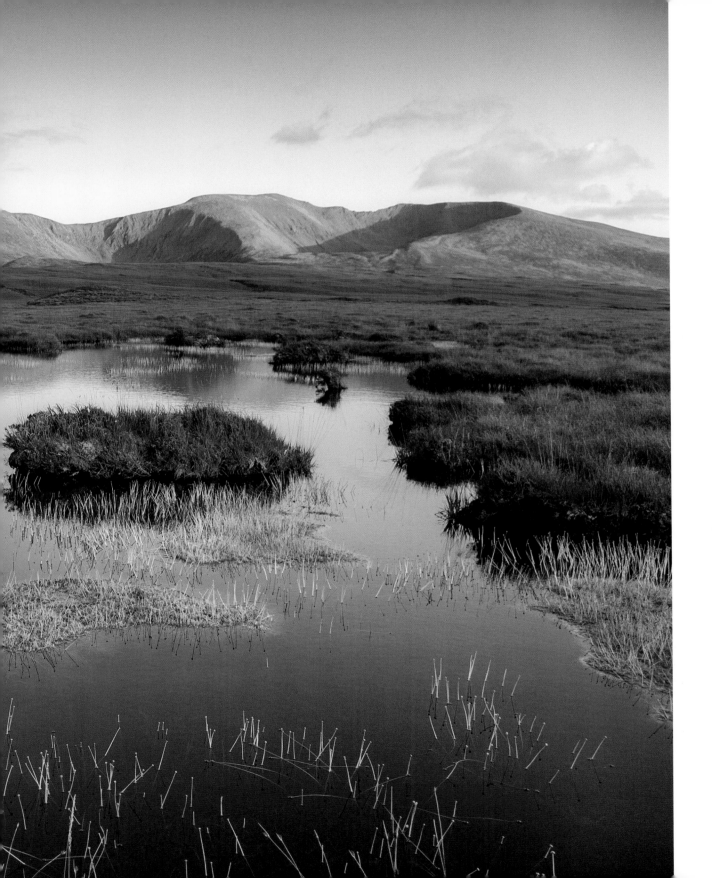

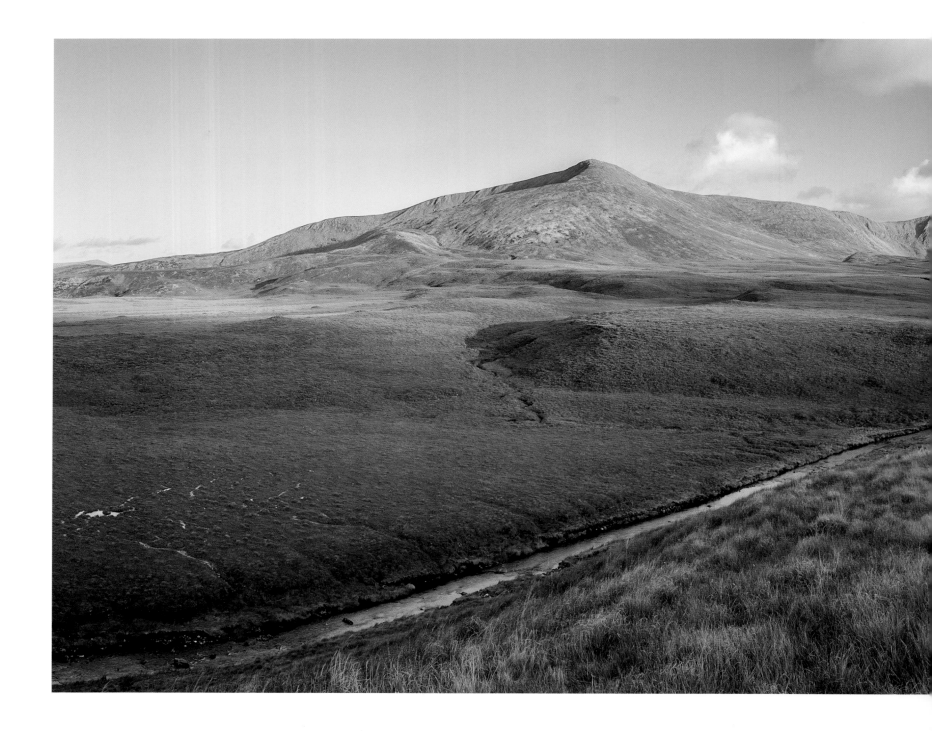

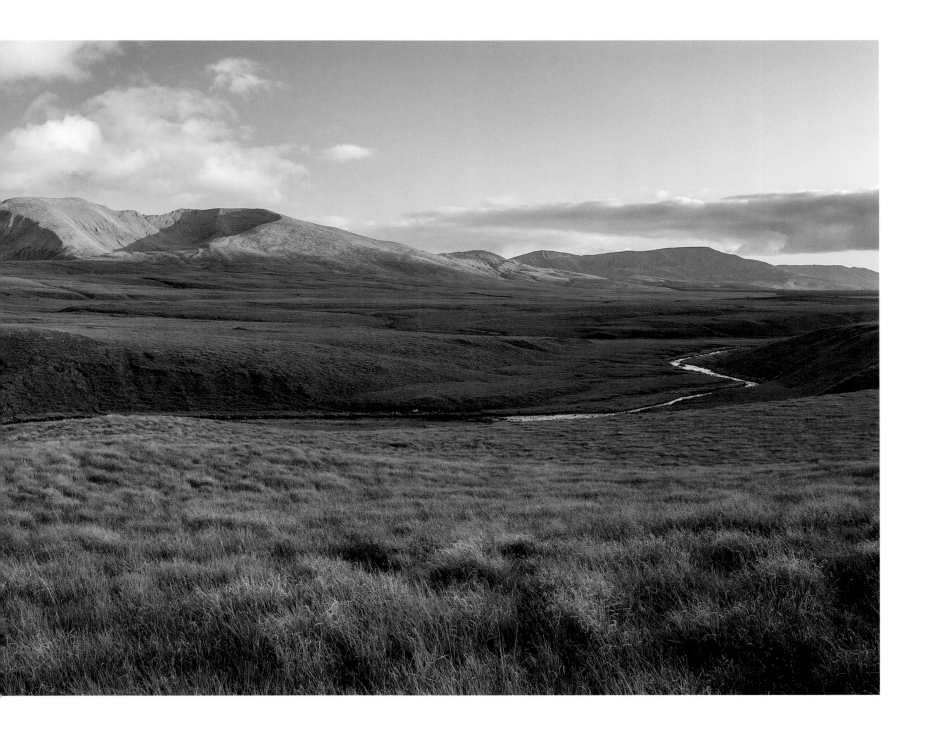

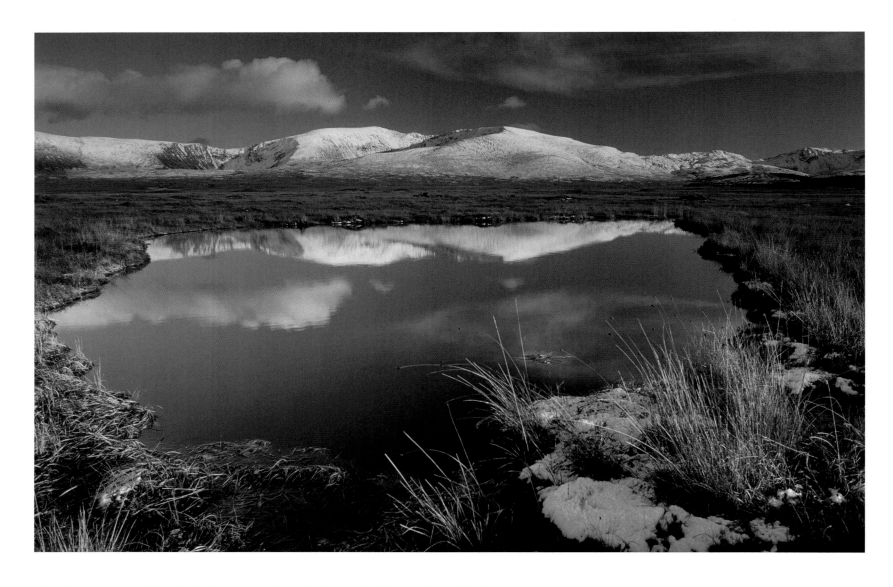

Above: The snow-covered Nephin Beg Mountains reflected in a bog pool in Ballycroy National Park.

Right: A walker looking towards a snow-covered Birreencorragh from the slopes of Nephin.

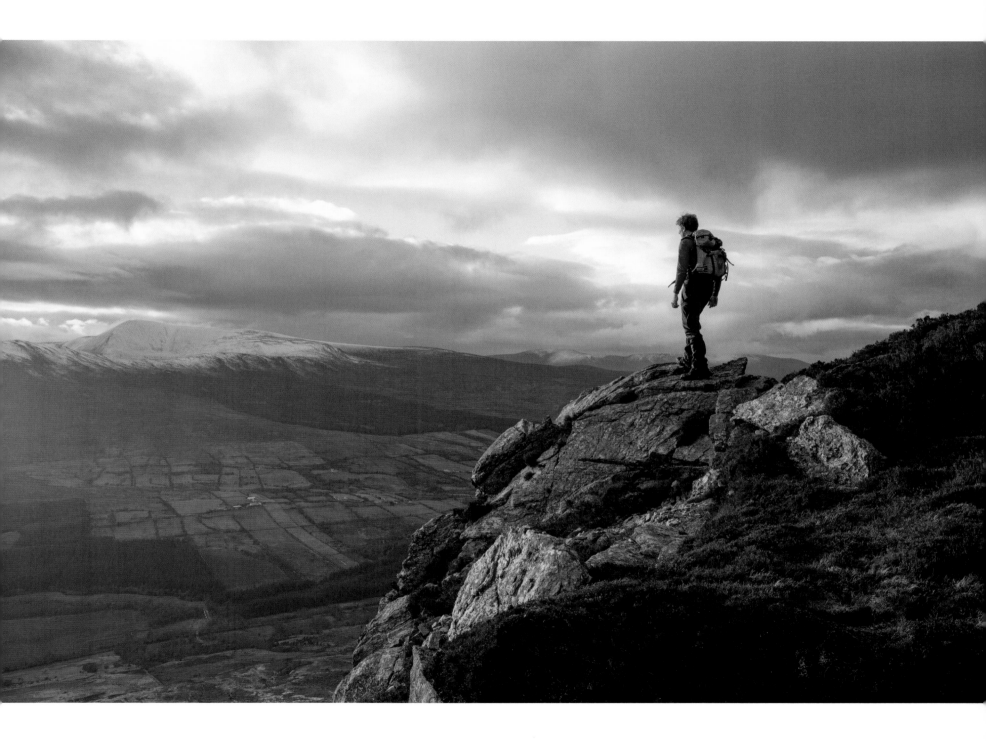

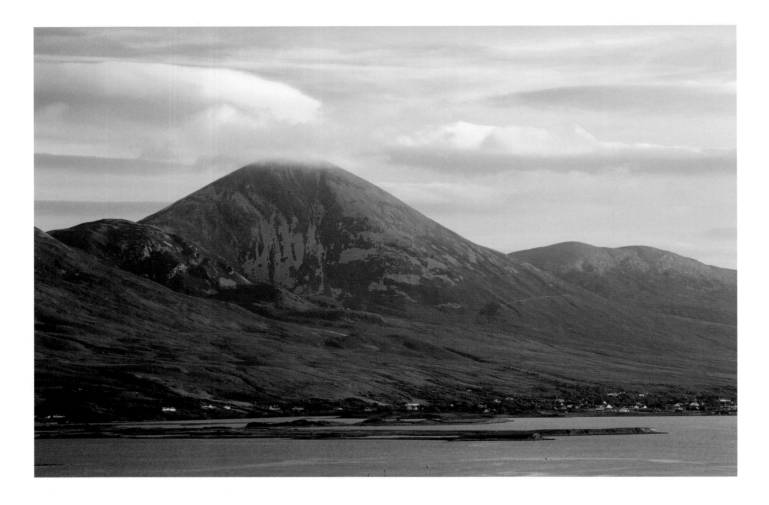

Above: A halo of cloud brushes the top of Croagh Patrick, Ireland's 'Holy Mountain'. Having previously been a site of pagan celebration, this peak became the focus of Christian pilgrimage after Saint Patrick fasted at the summit for forty days and forty nights.

Opposite: Moon rising above Croagh Patrick. The chapel that marks the top is the highest church in Ireland.

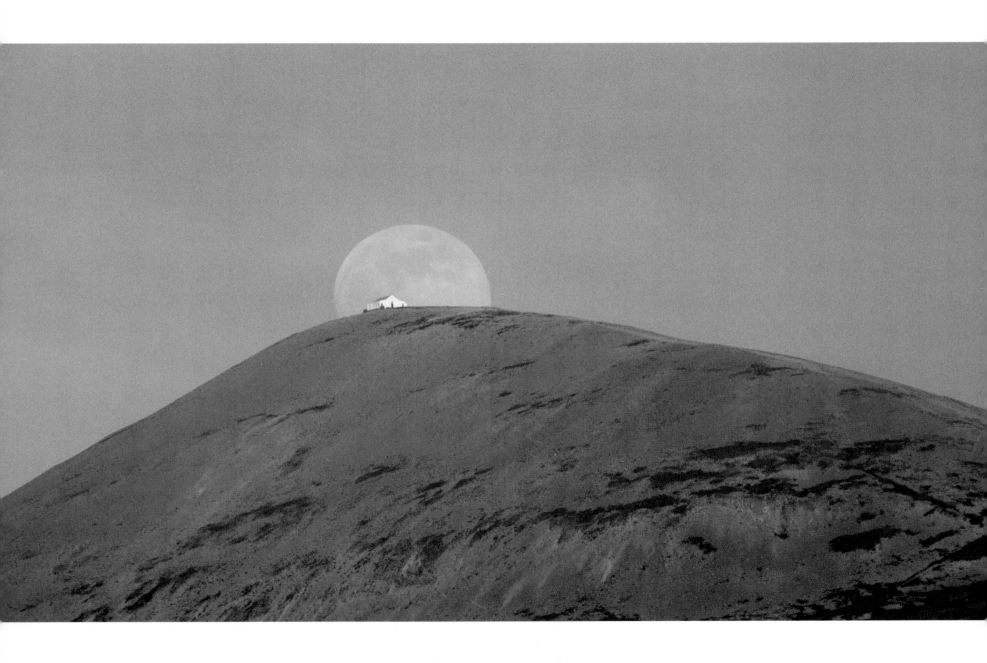

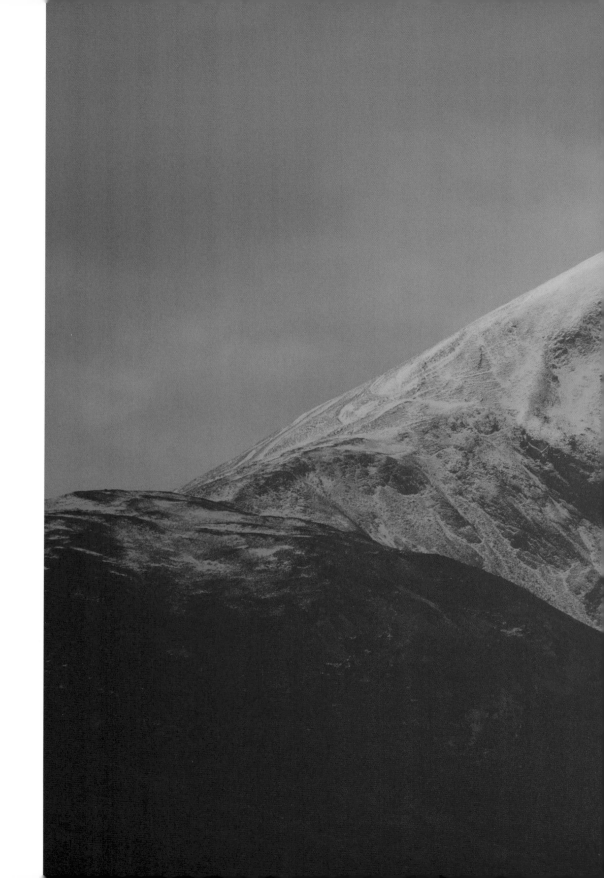

A winter storm blows past Croagh Patrick's summit cone.
The chapel that marks the top is the highest church in Ireland,
and is just visible through the gloom.

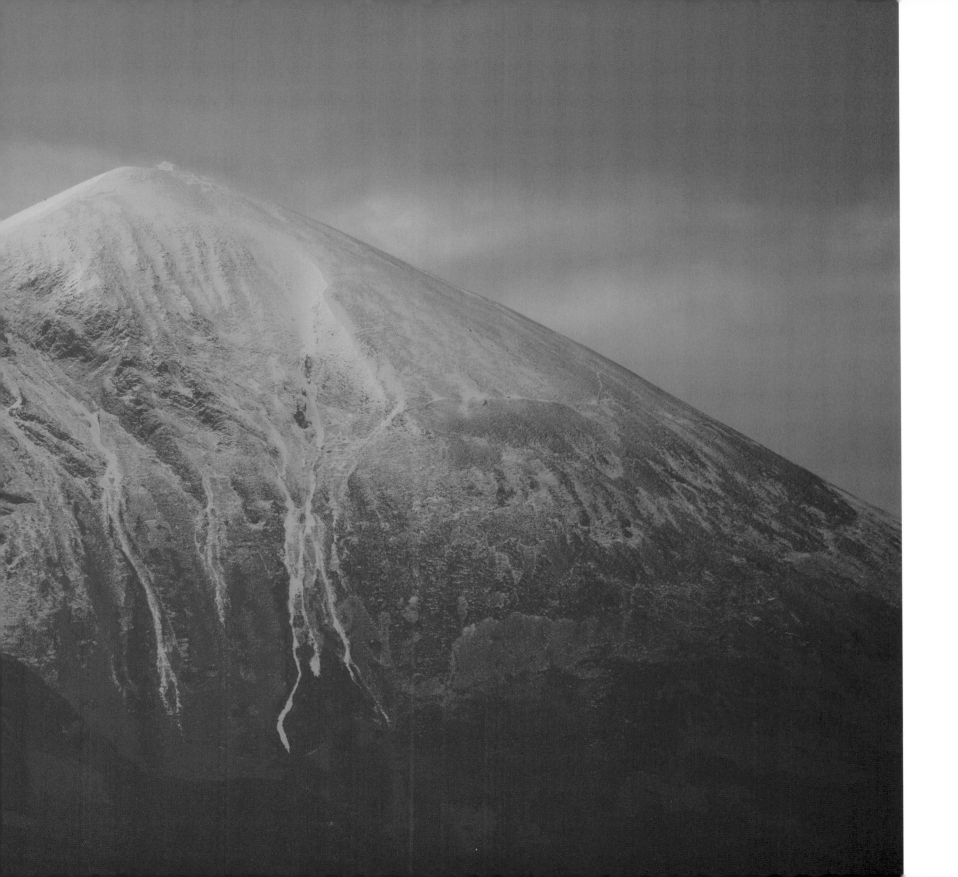

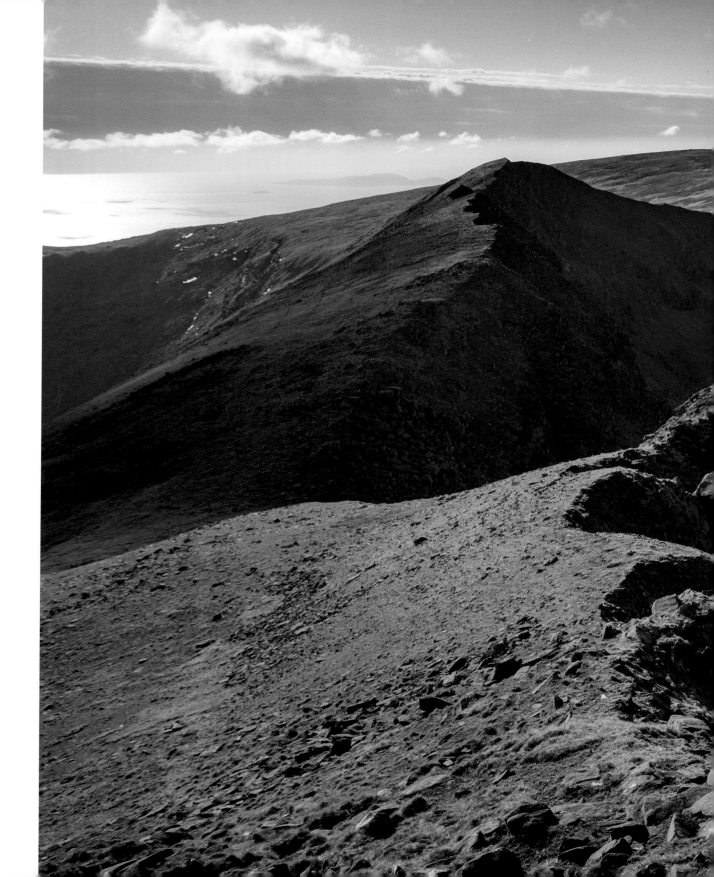

View across the deep corrie of Lugmore
or Coum Dubh, towards Ben Bury
in the Mweelrea massif.

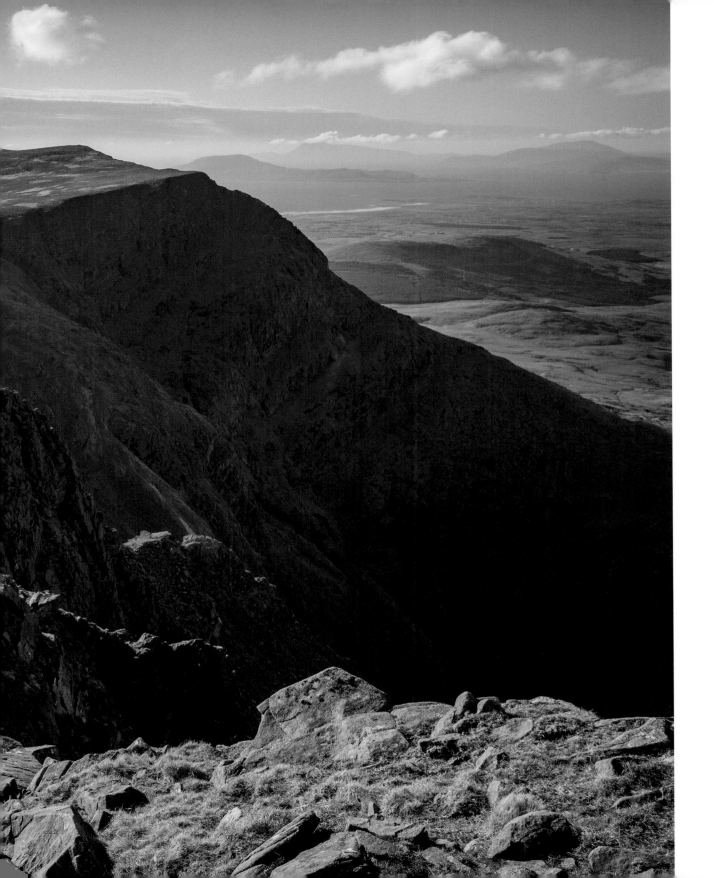

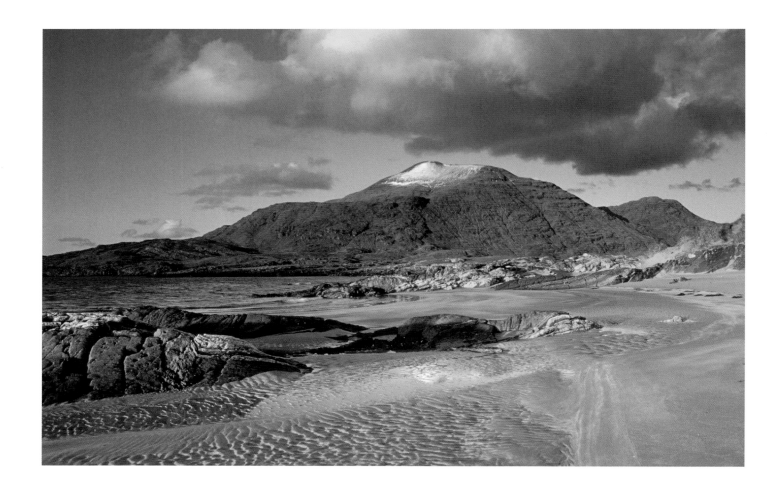

Above: Mweelrea's western slopes rise directly from the sea. Here the mountain is seen from Glassilaun beach, just to the south across Killary Harbour.

Opposite: After the rain. Mountain gullies become mini torrents as water seeks the most direct route to the valley below.

Next pages: Looking across Lugmore to Ben Bury and Mweelrea in winter.

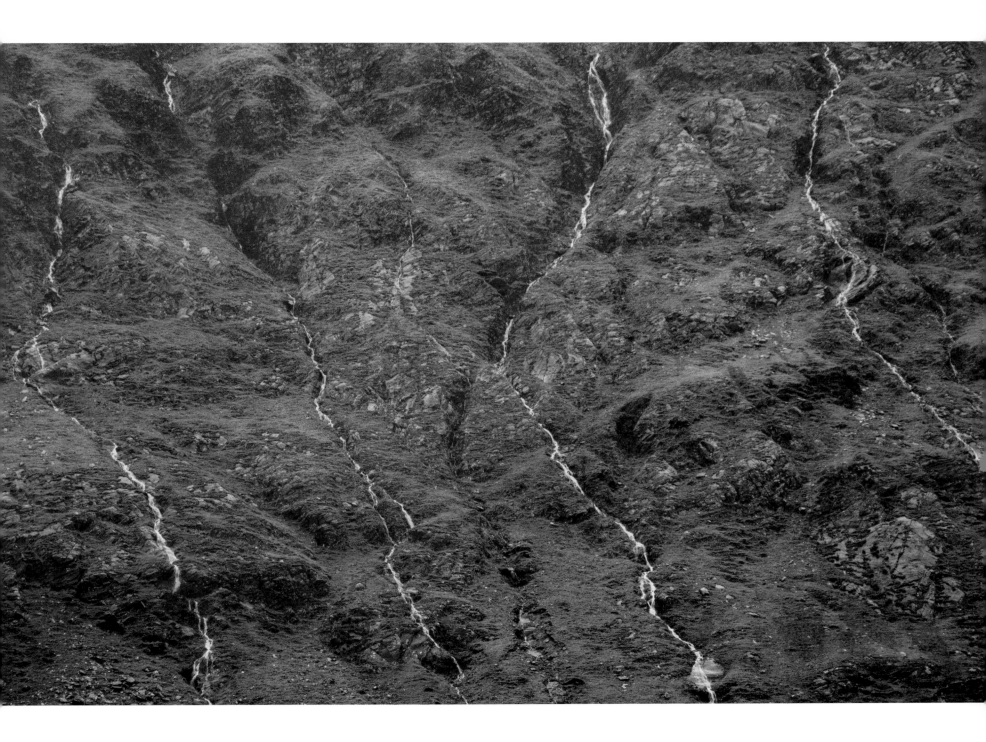

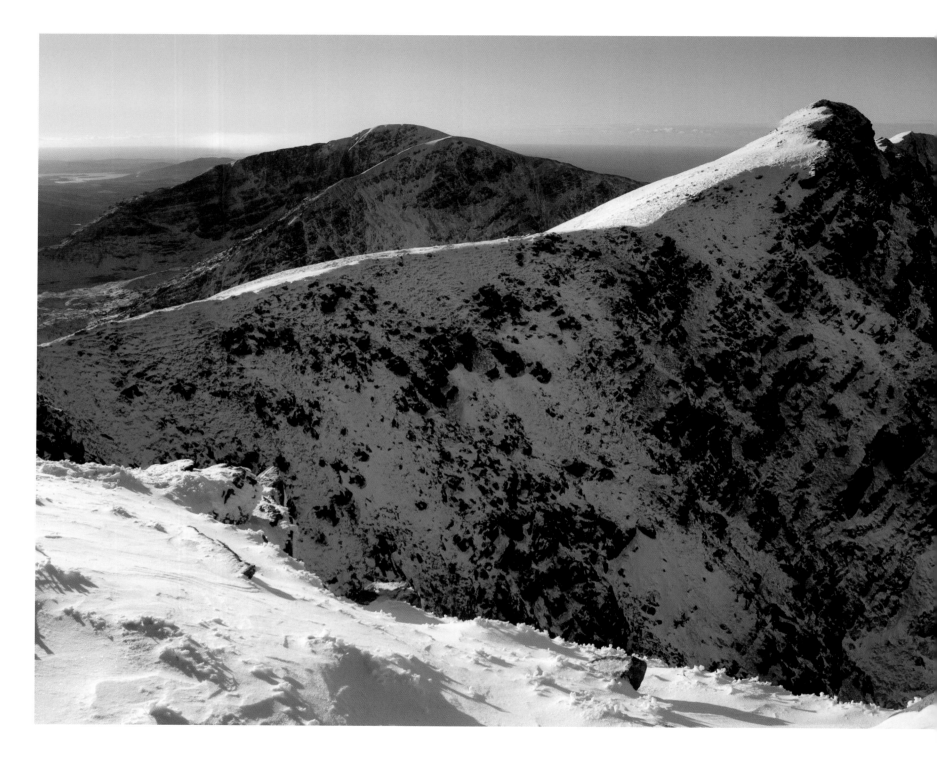

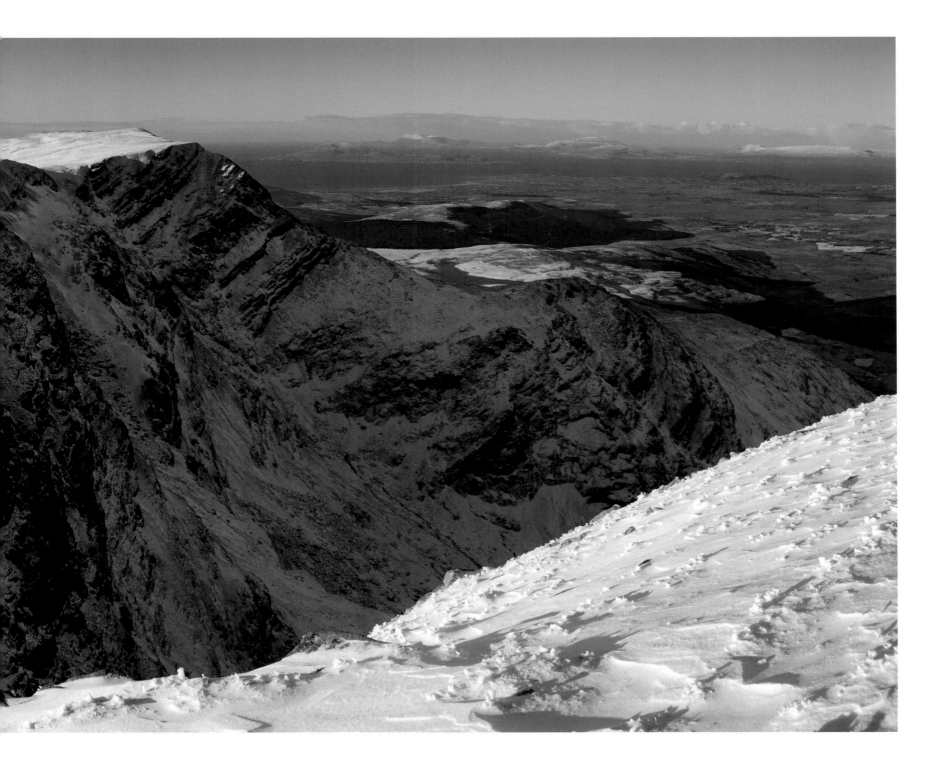

Winter fortress. The dark, snow-plastered cliffs of Lugmore or Coum Dubh, on the north-eastern face of Mweelrea.

Detail of bog flora, Doolough, County Mayo.

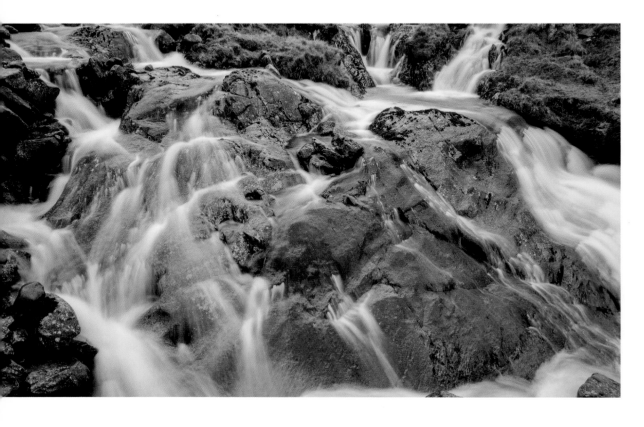

Above: Elements of the earth: mountain stream and rock.

Right: A walker takes in the view from the south ridge of Mweelrea.

Next pages: Evening light on Ben Creggan from the shoulder of Ben Lugmore.

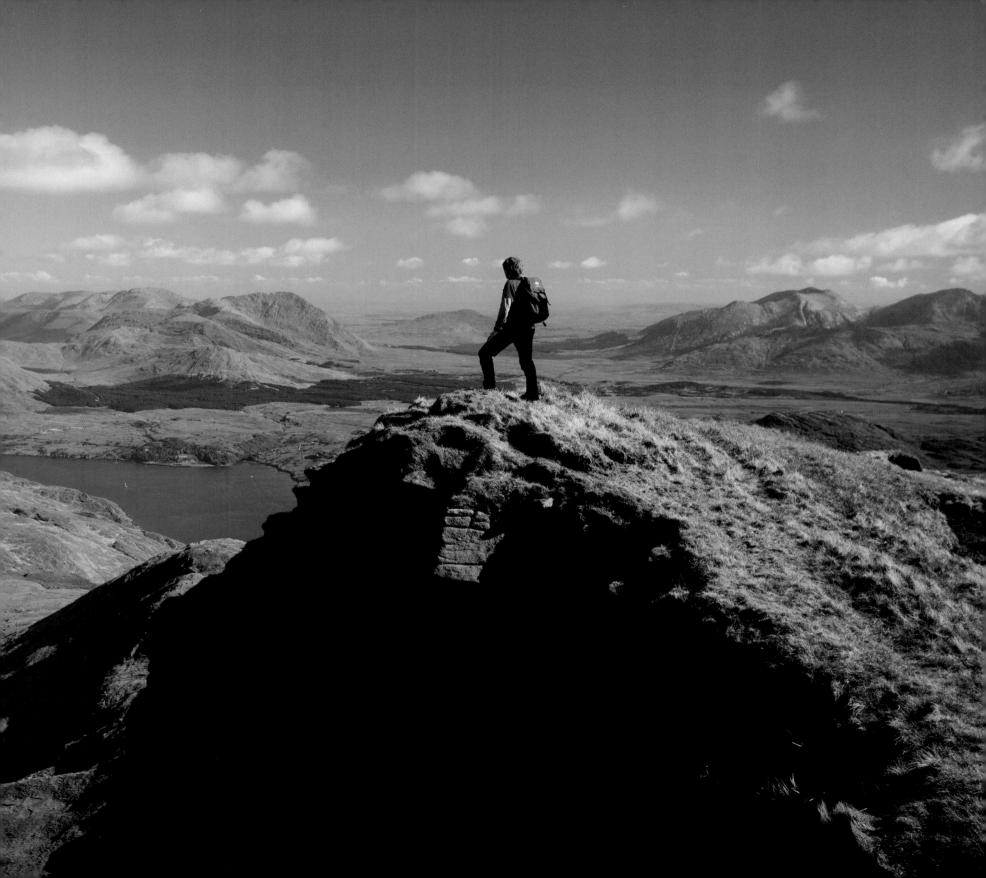

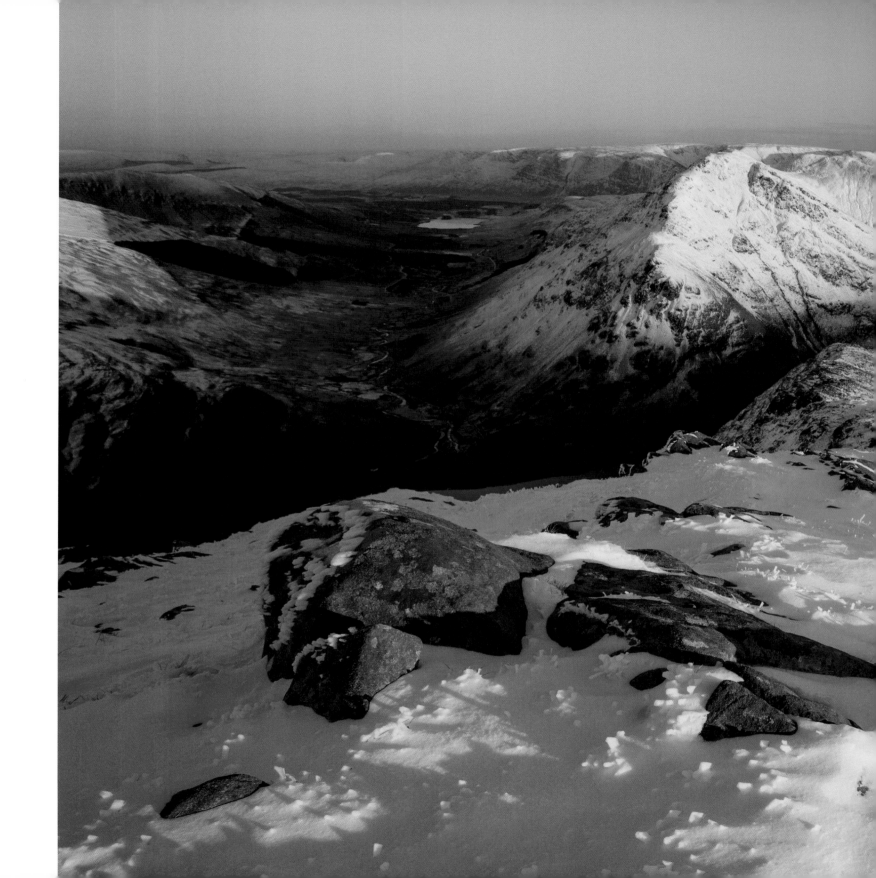

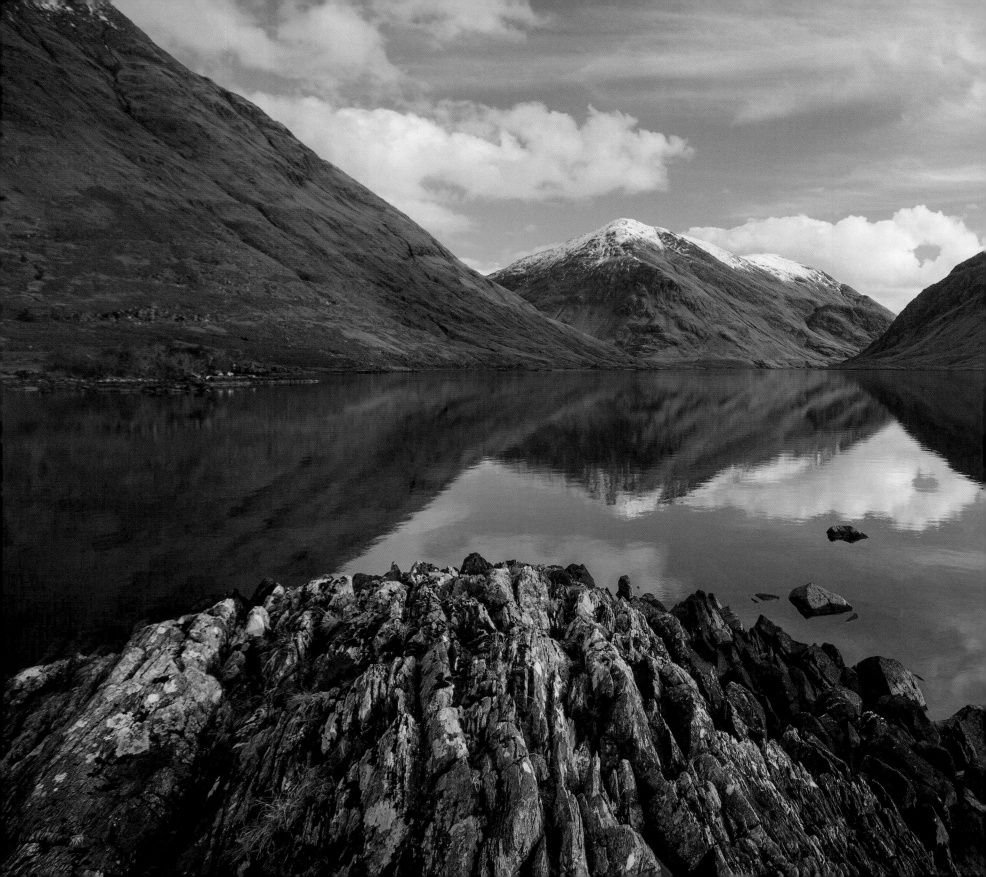

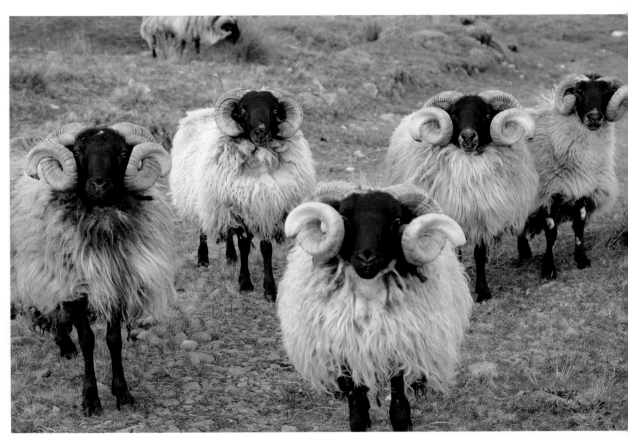

Above: Don't mess with the locals. A herd of Mayo blackface rams patrol the Erriff Valley.

Left: Ben Creggan reflected at the end of Doo Lough, with the Sheeffry Hills to the left and Mweelrea to the right.

Next pages: Natural symmetry: Maumtrasna reflected in the still waters of Lough Mask.

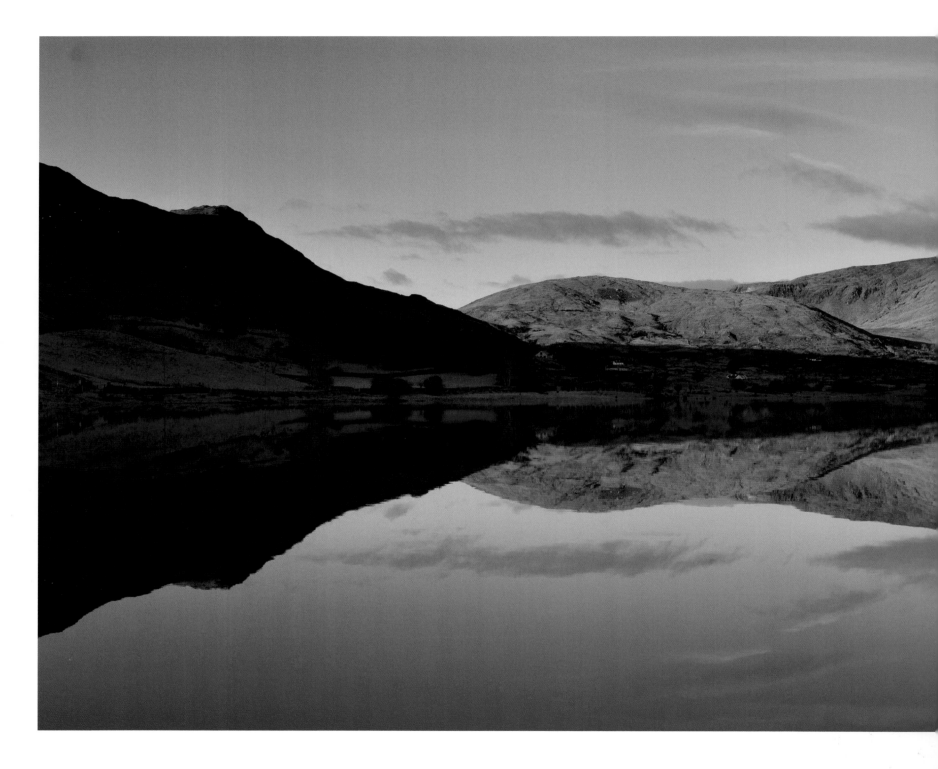

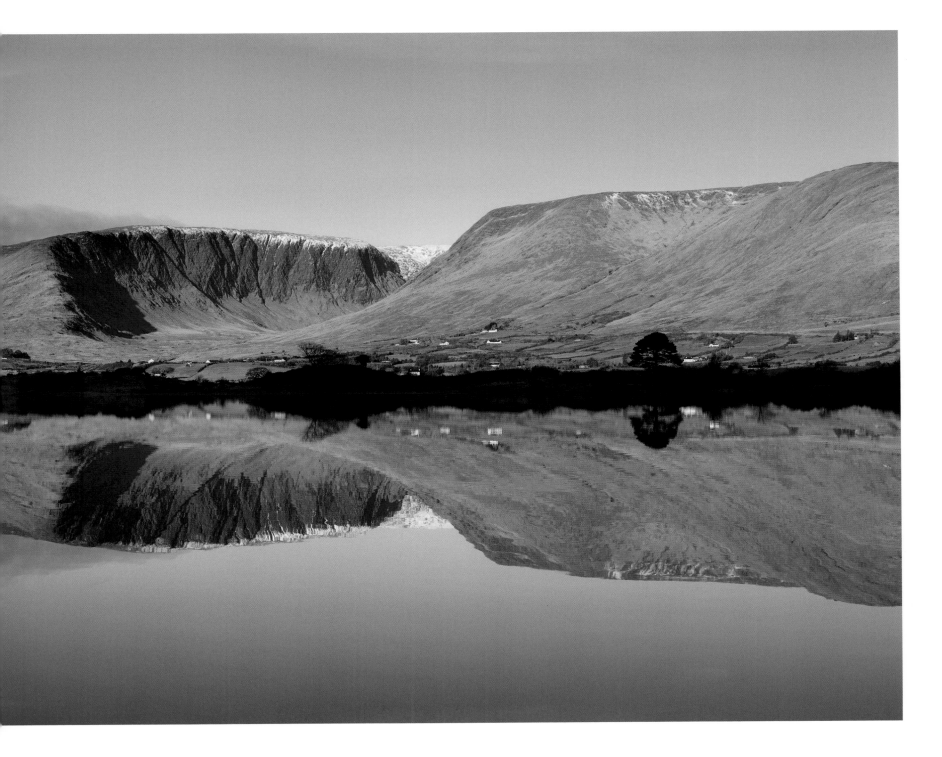

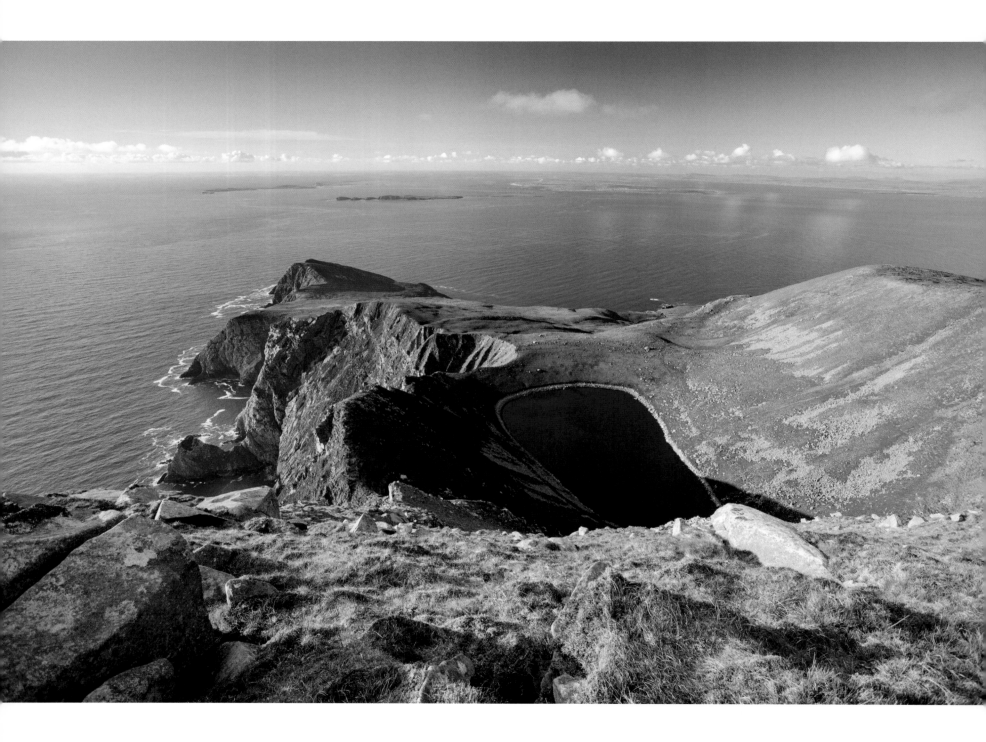

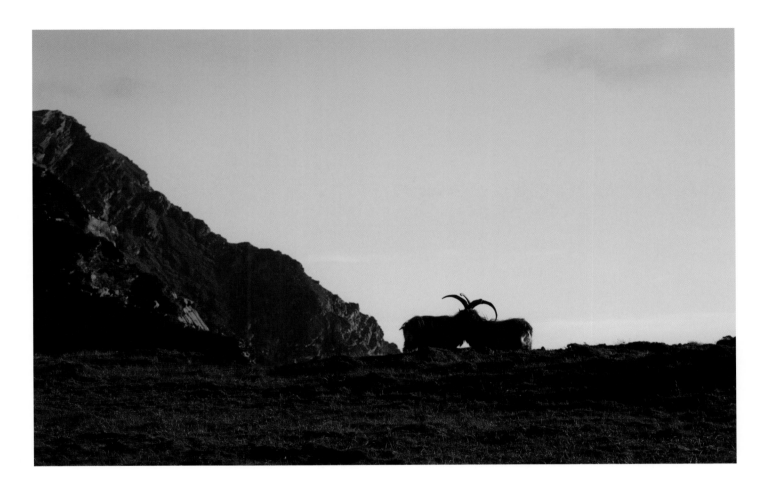

Above: Feral goats locking horns on Croaghaun, Achill Island.

Opposite: View over Bunnafreva Lough West from the summit of Croaghaun.

Next pages: Coastal giant: Croaghaun guards the western tip of Achill Island, its northern slopes culminating in the cliff-fringed promontory of Saddle Head.

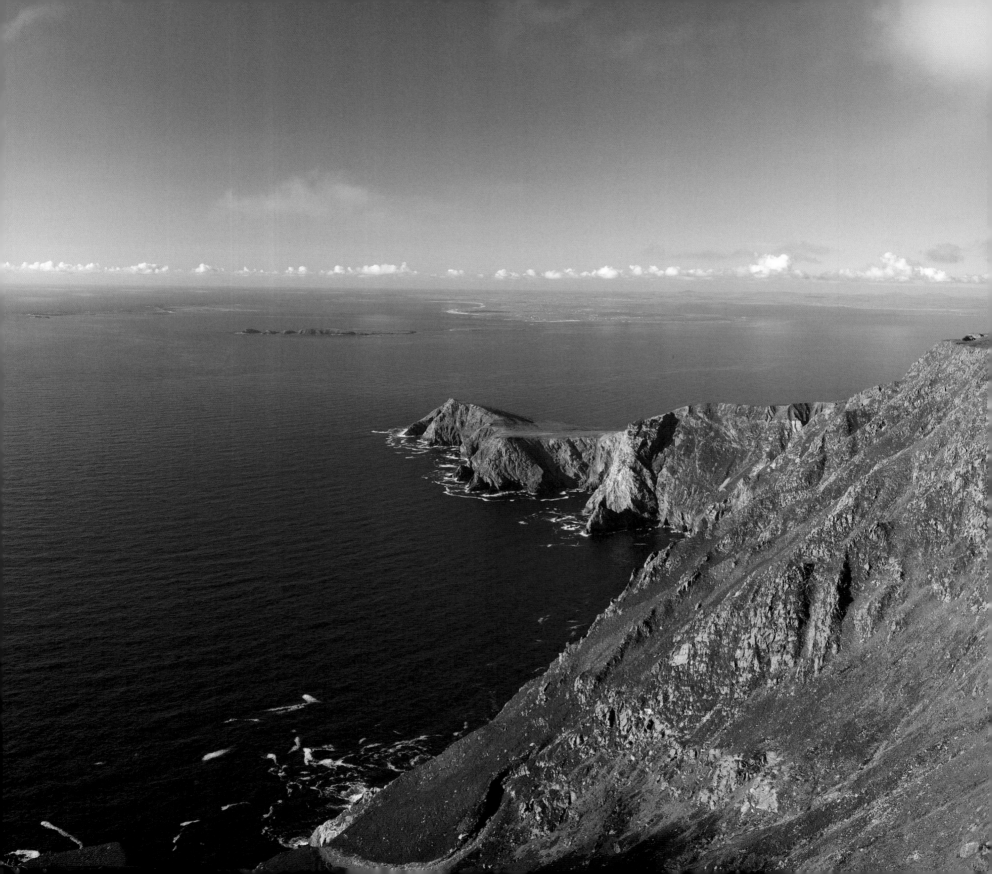

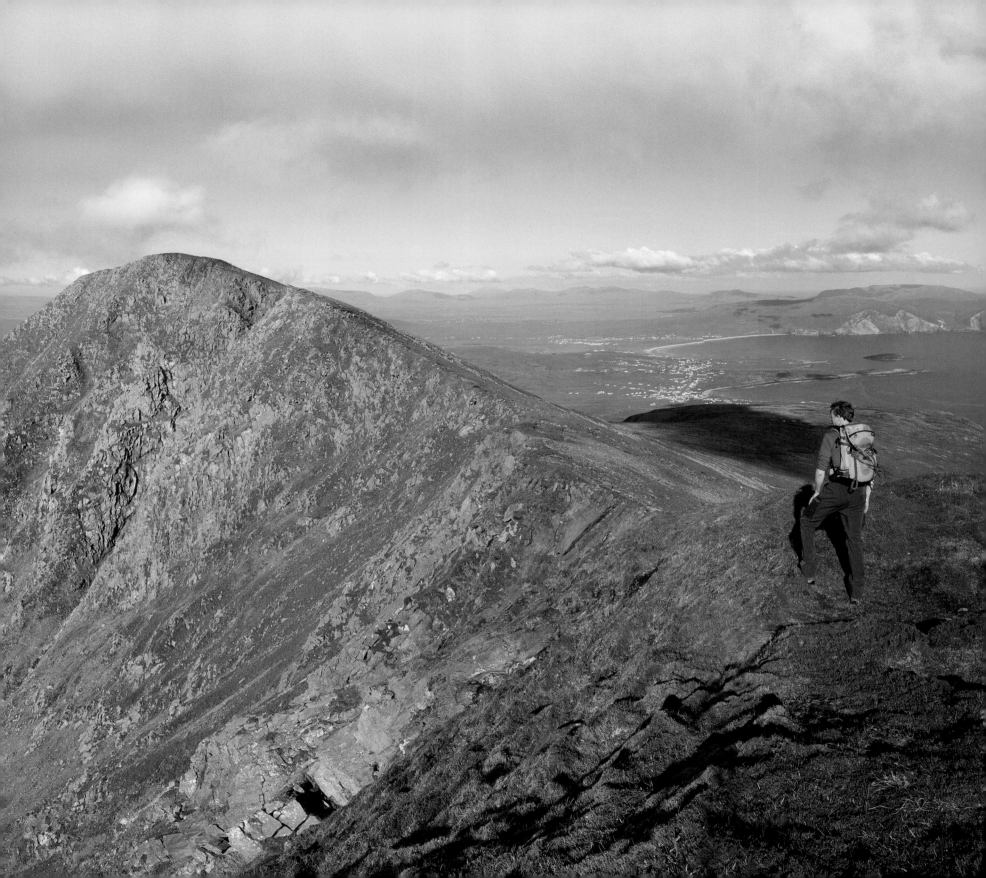

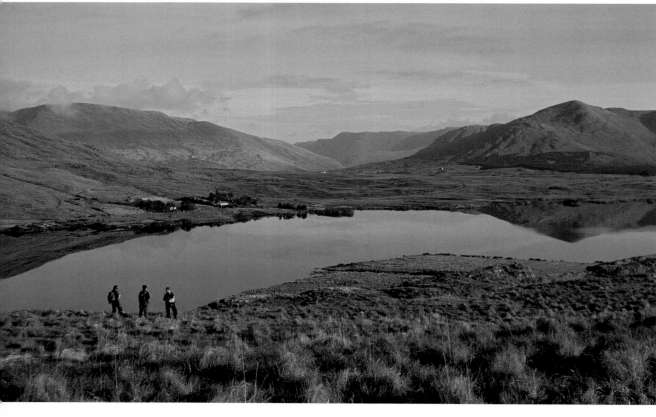

Left: Walkers on the shore of Lough Fee, Connemara.

Below: A crazy-paving pattern of lichen growing on a boulder in the Sheeffry Hills.

Opposite: St Patrick's-cabbage (*Saxifraga spathularis*) growing on the summit of Croaghaun on Achill Island, County Mayo. This saxifrage is part of the Lusitanian flora, native to Ireland and the Iberian peninsula but absent from Britain.

Next pages: Sessile oaks growing on the banks of the Owenmore River in Erriff Woods. This rare pocket of oak woodland is a remnant of our original native forests.

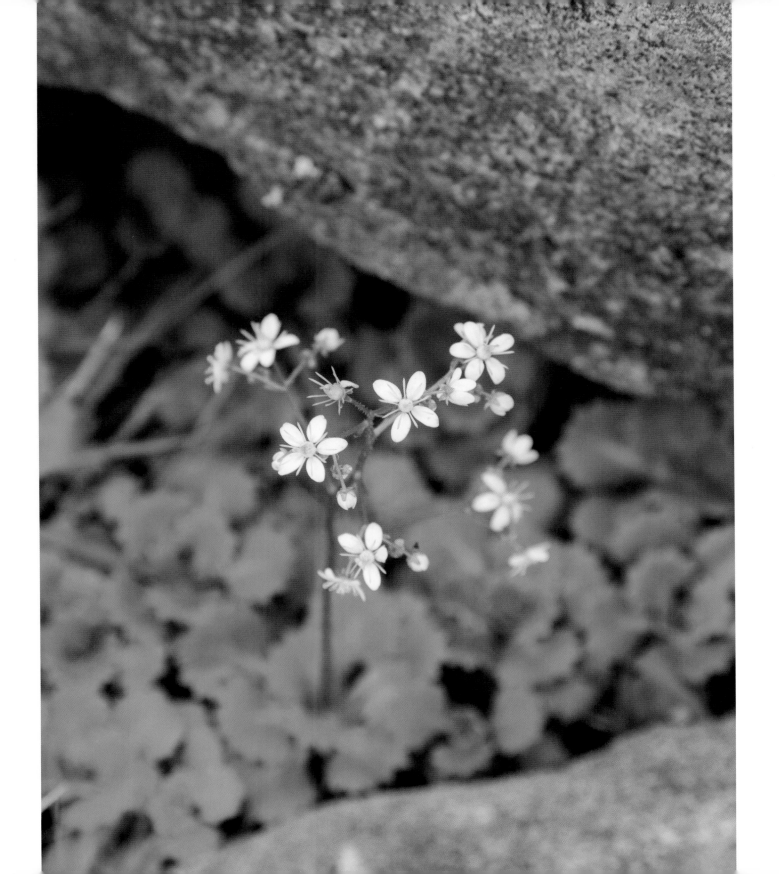

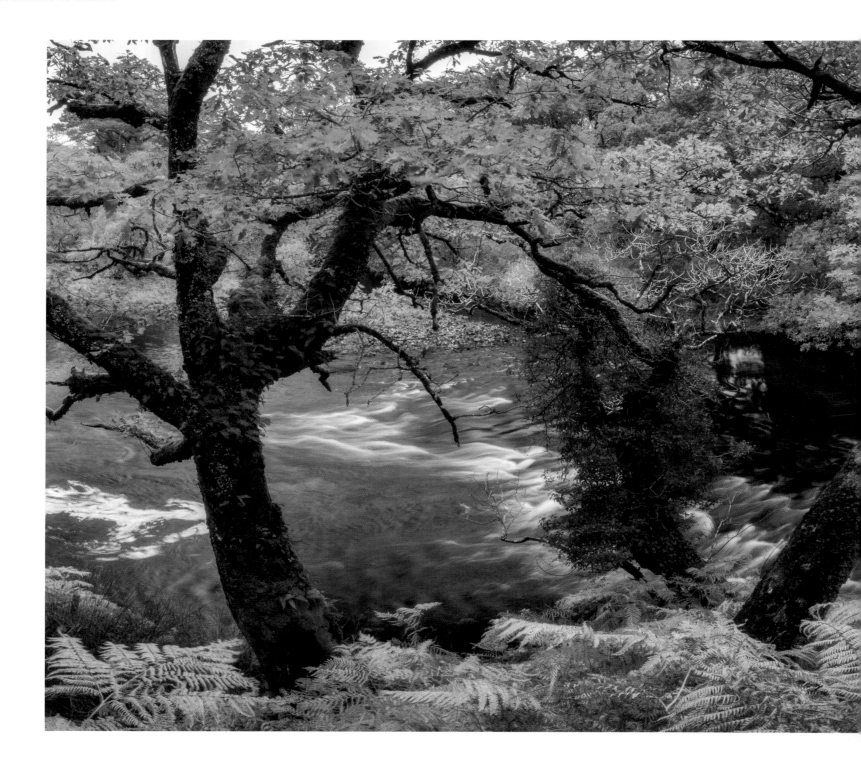

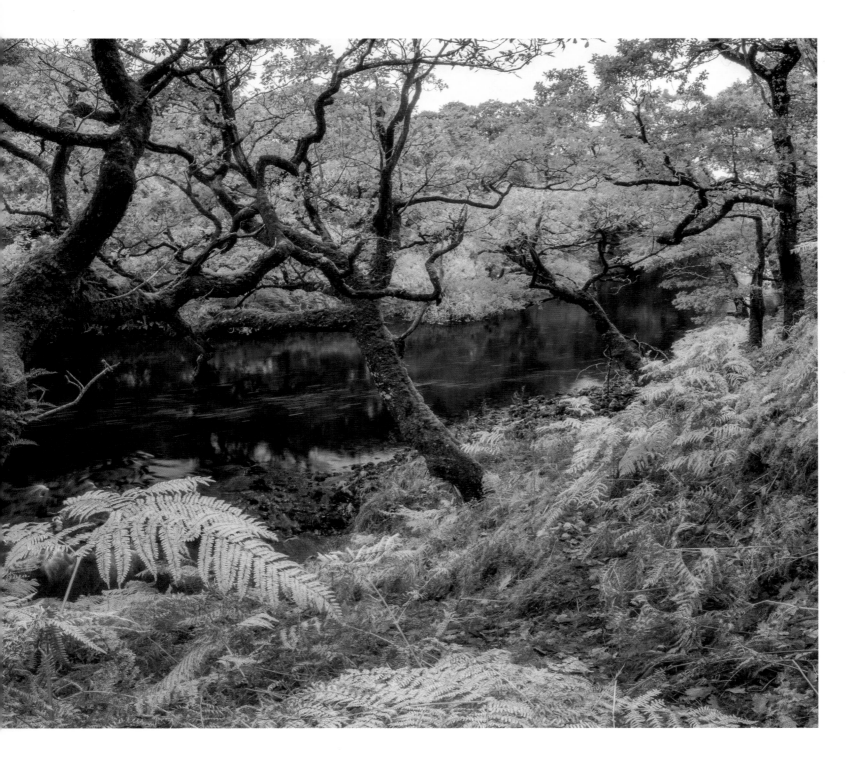

People and the Mountains

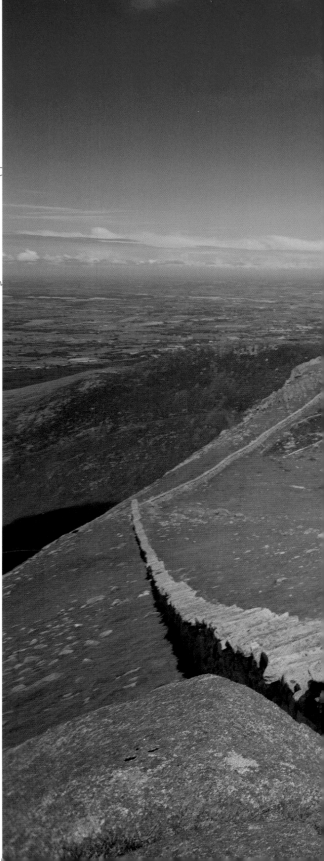

Our mountains, black rock and bog are old and weathered like our culture, our history, and our folklore. Roaming through the mists of some dark corrie, it would somehow not seem incongruous for that hero of Celtic mythology Cuchulainn to emerge from the slow-drifting gloom, even in the second decade of the twenty-first century. Ancient burial cairns lie scattered across our hills and mountains in such profusion that it is impossible to escape their significance to our ancient forebears – the high places were central to their rituals, religion and spirituality. The Irish mountains are small enough to climb easily and build small structures on, yet high enough to command the surrounding landscape and allow the visitor to feel elevated above the everyday world.

While Megalithic, Neolithic and Celtic peoples largely used the stone and rock they found lying on the mountainside to construct cairns, their Christian descendants indulged the need for penance by carrying additional building materials up the mountain. Through such grinding labour the church on the summit of Croagh Patrick was built over a century ago, and crosses were erected on summits like Carrauntoohil, Brandon and Galtymore. Indeed, a single man was responsible for building the distinctive grotto on Cruach Mhór in the MacGillycuddy's Reeks.

Walker on the summit of Slieve Bearnagh in the Mourne Mountains.

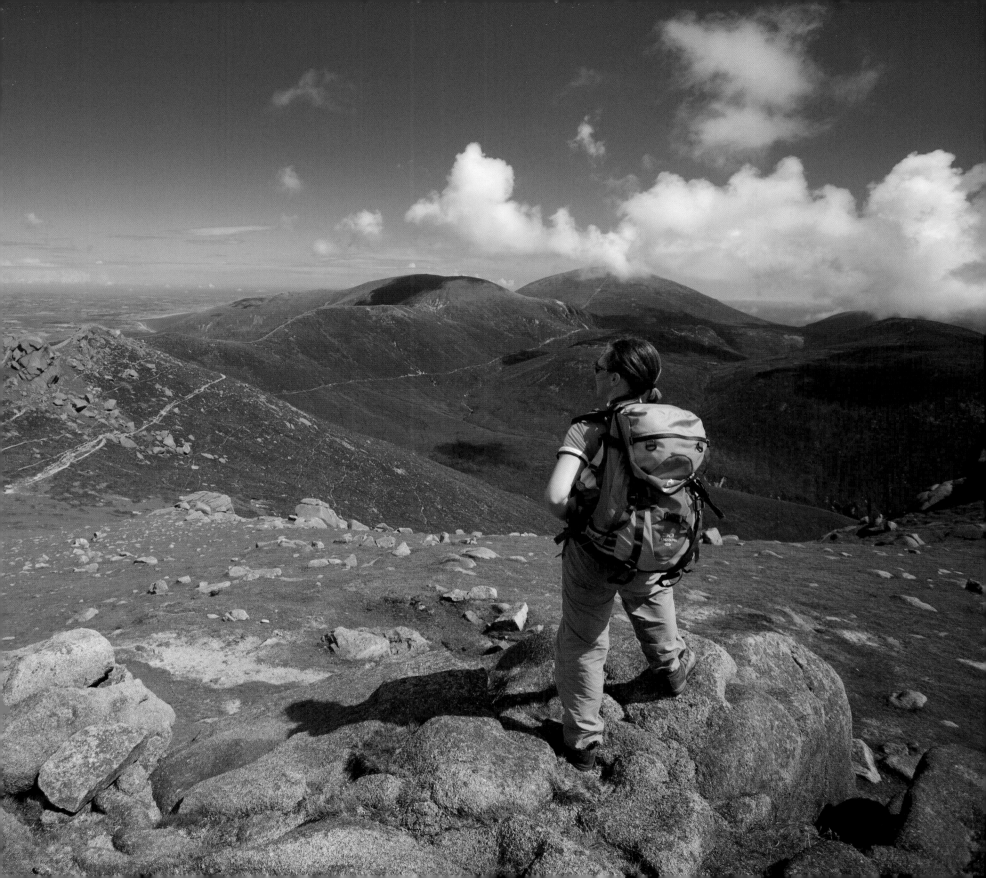

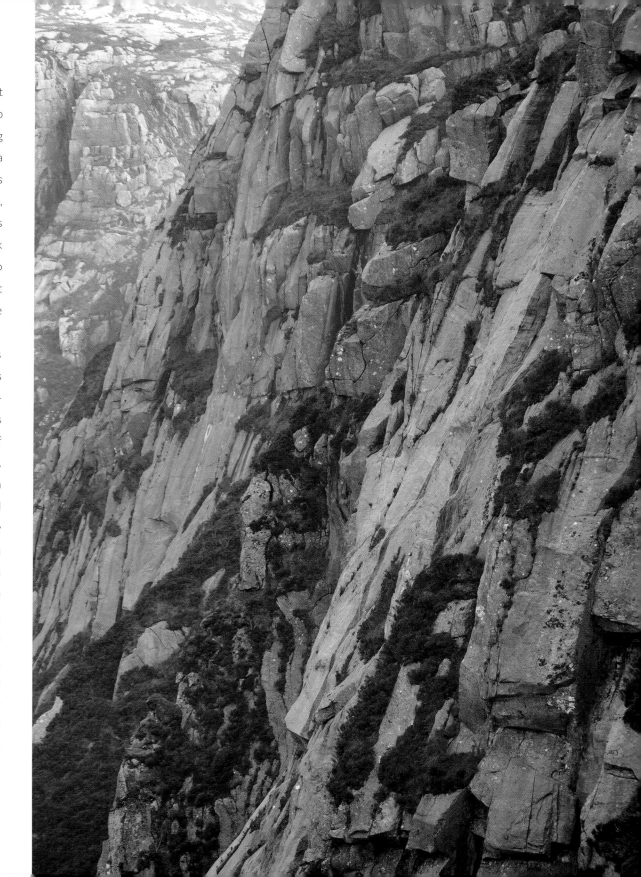

This was penance and atonement of the highest order, but the physical height of the mountains also allowed people to feel closer to the heavens. Leaving a mark of Christianity on the peaks helped 'civilise' a wilderness still populated by the monsters and demons of Celtic and pagan mythology. Some mountains, such as Brandon and Croagh Patrick, remain sites of pilgrimage today. Reek Sunday on Croagh Patrick brings tens of thousands of people of all ages onto the mountain on the last Sunday in July, making it by far the largest single human interaction with the mountains in Ireland.

On most other days the summits of Ireland's mountains are the preserve of recreational users – walkers and climbers, who are visiting in ever-increasing numbers. This explosion in popularity has much to do with a societal sea change in our view of exercise, but also with our expanding leisure time. Only thirty years ago the idea of walking in the Irish mountains was very much a niche pastime, pursued by a tight-knit bunch of aficionados clad in wools, itchy synthetics and waterproofs, which would succeed in making the wearer almost as wet from the inside as the rain would have made them from the outside. The arcane ritual of learning how to navigate by compass and map was a rite of passage into hills where paths were virtually unknown. Today some new walkers, though ostensibly well-equipped and clad in highly designed and fashionable outdoor clothing, rely for navigation on the new trails worn by the passage of many feet and those get-out-of-jail-free cards: the GPS and mobile phone.

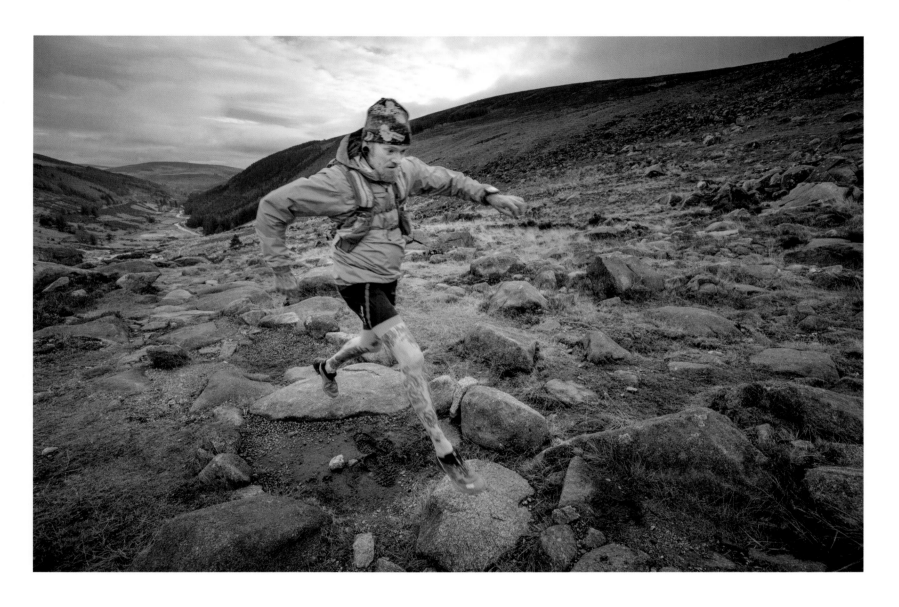

Above: Mountain and trial runner Juju Jay on St Kevin's Way near Glendalough, County Wicklow.

Left: Kevin McGee climbing 'Michéal' (E1 5b) on the West Buttress of the Poisoned Glen in Donegal.

With increasing footfall, there is an expanding workload for the mountain rescue teams around the country. Perhaps because of their modest height, Ireland's mountains are continually underestimated. Our notoriously fickle and wild weather is amplified in the mountains and although not all accidents are caused by complacency or inexperience, serious injuries and fatalities are surprisingly common. Comprised of volunteers drawn from the local communities, mountain rescue members are invariably also climbers and walkers, ready to go onto the mountains at any time and in all weathers.

More than anyone else though, it is the people who live and work in our mountains who have had the biggest impact on how they look today. Since Neolithic times, our mountains have been used to graze cattle, goats and sheep. Agriculture in our upland areas probably reached its peak prior to the Famine as can be seen from the ruined cottages and lazy beds in areas remote from the closest modern habitation.

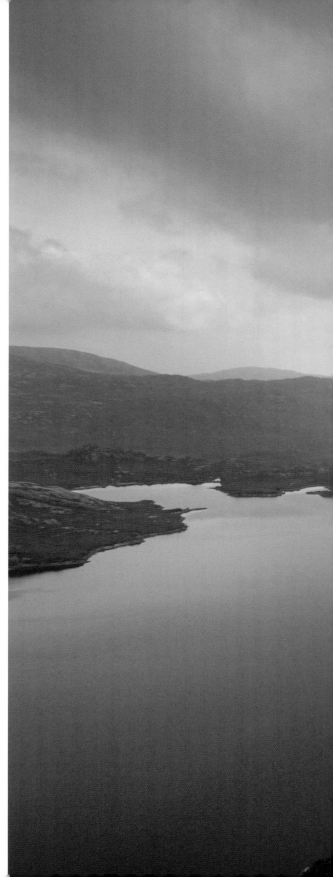

Above: Rock-climbing equipment hanging from a harness.

Right: Geoff Thomas near the crux of 'Classical Revival' (HVS 4c, 5a, 4c), high above Lough Belshade in the Bluestack Mountains of Donegal.

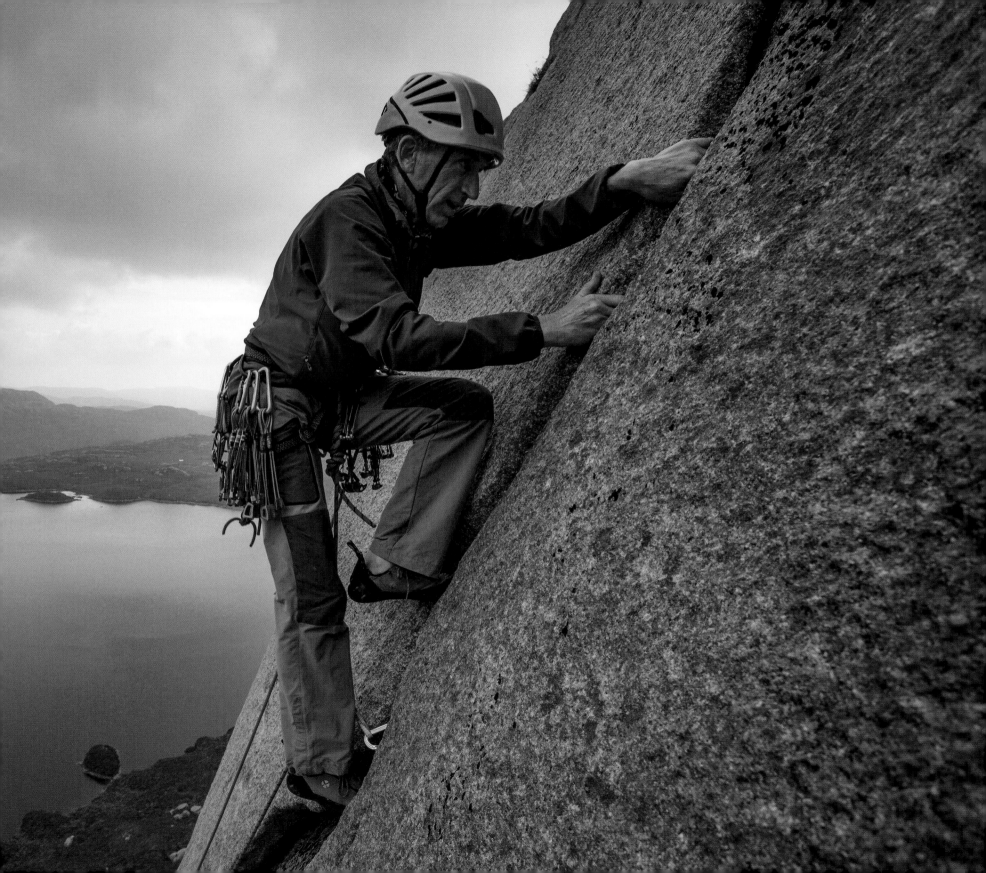

Currently there are approximately 15,000 hill-farmers in Ireland, but even that number is in decline. There are several contributing factors, foremost of which are unfair pricing structures in the agricultural and food industry, which means it is often impossible for hill-farmers to recoup the costs of production. Despite compensatory farm payments, a majority of hill-farmers now have other jobs outside the farm, and the vocation of hill-farming is becoming a less attractive proposition to the next generation. Other bugbears for hill-farmers include the shifting bureaucracies of European agricultural policy and planning hindrances caused by the designation of the vast majority of upland areas as Special Areas of Conservation.

The mountains are perhaps our wildest natural landscape, but apart from the highest summits, they are not a true wilderness untouched by the imprint of human activity. Our upland ecosystems have developed over millennia through a delicate and evolving balance between natural and human influences. Conservation requires the maintenance of that human influence if we want the landscape to remain as it is.

Stocking levels have fallen in most areas, and while there were historically some mountain areas that suffered from severe overgrazing, it is now under-grazing that is more likely to be an issue. The trend towards smaller flocks and part-time farming means

Above: Parascender riding updrafts above the Conor Pass on the Dingle Peninsula.

Left: Pre-Famine boundary walls and lazy beds on a mountainside above Lough Mask in County Mayo.

that remaining stock is now farmed on smaller areas, lower down the mountain. Without grazing, heather quickly begins to dominate, followed by a scrub of gorse on the lower slopes. Why does this matter? Well, dominance of heather is often at the expense of a variety of other plant species, leading to a reduction in diversity. It is also bad news for walkers. Anyone who has ever walked for a distance through thick, deep heather will know how maddeningly difficult it is.

There are also other environmental challenges. The siting of wind farms on prominent sites has been a contentious issue for many years, and one not likely to go away, given our need to generate more energy from renewable sources. Erosion on our most popular walking routes is an increasing problem, hugely exacerbated in some locations by the irresponsible use of motorbikes and quad bikes for recreational purposes.

The relationship between famers and recreational users has, despite some high-profile incidents, been largely positive. Most landowners in mountain areas are happy to allow responsible access. Responsible access relies on three key tenets: being respectful, leaving things as you found them, and not bringing dogs. But with increasing numbers of visitors comes pressure to formalise access and a minefield of surrounding issues such as liability, privacy, upkeep

of stiles and paths, and of course questions over who should pay for it all. Progress is being made, but there are challenges ahead in many areas in order to arrive at a situation that both landowners and visitors find satisfactory.

When viewed from the perspective of geological time, there is very little about how we treat our mountains that really matters. In time, the sandstone mountains of Kerry and the granite of Donegal will be laid low by weathering and subsumed into some new rock formation. Perhaps in the grinding tectonic gyre of another epoch many millions of years from now, those rocks will metamorphose in the cauldron of mountain building and be cast up as a new range on a new continent.

There is an undeniable, fatalistic truth to this argument. But surely what really matters is our experience, and our children's experience of the mountains in the here and now. The mountains of Ireland are many things to many people: a home, a resource, a habitat, a place of pilgrimage, a salve for the stresses of modern life. Balances need to be struck between conflicting interests, but in the end we are all stewards of our environment. Our mountains are above all the crowning glory of our natural heritage, and a wealth beyond value.

Conservation Ranger Leonard Floyd of the National Parks & Wildlife Service surveying in Ballycroy National Park, County Mayo.

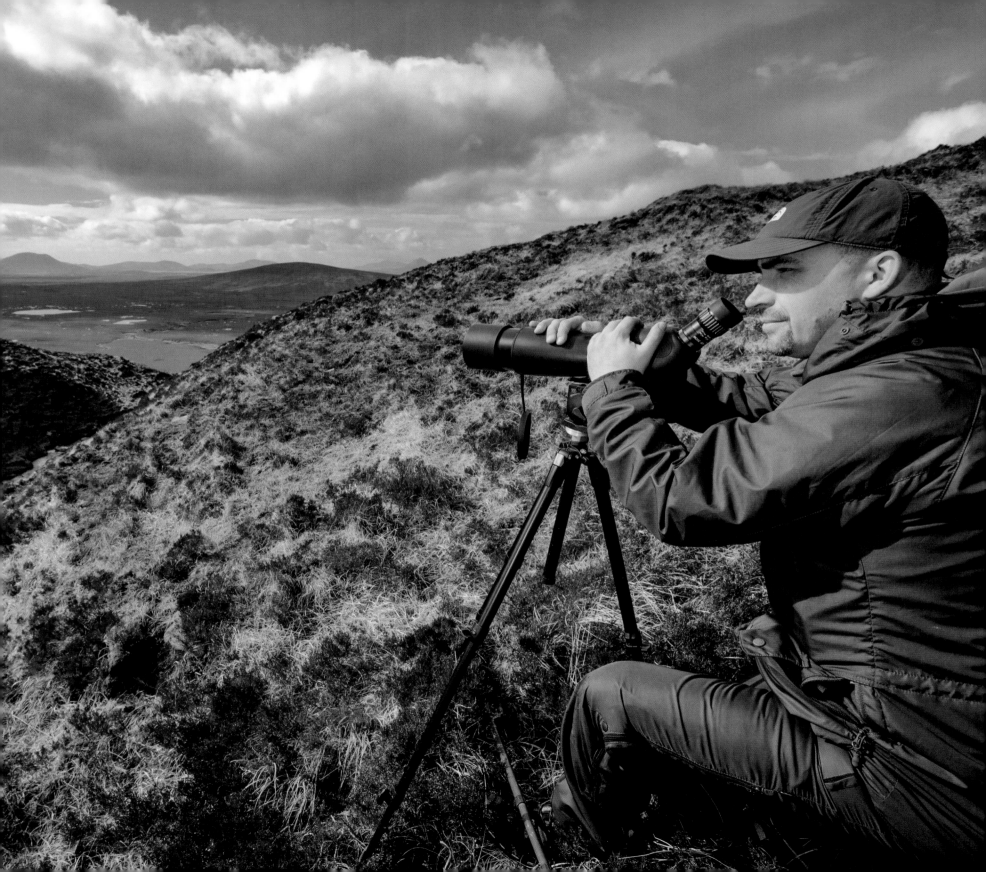

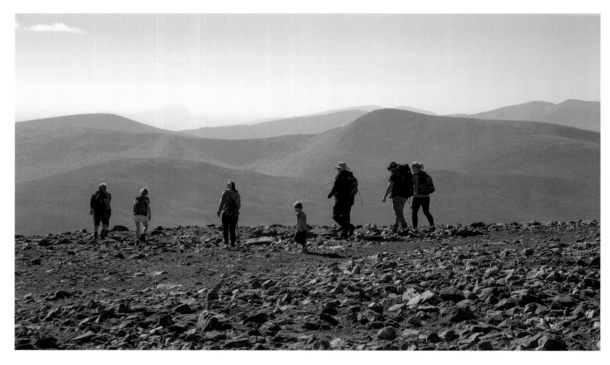

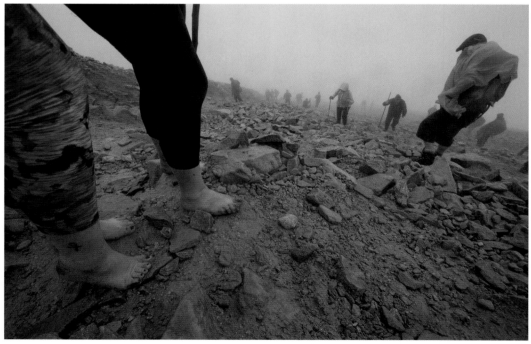

Above: Family walking group enjoying a fine summer day high on Nephin in County Mayo.

Right: Barefoot pilgrims on Croagh Patrick. Thousands of people climb the County Mayo mountain on 'Reek Sunday' (the last Sunday in July) each year.

Opposite page: Members of Mayo Mountain Rescue.

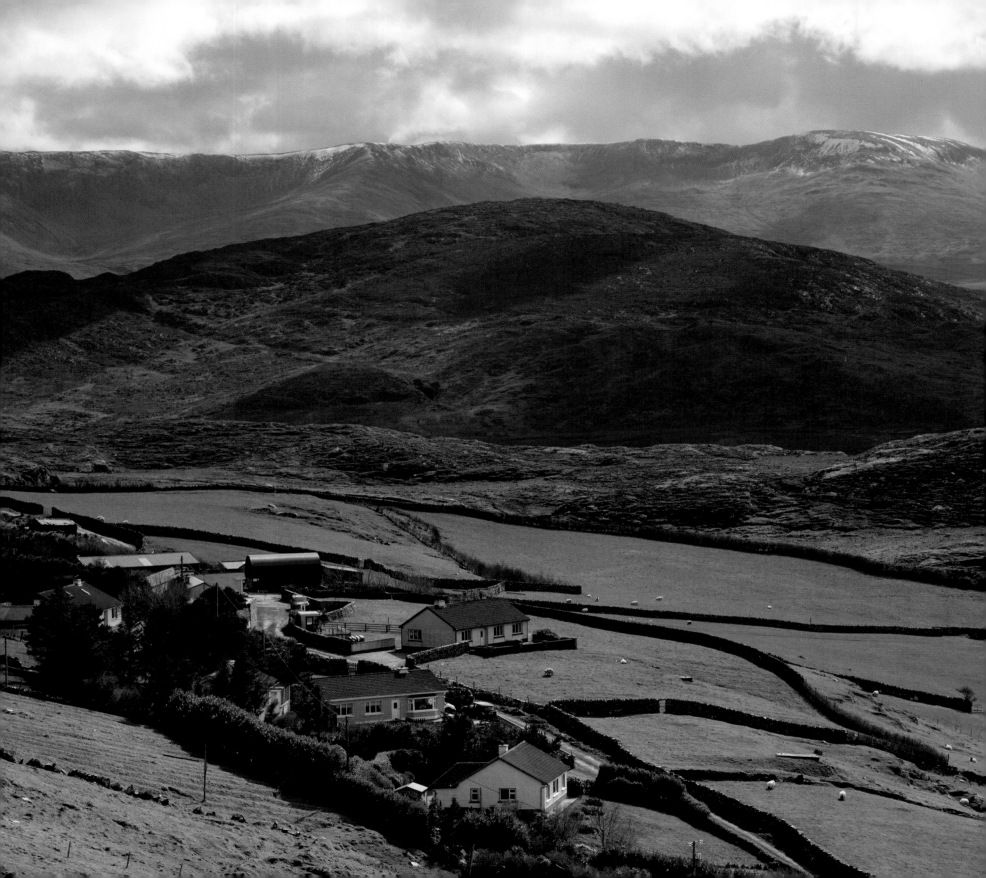

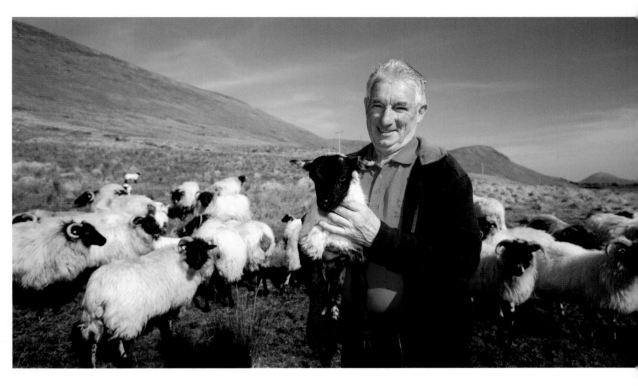

Above: Hill-farmer Michael Laffey in the heart of the Maam Valley, County Galway. As a hill-farmer and keen mountain walker, Michael is in a unique position to see both sides of the access debate.

Left: Hill-farm and houses at Cuilleen on the side of Croagh Patrick in County Mayo.

Acknowledgments

Special thanks to Martin Joyce and Colette Cowlard, publishers of *Walking World Ireland* magazine in the late 1990s and early noughties, without whom this book might never have got off the ground.

Thanks to Alan Tees and Geoff Thomas for undertaking the long slog to Lough Belshade to climb 'Classical Revival' for the camera. Also to Kevin McGee and Iain Miller for taking me along to their project in the Poisoned Glen. Thanks to Mervyn Gawley, Richard Creagh, Michael Laffey, Helen Lawless at Mountaineering Ireland, Ruth Cunniffe, Mary Walsh and Clem Quinn of Mayo Mountain Rescue, Juju Jay of Mud Sweat and Runners, and Susan O'Callaghan and Leonard Floyd at the National Parks and Wildlife Service.

First published in 2016 by
The Collins Press
West Link Park
Doughcloyne
Wilton
Cork
T12 N5EF
Ireland

A CIP record for this book is available from the British Library.

Hardback ISBN: 978-1-84889-289-7

Design and typesetting by Bright Idea
Typeset in Calluna and Lato
Printed in Malta by Gutenberg Press Limited

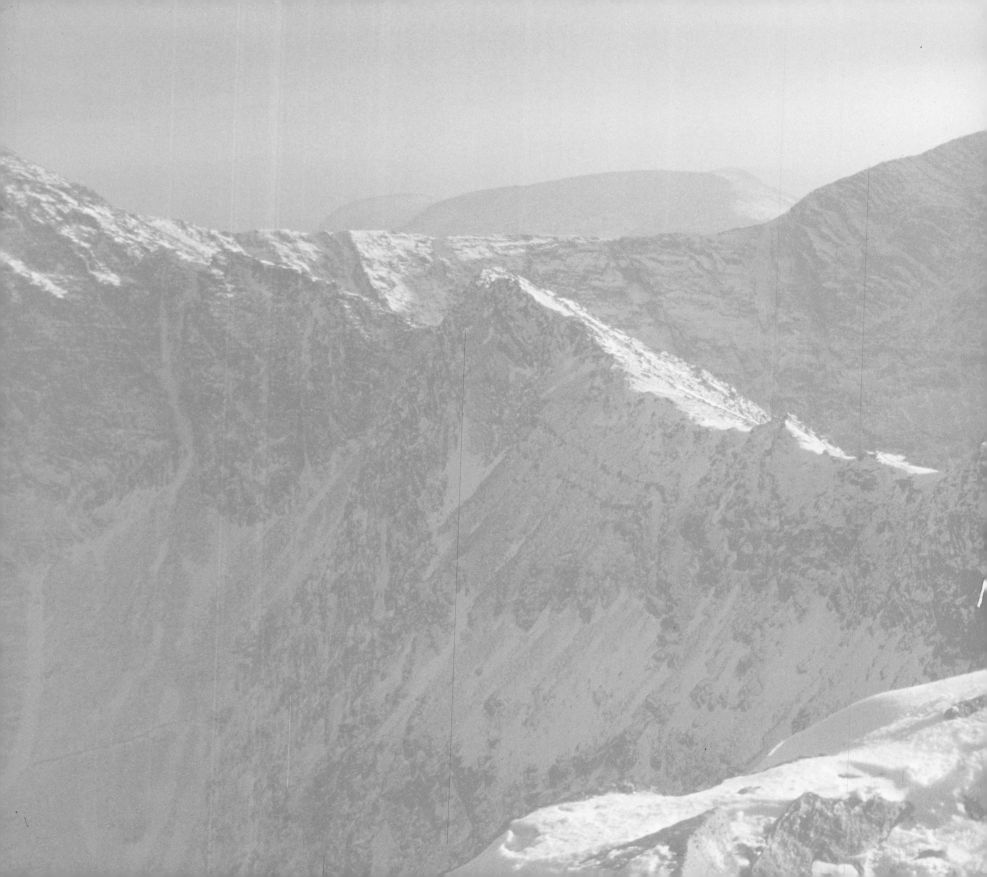